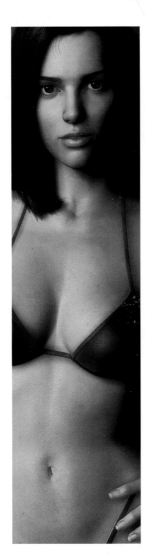

CHARACTER MODELING

d'artiste

DIGITAL ARTISTS MASTER CLASS

d'artiste™

Published
by

Ballistic Publishing

Publishers of digital works for the digital world.

134 Gilbert St
Adelaide, SA 5000
Australia

www.BallisticPublishing.com

Correspondence:
info@BallisticPublishing.com

**Fourth Edition published in Australia 2008
by Ballistic Publishing**

Softcover/Slipcase Edition ISBN 978-1-921002-11-3
Limited Collector's Edition ISBN 978-1-921002-12-0

Editor
Daniel Wade

Assistant Editor
Paul Hellard

Art Director
Mark Snoswell

Design & Image Processing
Stuart Colafella, Lauren Stevens

d'artiste Character Modeling Master Artists
Pascal Blanché, Francisco A. Cortina, Steven Stahlberg

Printing and binding
Everbest Printing (China)
www.everbest.com

Partners
The CGSociety (Computer Graphics Society)
www.cgsociety.org

Also available from Ballistic Publishing
d'artiste Digital Painting ISBN 978-0-9750965-5-0
d'artiste Matte Painting ISBN 978-1-921002-16-8
d'artiste Concept Art ISBN 978-1-921002-33-5
d'artiste Character Modeling 2 ISBN 978-1-921002-35-9

Visit www.BallisticPublishing.com
for our complete range of titles.

Cover credits

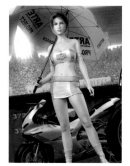

Figure study
Francisco A. Cortina
USA
*[Front cover: d'artiste
Character Modeling
Softcover edition]*

Track Day
Olli Sorjonen
FINLAND
*[Back cover: d'artiste
Character Modeling
Softcover edition]*

Mermaid
Pascal Blanché, CANADA
*[Cover: d'artiste Character
Modeling Limited Edition
cover]*

/ B A L L I S T I C /

Daniel Wade
Managing Editor

Paul Hellard
Assistant Editor

Welcome to the second book in our Digital Artist Master Class series. The d'artiste imprint (pronounced dah-tee-st) means both 'of the artist' and 'digital artist'. Each d'artiste title features techniques and approaches of a small group of Master Artists. However, the focus of d'artiste books is not limited to just techniques and technical tricks. In addition, we also showcase galleries of their own work and other artists' paintings that inspire them. Along with artist interviews this gives the reader a comprehensive and personal insight into the Master Artists—their approaches, their techniques, their influences and their works.

d'artiste: Character Modeling showcases the work and technical prowess of: Pascal Blanché, Francisco A. Cortina and Steven Stahlberg. Each Master Artist presents their character modeling techniques which start with modeling concepts, and also include texturing and lighting. Though the artists use specific 3D software in their tutorials, the concepts are universal to most 3D applications.

d'artiste: Character Modeling is broken into three sections based around each Master Artist. Artists' sections include a personal gallery, the artist's work and thoughts in their own words, a large tutorial section, and an invited artist gallery featuring characters from some of the most talented digital artists in the world.

Ballistic Publishing continues to expand the d'artiste series to encompass all aspects of digital content creation. Look for d'artiste Matte Painting which follows the art and techniques of three world-leading matte painters in Alp Altiner, Dylan Cole and Chris Stoski. Visit www.BallisticPublishing.com for new titles.

The Editors
Daniel Wade and Paul Hellard

FRANCISCO A. CORTINA PASCAL BLANCHÉ STEVEN STAHLBERG

d'artiste™

DIGITAL ARTISTS MASTER CLASS

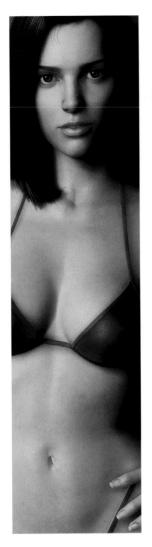

CHARACTER MODELING

FRANCISCO A CORTINA

Francisco Cortina recently finished work on the film 'Aeon Flux' at Digital Domain in Venice, CA. His digital career began soon after earning his Bachelor of Fine Arts degree at the Maryland Institute of Art. He joined the Japanese video game giant Square USA, where he worked on several game titles such as 'Parasite Eve' and 'Final Fantasy IX', the animated feature film 'Final Fantasy: The Spirits Within' and the animated short 'Animatrix: Final Flight of the Osiris'. After his tenure at Square, Francisco joined Dreamworks Feature Animation as a Technical Director, working in their Modeling, Character Technical Directing and Lighting departments.

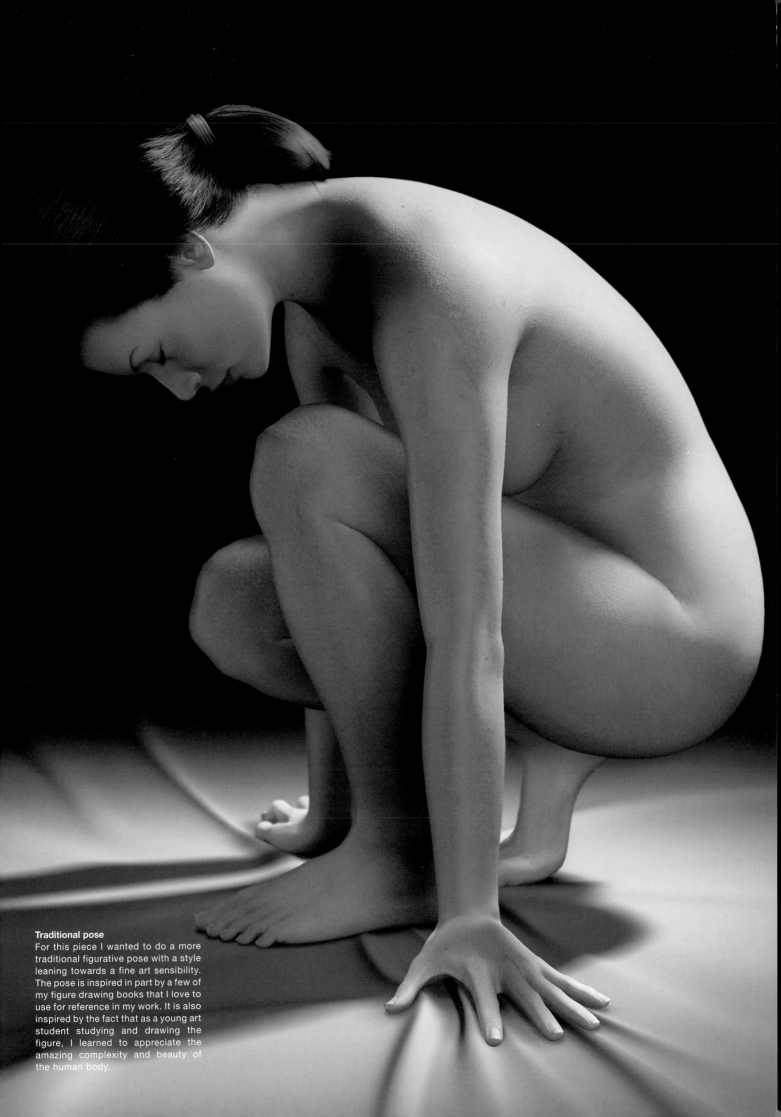

Traditional pose
For this piece I wanted to do a more traditional figurative pose with a style leaning towards a fine art sensibility. The pose is inspired in part by a few of my figure drawing books that I love to use for reference in my work. It is also inspired by the fact that as a young art student studying and drawing the figure, I learned to appreciate the amazing complexity and beauty of the human body.

CONTENTS

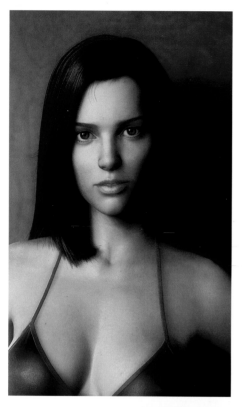

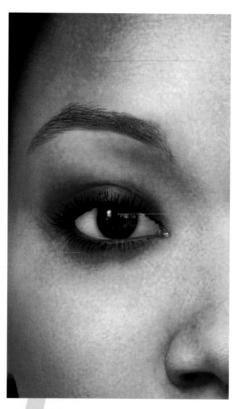

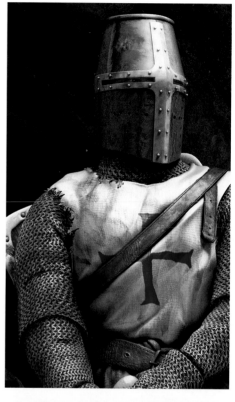

FRANCISCO A. CORTINA: THE ARTIST

Background
Watching morning cartoons such as Spiderman, Transformers and imported Japanese animation influenced me to draw figures, faces and robots. I was so captivated by the idea of creating my own worlds and characters that I would secretly draw robots and characters during my classes in grade school. Ever since I was a young boy, I wanted to become an artist, either in painting or drawing.

Education
One of the most important experiences of my artistic life happened at nine years of age when my parents, urged by my school teachers, signed me up to be tested for acceptance into an arts-related elementary school called Rainbow Park. It was there that my passion for art grew immensely. The school taught students to use our environment as reference and to draw only what we see, which meant that we would be drawing mostly still lifes of plants, drapes and all sorts of colorful fruit. It wasn't exactly drawing robots or mechs, but after that I knew that it was what I wanted to pursue as my career. I continued attending public schools with art programs from middle school (Norland North Center for the Arts) through high school (New World School of the Arts in Miami, Florida). The great thing about attending these programs was that they focused on building a strong fine arts foundation, including drawing, painting, sculpting, printmaking and photography.

Digital beginnings
I first encountered computers while in middle school. Our art teachers introduced us to the boxy looking thing called the Macintosh. We made fun of the funny name, too. It had these strange vector- and bitmap- based painting programs, but because they were slow and had no color, I really didn't like it. In high school I got to use the more powerful Apple II, which had full color painting and a simple modeling program called Swivel 3D. Things sure have come a long way since then. It wasn't until a few years later while studying at the Maryland Institute College of Art in Baltimore, Maryland, that I saw just how powerful and creative computers could be. After seeing my roommate working on a program called 3D Studio R3, I couldn't believe how creatively powerful that tool was. I knew I had to purchase a computer immediately so that I could start using those tools and create my own work. Not long after, I began creating and animating medieval characters, figures and faces as an extension of my drawings and paintings and the rest was history for me.

Into the workforce

Since I was studying at a traditional fine arts college (which had no animation or 3D graphics program at the time), I essentially had to teach myself as I went along. I read all the manuals, magazines and usenet articles that I could get my hands on to understand the concepts of 3D and how others were creating their works. My first computer graphics job came about during my last year of college when I saw an opening for a part-time animator/modeler at the nearby Johns Hopkins University and Hospital. Strangely enough, the job involved working for an internal development group at the Wilmer Eye Institute creating models of eye surgery tools as well as creating animations and video edits relating to eye surgery. It was not exactly the easiest job since I had to sit through surgeries in order for me to create the video edits. Though some of that was not fun, it gave me the necessary experience in different areas to get myself into the computer graphics industry. After my job at Johns Hopkins, I took a full-time position at Square USA. It was there that I began to learn at a much more accelerated pace. Not only was I exposed to new tools, such as Alias PowerAnimator and StudioPaint 3D, and hardware like the SGI, but I was also exposed to techniques and ways of doing things in a production environment. I learned a great deal from my peers since we all had different backgrounds and varying levels of experience.

Tools of the trade

It all started for me using 3D Studio Release 3 and later 3D Studio MAX, but eventually I moved onto the SGI platform using 3Design, Nichimen and Alias PowerAnimator. For 2D and 3D paint there was Amazon Paint, but the king of the hill was StudioPaint 3D, which I still really miss. For different productions, I have used many variations of software, including Renderman, mental ray, and even custom renderers for games. These days I really only use four packages. I use Maya for most of my 3D work and now have started using ZBrush for both my personal work and client/production work. For painting textures I have always used a combination of 2D and 3D software with Photoshop and now, BodyPaint 3D.

Gaming

As odd as it may sound, landing in the game industry sort of happened by chance. Even though I was always a fan of video and computer games, when I was hired to work at Square I had no idea that it was the same company that had created so many of those popular video games. While working on 'Final Fantasy IX', I had the pleasure of working with very talented artists. It wasn't until I had just about completed my work on that project that I was given the opportunity to work on the movie project. The transition from working on very stylized anime style characters to hyper-realistic humans was a great opportunity for me to push myself hard and put my interest in the human figure to use.

On the big screen

The first thing I did when I started on 'Final Fantasy: The Spirits Within' was to go to the bookstore to buy

as many reference books as I was able to, and absorb as much detail as I could. Early on in my artistic life I learned that gathering good reference for one's subject plays a very important part in how successful or how well it turns out. In terms of software, I had to transition myself from spending most of my time in PowerAnimator to using Maya and Renderman for rendering. 'Final Fantasy: The Spirits Within' was my first movie, followed by the 'Animatrix: Final Flight of the Osiris' animated short movie, 'Shark Tale' (formerly 'Sharkslayer') and just recently, 'Aeon Flux' (Charlize Theron). The process for 'Final Fantasy' was my first experience in a blockbuster-sized production environment. Since I came from smaller sized productions in games, it was at first overwhelming. After I got used to the environment, I realized that there was quite a lot of freedom for CG artists that were generalists (Modeling, Texturing, Look Development and Lighting) to do different things and possibly, cross different departments. Similar to departments in live action movies, there were Sets and Props, Character, Lighting and Compositing. One good feature in that system was that modeling, texturing and character setup all were under the umbrella of the Character department, allowing for a very efficient pipeline of work to be established and managed. The Animatrix short movie was produced under the same type of pipeline structure as 'Final Fantasy', which I believe contributed to its very quick production schedule and turnaround time. Of all

the projects that I have been involved in, the most enjoyable was the Animatrix. Because we were able to recycle almost all of our pipeline from the previous production that gave us more time to be able to push both the technical and artistic envelopes. One of the things we were able to introduce during that production was a Pose Space-based system for character rigging that allowed us to model an infinite number of muscular deformation poses that blended between each other with little distortion.

Breaking into CG
For artists who are starting out I always give them the same piece of advice: find what it is that really drives you creatively and run with it. Although pursuing a career in CG as an artist doesn't really require a background or foundation in art,

having it is a great asset and the possible difference between becoming successful or not. For up and coming digital artists who feel they are struggling to create or achieve a certain look, I always recommend going back to the basics of drawing and sculpting things from real life (still lifes, faces, landscapes, or even mechanical objects). Because CG is a blend between the technical sciences and fine arts, there is more room for blurring of the lines between the two disciplines. Some roles in CG don't require artistic skills, such as a plug-in programmer or a full-fledged scripter. However, being an artist who becomes technical enough to script or program can be a great asset. Whether it's modeling, texturing, lighting or compositing images, it is important to find exactly what areas you really love to focus on.

Some people, such as myself, are generalists focused on specifics like creating characters or creatures. Others specialize in one area and find great interest and joy there. By trying different things you eventually find what motivates you and when you love what you do, you will be successful at it!

Modeling in the future
It is unbelievable how quickly computers have evolved, even in the past decade. The biggest change that has empowered our field has been raw processing power. We are beginning to see a change in trends with companies embracing hardware-based renderers. For artists it means less time waiting for your machines and more time actually creating. There is also a steady convergence in the game and film industries, and I believe that the

quality of games will eventually surpass that of film. We will see less separation between us and the computers we create on, with no limits to geometric density, free form and automated parameterization for texturing and more robust and sensitive hand-based input devices.

Francisco's future
After having spent a good amount of time in the game and film industries, I'm reaching a point where I'm ready to shift in a slightly different direction. Since I have worked in different areas of CG, I already know that my love is with creating characters and it's something that really motivates me. I am currently in the process of going independent and starting a company identity to create digital characters for clients in different industries.

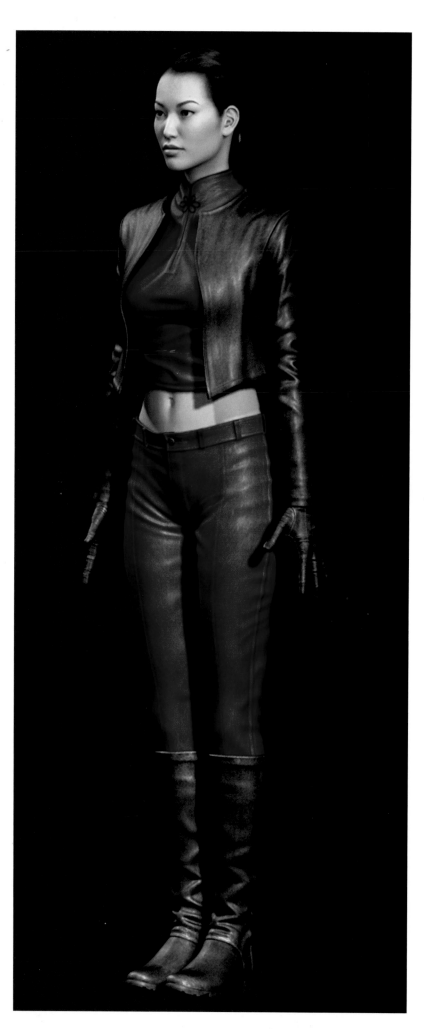

Jue's outfit model
I created her outfit so that all the wrinkles and leather folds were modeled into it. Because it was fairly tight on her body, there was little need for animated wrinkles or simulation. Modeling/hair: Francisco A. Cortina. Face/Facial textures: Steven Giesler. Outfit textures: Jake Rowell Image copyright Square USA, Inc.
[left]

Digital Bikini Babe
This was a collaborative piece I worked on with Steve Giesler. Although we were under a very tight deadline, we had a great time working on it. I did the modeling and hair and he did the textures and face. Andrea Maiolo also helped us with adding an extra GI lighting pass. Image copyright Square USA, Inc.
[right]

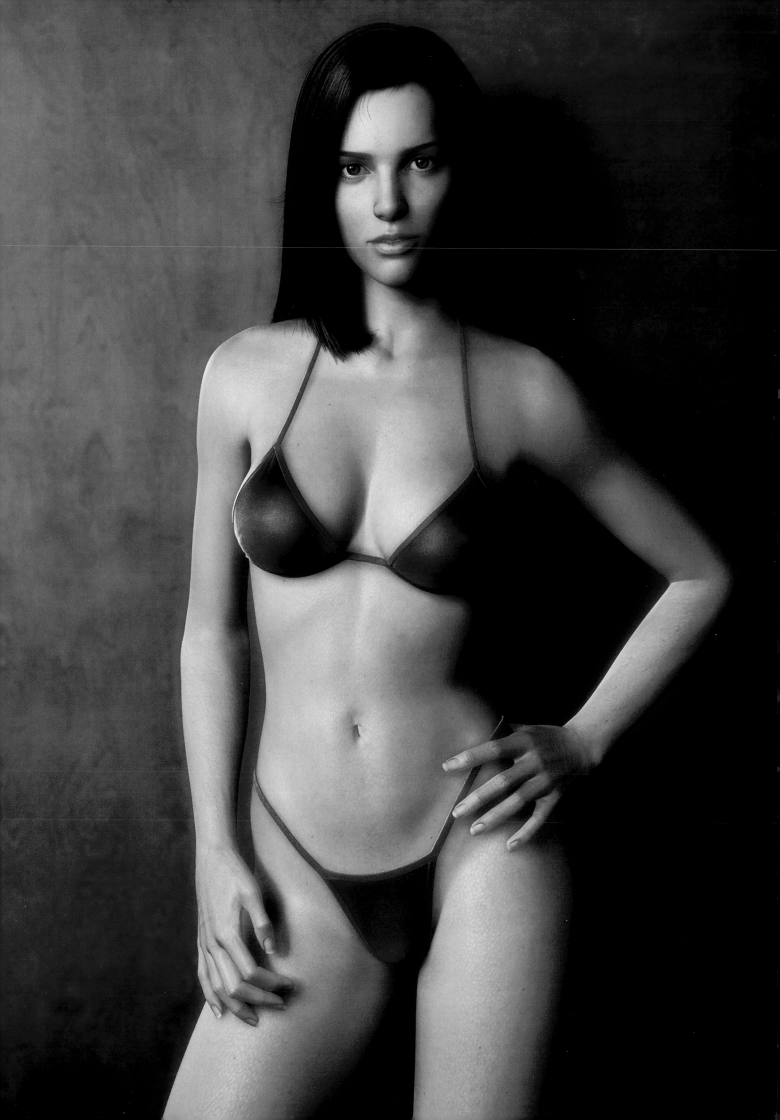

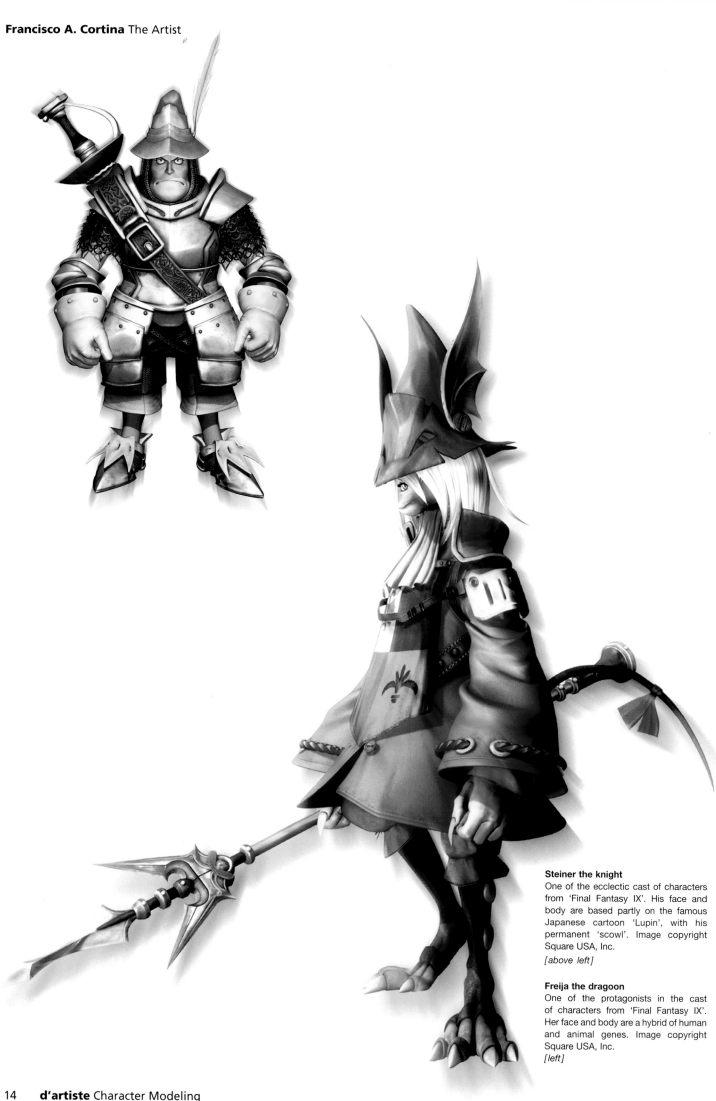

Steiner the knight
One of the ecclectic cast of characters from 'Final Fantasy IX'. His face and body are based partly on the famous Japanese cartoon 'Lupin', with his permanent 'scowl'. Image copyright Square USA, Inc.
[above left]

Freija the dragoon
One of the protagonists in the cast of characters from 'Final Fantasy IX'. Her face and body are a hybrid of human and animal genes. Image copyright Square USA, Inc.
[left]

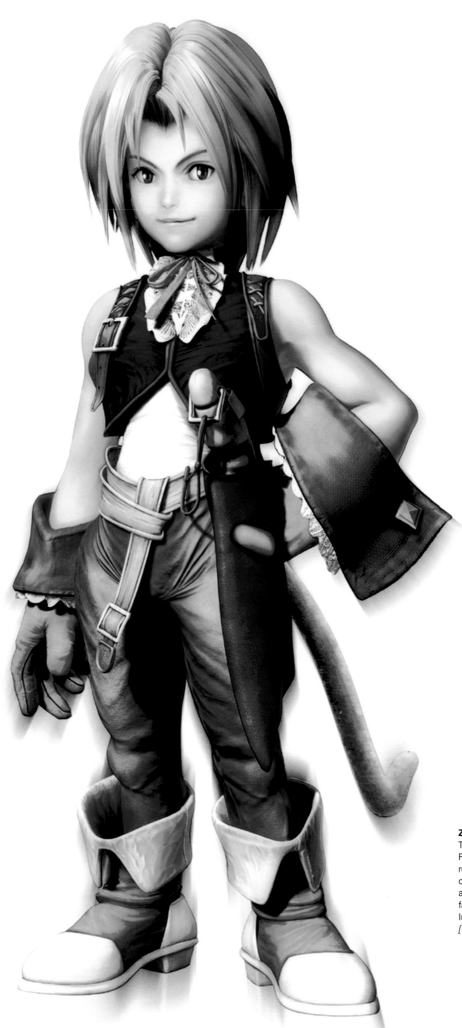

Zindane the mutant
The rascal protagonist from 'Final Fantasy IX' who is half-human and half-rodent. This piece was a collaborative one with me doing the body texturing and re-modeling, Yoshio Yamakawa the face and Koji Kawamura the old model. Image copyright Square USA, Inc.
[left]

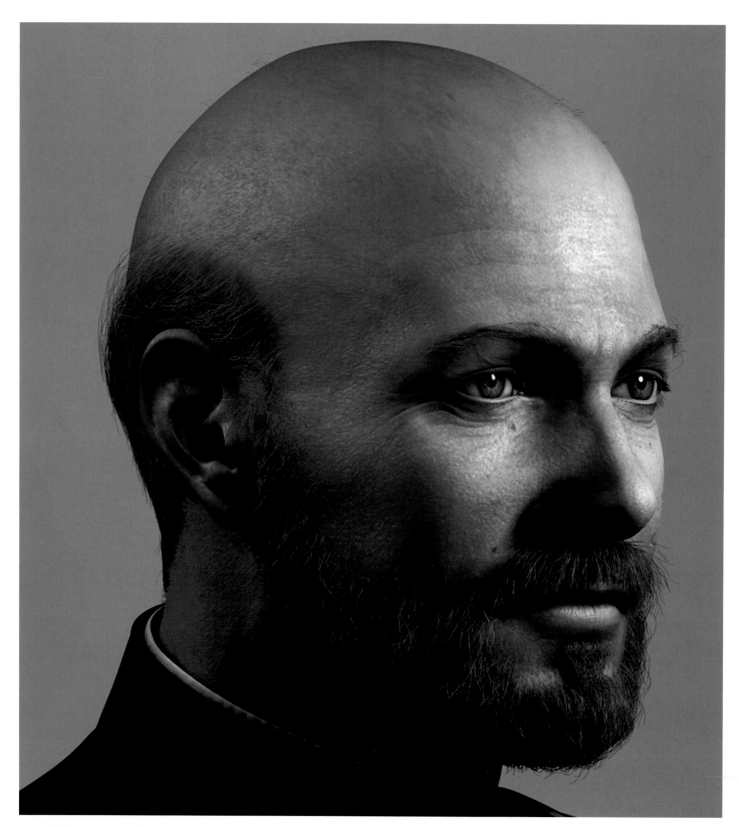

Creepy Priest
When I was working on this character he seemed to take on a somewhat creepy personality. I emphasized it I think by keeping his eyes towards blue, yet making his beard and facial hair very dirty and brown.
[left, above]

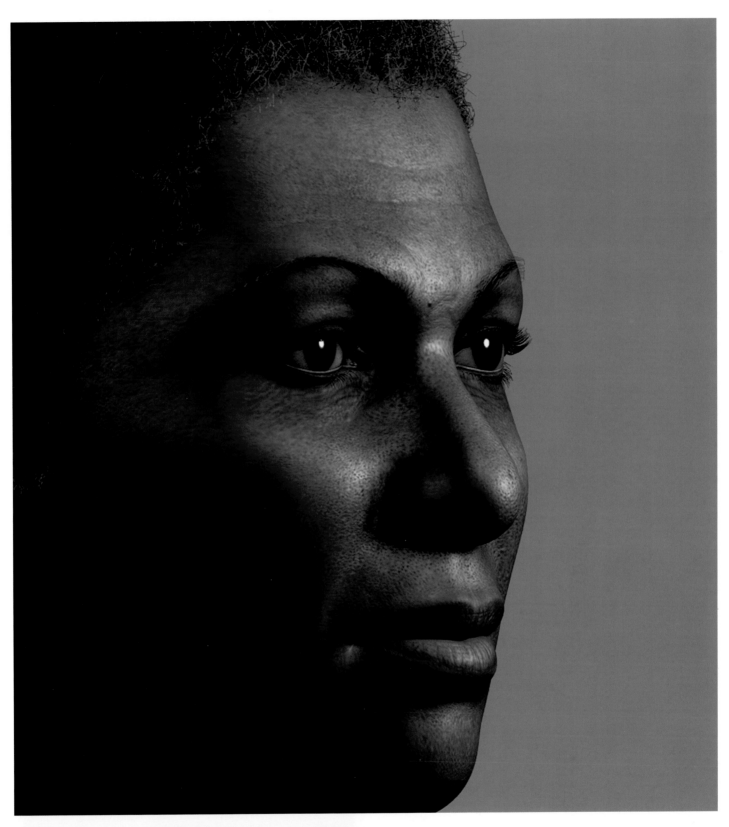

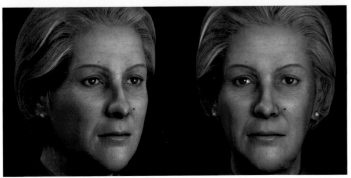

Grandma
My first attempt at an older woman which reminded me of my grandmother. One of the most difficult elements I wanted to achieve was the feeling skin that felt old but delicate, and not too shriveled or wrinkly.
[left]

Shanikua worried
I wanted to give this character the feeling of looking older not so much because of age, but hardship.
[above]

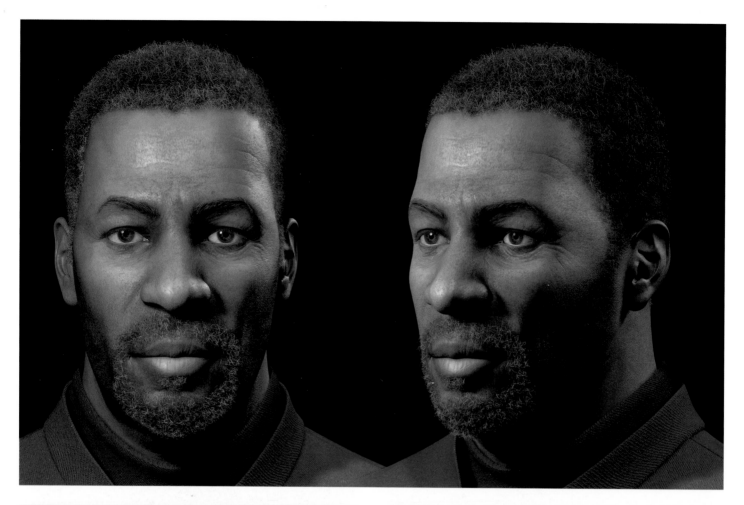

Police Chief
Based a little on the famous actor Morgan Freeman, I wanted to give this man a strong sense of confidence and sternness. The graying rough goatee and hair are the main elements contributing to the strength of his character and I wanted those to be the focus.
[left]

Gray Mag
This was a collaborative piece I worked on with Steve Giesler. I did the modeling work, hair, and displacements and he worked on the face and textures. After we created the Maxim image we were asked to create a shirtless posed CG image of our lead protagonist from 'Final Fantasy'. Image copyright Square USA, Inc.
[right]

Count Viggo
Once I was close to finished modeling his face, I realized that he was starting to look like a vampire. The hair, brow shapes and odd lips gave him an odd personality.
[far left]

Military Council member
He was one of those character faces for which I was not able to put much modeling time into, yet a persona still came through.
[left]

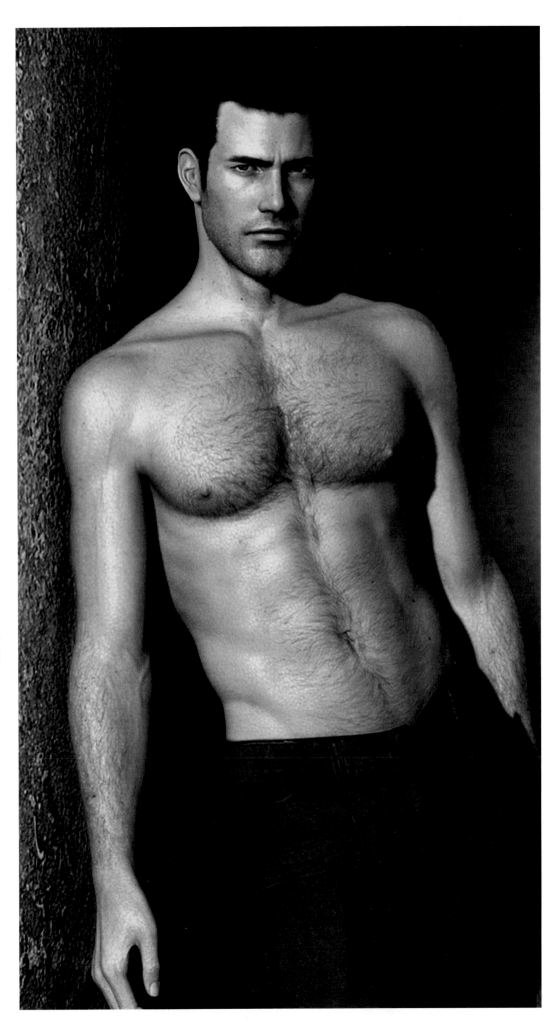

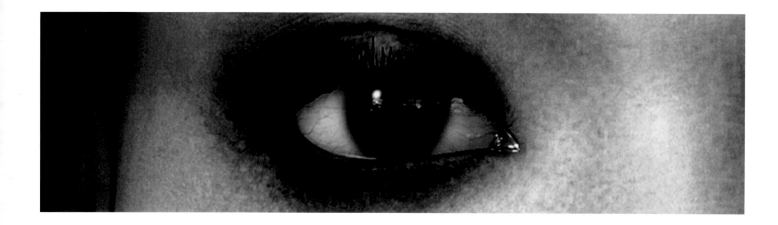

HUMAN MODELING: YOUNG GIRL'S FACE

Inspiration

One of the things about faces that fascinates me is how they always seem to reveal that person's history, and the emotions they're feeling, without showing a particular facial expression. This piece is inspired by many of the beautiful images I've come across in books and magazines.

Subject

I have always wanted to create the face of a younger black woman with slightly fairer 'mulatto' skin. Rather than presenting a natural look, I wanted to create the image complete with facial cosmetics such as eyeshadow and mascara.

Technique

My general approach to creating a face from scratch is to first establish the overall structure, depicting the key parts of the face. I then work into the details, paying the most attention to the eyes. I generally build my models in two or three stages, successively subdividing the mesh to achieve the optimal base model. Throughout the modeling process, I like to have the cage and smoothed cage in different view layers so that I can toggle between them. Once I feel comfortable with the model and it is near completion, I tackle the process of adding UVs and painting the textures. I apply the same approach to texturing that I use with modeling, working in the overall areas until the tone and balance is right, before going into the finer details.

Starting point

Early on, I didn't look at reference material. Instead, I just focus on getting the generic facial shape fleshed out. Once the face begins taking on its own personality, I then began to look at facial images from my reference library, allowing this character to become a blend of all of those influences.

Composition

My first thought was to pose her face with a particular expression and unusual camera angle. In the end, I decided to go with a straight frontal composition and pose.

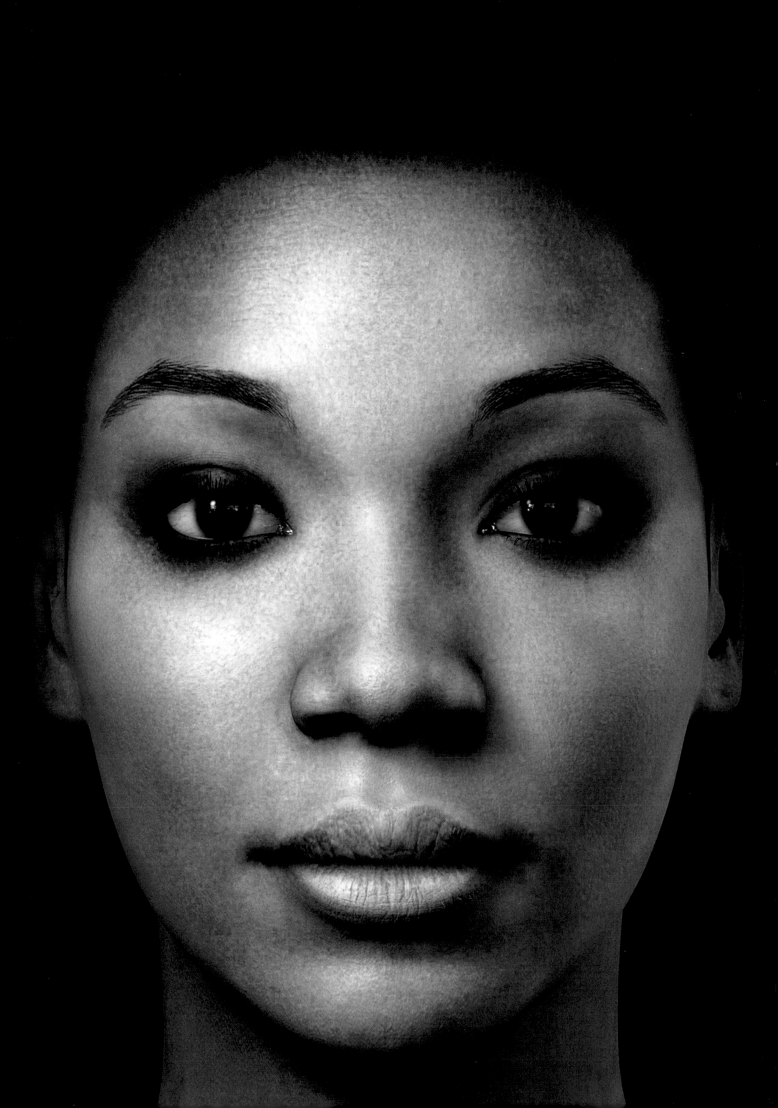

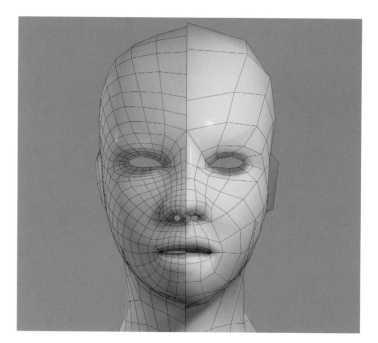

Starting primitively

Starting with a very low resolution model, I began to delineate the main elements of the face, placing and connecting the edges as I would with Nurbs patches. For the first few steps, I have the base cage on the right half and the smoothed version on the left. By keeping the connective history between the two, I'm able to modify the lower resolution cage and view the results on the opposite side. Here, I work in the overall facial proportion and begin placing the eyes, nose and mouth.

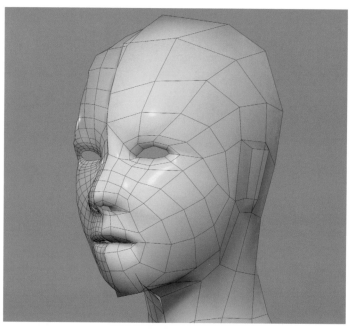

'Form Loop' refinement

Once I've achieved a rough representation of the face, I hide the original blocky cage and re-smooth the original smoothed cage. I then continue to refine the facial areas by adjusting the vertices so that the edges maintain their looping flow around the mouth, eyes, nostrils and ears. As soon as the face begins to feel natural, I start to focus on the eyes, shaping them around a spherical ball that I place inside the eye socket as reference. I pay careful attention here to the contour of the eyelids and the inner and outer eye corners. Throughout the entire modeling process, I use Lattice deformers and Brush Model deformers to push and pull the shapes in a more general and intuitive fashion.

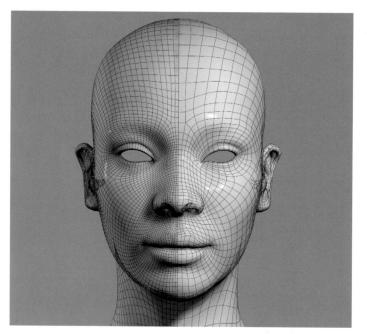

Final low res cage

At this point I want to be sure that I have enough model detail in the key areas of the nose, ears, eye lids and lips. The most difficult part is finding the balance between having enough detail to achieve what is needed and building as light a model as possible. The more dense a model becomes, the harder it is to manage, both for stills and for animation. For still images, it's sometimes okay to really let go and add all the detail desired, but I have always believed that achieving a good balance between model and texture detail is key (particularly with the smart use of displacement maps).

Windows to the soul: eyes

The eyes are the most important identifying feature on a person's face and the thing many look at first. The impression of a person's eyes is influenced greatly by the curves formed by the upper and lower eyelids and that is what I focus on here. I used to build eyes with multiple pieces for the cornea, iris, sclera, etc. However, these days I have learned that the fewer eye parts the better. I now build the eyeball itself with only two surfaces. The outer one is used to catch only specular and reflective highlights and is built to include the bulge-like shape of the cornea. The inner surface is built to receive diffuse light only and is mapped with eyeball and iris textures, and unlike the outer surface, is flattened where the iris and pupil are located.

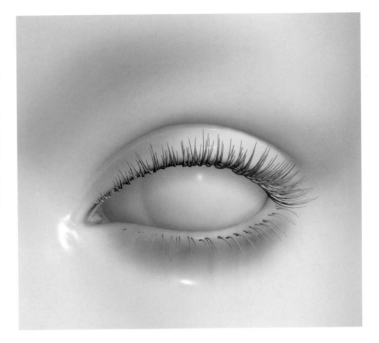

Nose and lips

Both the nose and lips contain some of the most subtle variations in shape on the face. As with drawing and sculpting faces, the key is understanding the planes and angles they follow based on the underlying bones and muscles. The width of the nose is usually equal to a vertical line drawn from the inner edge of the eyes, while the mouth extends further than that, at about a quarter of the size of the eyes from that same invisible vertical line.

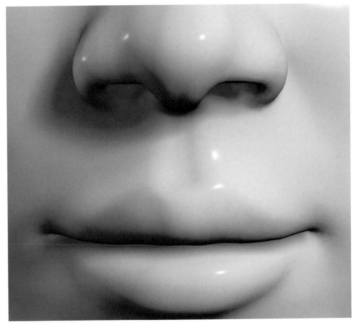

Ears

Ears usually tend to become an afterthought when working on a figure or a face. Ironically, they take time to create and contain subtle form changes. I begin modeling the ears with a very low polygon 'doughnut' primitive loft, successively smoothing and tweaking the cage, finishing with the smoothed and detailed final version.

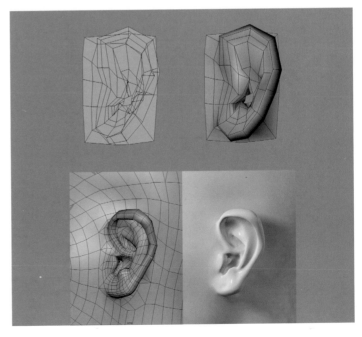

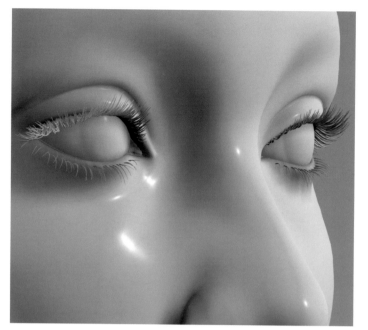

Lashes, tears and brows

Lashes are one of the more straightforward parts to create. However, an important thing to remember is to get the correct amount of bunching and randomness in both length and placement. The lower lid's lashes tend to bunch in smaller numbers, while the upper lid's lashes bunch in greater numbers. The small membrane on the inner corner of the eyelids, or the 'caruncula lacrimalis', is one of the most important elements of the eyes, yet it is rarely ever noticed when looking at someone. I tend to model it as one piece, but pay careful attention to the edge membrane that stretches with the eye as it rotates. Although I usually build brow geometry for faces and use a combination of texture and model, this time I decide to go only with textured brow hairs, including bump. I equate brows with ears because although they seem easy, they are very complex and difficult to master.

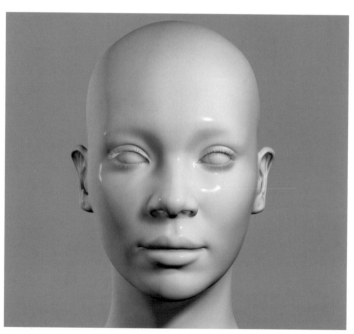

Finished model?

I consider displacement painting a part of modeling. However, for this tutorial I'm focusing more on the overall process of creating the character from beginning to end rather than working on the 3D sculpting and displacement work. In reality, the model itself is far from finished. Nevertheless, it is all of the different elements combined together that give the impression of a live person.

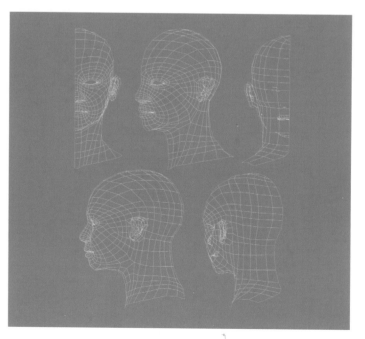

UV coordinates

I chose to create the starting UVs from five initial projections. Once I have these initial projections, I copy the u and v positions from texture space into the model's x and y positions in world space. I then modify the UVs with my modeling tools.

2.5D paint approach

I generally prefer to layout UVs in a connected and logical manner instead of using an algorithm like Auto UV, which really gives you no ability to do texture painting in 2D. Although in this case there aren't multiple pieces that need to have connecting texture seams, the UVs should be as proportionally similar to the model as possible and be constructed so that they simplify the texture painting process.

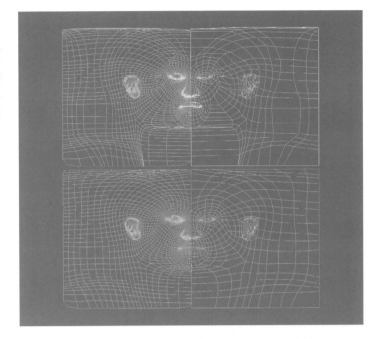

Finished UVs

Although there are different ways of applying texture coordinates, I chose this method for the tutorial to illustrate a technique that could be applied without any special software. When checking UVs in detail, I usually apply a checkered or colored box texture as seen in this image in addition to a very fine bump texture like skin pores.

It's all in the eyes, baby

As I mentioned in the modeling stage, the eyes are really what set the table for how the rest of the character is going to look and it's the key to bringing a character to life. Here, I show the eye area, which is still being adjusted, with the iris and sclera texture map only (no specular reflections).

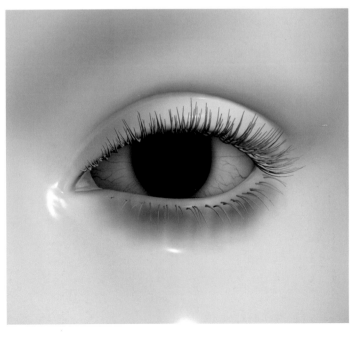

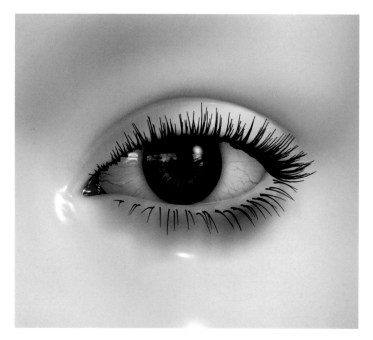

Adding reflections to the eyes

The reflectivity of the outer globe is controlled by a small map that is almost black at the outer part of the eye (inside the lids) and gradually increases as it reaches the rim of the cornea. Since I'm raytracing the eyes to get true reflections and refractions, I set the refractive index of the outer globe and cornea to 1.38, but set the thickness high enough for the refraction to work.

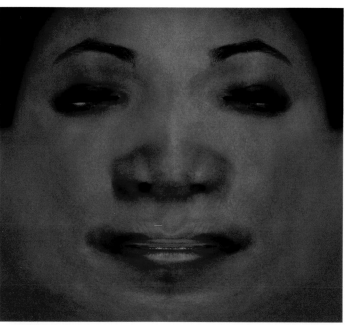

Color pass

Clearly this is the most important, yet the most 'faked' element of creating skin. What I mean is that what we perceive as skin color is in reality several layers containing many things such as blood, pores, hair follicles, dirt, veins, blood vessels and birthmarks. One thing in particular I wanted to take into account with this character was emphasizing the effect of makeup, such as eyeliner, mascara and skin powder, on her face. Note that with these sample textures I cropped them horizontally to fit them in the page.

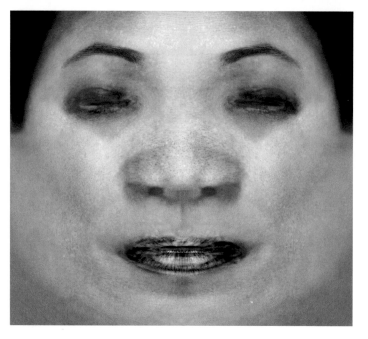

Bump and displacement

For this tutorial, I chose to go only with bump mapping since I wanted to keep my render times as manageable as possible. Most of her face bump consists of small pores and blemishes, with the most detailed and carefully painted areas being the lips, eyes and nose. Generally, I prefer using displacements in combination with bump; the bump used for smaller and lower frequency detail and displacement for larger wrinkles and general form changes.

Specularity

The specular reflectivity of skin varies greatly depending on where it is located on the face or body. The amount of oil and moisture on the skin increases its specularity, so areas of the face that are touched often like the nose, forehead, cheeks, chin and lips are much shinier. I usually create the specular map by modifying both the bump and color maps. I then create a blend of the two since both the pores and wrinkles as well as the different tones and colors in the skin (such as makeup, birthmarks, blemishes etc.) affect specularity.

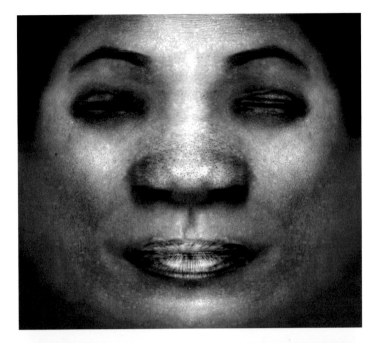

Environment reflection (aka Fresnel)

While there's very little reflectivity on her face from the environment, the effect of reflected specular light onto skin at grazing angles is significant. In the Fresnel component of my shader I usually map the Kr (or intensity) with a grayscale high-frequency noised version of my color and specular channels blended together. This helps break up the Fresnel reflections, giving them more of a dry and noisy look as they do in real life.

Skin shader

Creating realistic skin has been one of the holy grails of CG through the years. Although many tricks and techniques or 'hacks' have been developed and used, it wasn't until the emergence of the BSSRDF subsurface scattering technique that the ability to create more believable skin shaders became mainstream. Skin is like an onion in that it contains multiple layers of translucent material; light penetrates it, spreads and bounces back out. During this process, it illuminates skin pores, blemishes, warts, blood and all the matter it contains. This image illustrates just how much of an impact the subsurface component has on the final render.

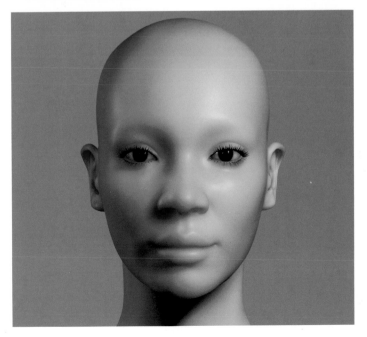

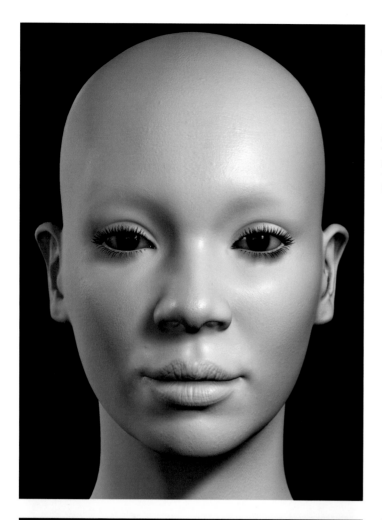

Traditional lighting and ambient occlusion

Although I could have lit the face using only a background image, or even an HDRI (High Dynamic Range Image) environment, I wanted to use a combination of traditional spot lights and a raytracing technique like ambient occlusion. I always like to keep my light rigs very simple, following the key, rim, fill concepts. As a side note, even when using an HDR image to light my scene, I like to define a very specific 'key' or light direction. This sometimes requires modifying the HDR itself in HDRShop to get the right exposure intensity and exclude unwanted light information.

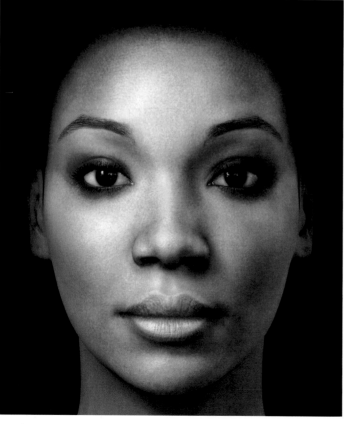

Wrapping it all up

The last ten percent of working on a piece is always the most difficult and at the same time the most critical. At this point I make small refinements to key areas like the eyes and lips, including introducing some soft depth-of-field blur and a very small amount of noise to all of my texture maps. One of the things I do to help finalize an image and make changes I might need is to look at the image in each of the component channels and in grayscale. I also squint at the image, allowing my eyes to only absorb general color and shape, which really helps me see things I may otherwise miss.

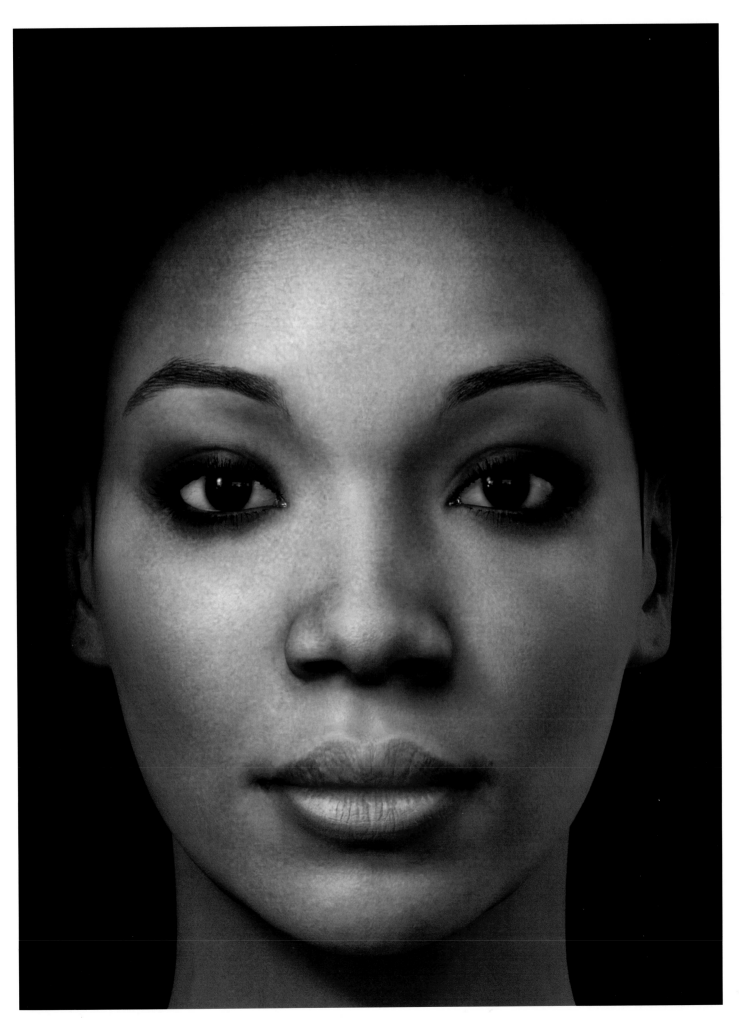

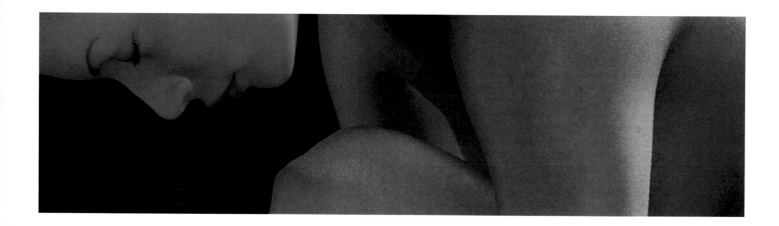

HUMAN MODELING: CROUCHED FIGURE

Inspiration

For this piece I wanted to do a more traditional figurative pose with a style leaning towards a fine art sensibility. The pose is inspired in part by a few of my figure drawing books that I love to use for reference in my work. It is also inspired by the fact that as a young art student studying and drawing the figure, I learned to appreciate the amazing complexity and beauty of the human body.

Subject

The lines formed by her legs and arms, as well as the high curving back, is what really attracted me to this pose. Although I initially didn't plan to render her fully naked, I decided that clothes hurt the flow and naturalness of the pose. It was important to me to give her a sensual, yet tasteful, feel. This is why I did not choose a more frontal and revealing angle.

Technique

The technique I usually employ for full figure characters is to first build the model in a default pose, then either manually pose it or use a rig to deform it into a pose. For the purpose of this tutorial I chose to manually model her into the pose. During the modeling process I keep in mind how I want the UVs to be laid out. After applying and testing the UV coordinates, I proceed to the texturing phase, where I paint in both 2D and 3D to achieve the necessary detail. While painting the textures I begin working on the shader networks, creating test renders until it begins to look natural. Once the model, textures and shaders have been balanced, the process of lighting the posed figure begins. I usually continue making refinements and fixes to both the model and textures during the lighting process as lighting often brings out both the good and flawed parts of the character.

Starting point

Before I begin modeling work, I gather as many reference images as possible so that I can use them for both visual inspiration and direction. Once I have several images I place them as image planes in separate cameras that I switch between during the modeling and texturing process. Sometimes I like to start models from poly spheres that I extrude and build out from. For more organic objects such as characters, I like to use a hybrid poly-nurbs technique, constructing the main forms from one degree Nurbs patches, then converting them into polygons which are welded together and smoothed into subdivision surfaces.

Composition

I wanted the character to appear as if she were posing in a figure drawing or painting class. Fitting the figure within a vertical frame and utilizing an inclined camera angle keeps the viewer's eye focused on the lines and curves of the figure.

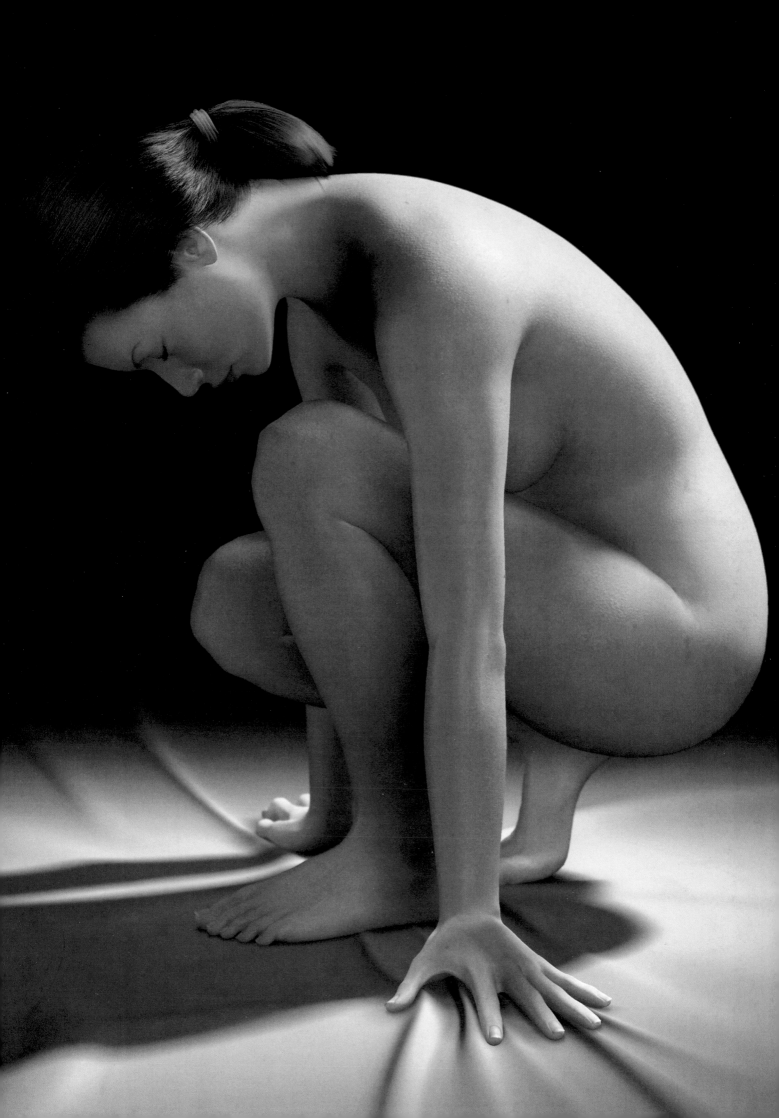

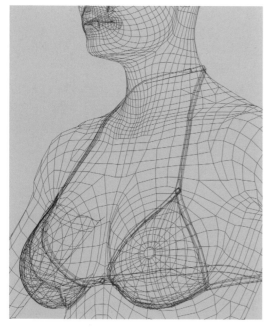

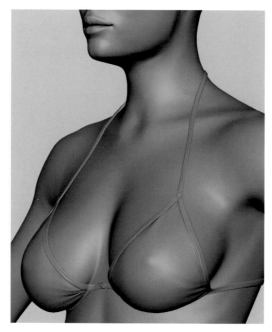

The default pose model

I always approach the modeling process by first working out the general shape and structure, then working into the details. Most of the main body model is begun from many deformed one degree Nurbs patches shaped and snapped to each other. As soon as I establish the general forms and structures of the body, I convert all the pieces to polys and weld them together. From this point on, I do all my work in polygons and subdivision surfaces.

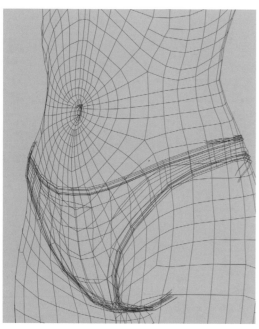

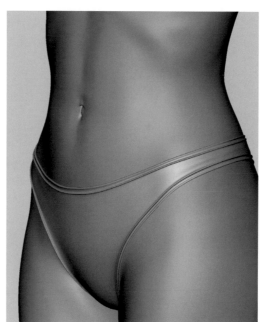

Lower torso

I chose to model the belly in a radial shape because it allows for an easy transition into the belly button and other areas such as the groin and ribcage. When modeling, sometimes it's important to add extra definition so that when the area is textured and rendered, the forms still stand out and feel natural. This is what I have done with both the ribcage area and the belly.

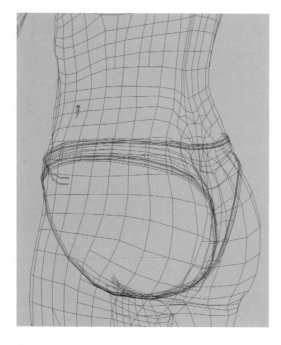

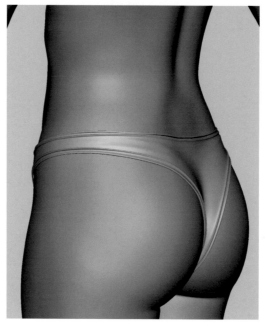

Rear side

As the edges flow down the torso, I make sure that any discontinuity in density, such as an extra edge creating a five-sided polygon, makes sense for both its purpose and deformation. Some modelers prefer to avoid things such as five-sided polys. However, when a mesh is rendered as a Catmull-Clark SubD or smoothed into quads, careful use can be a great advantage and helps keep model density low. A good example of this is in the lower buttocks area where the skin wrinkles slightly and folds onto itself. Having carefully placed edges in these areas, and not all the way around the leg, is a significant plus.

The knees and upper legs

Since I want her to be trim and athletic, I have accentuated some of the musculature in her legs. The base leg model is essentially a carefully modeled tube with very specific knee and back of the knee topologies. Modeling knees is one of the most difficult things to do because depending on how the leg is flexed, they can look both angular and soft at the same time. You'll notice that I have also accentuated her quadriceps, or the leg muscles just above the knees, so that they are in a half-flexed and half-relaxed state.

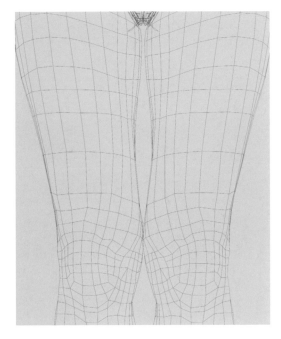
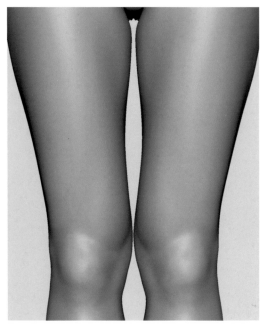

Two feet, ten toes

Like hands, feet are very difficult to create because they contain so many muscles and tendons. Since the feet have so much more model density than the lower legs, I have carefully chosen a weld area that will not affect the look when the feet bend. One of the keys to building good feet is to add enough model density to achieve the right shape. In this particular case you can see the extra edges on the top of the feet representing the tendons.

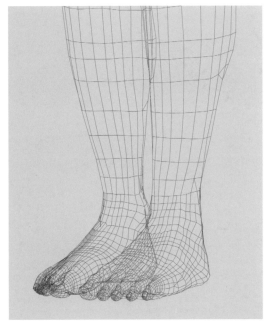
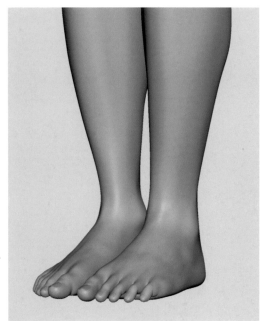

Final default model

Now that the figure is in a default type of pose, the process of posing her into the crouched position begins and I am one step closer to achieving the character model that I want to use for texturing, shading and rendering.

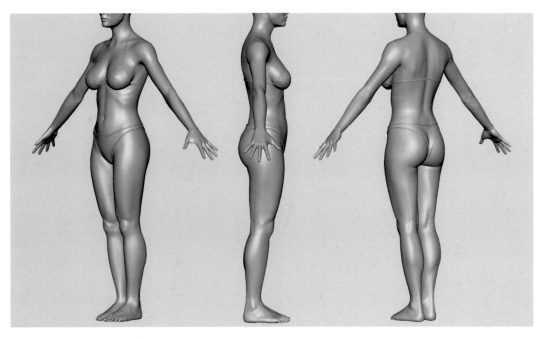

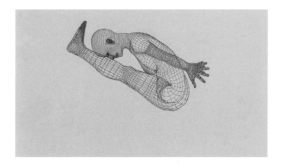

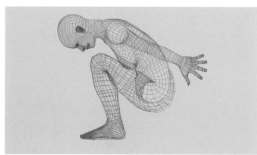

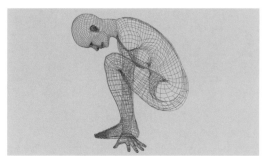

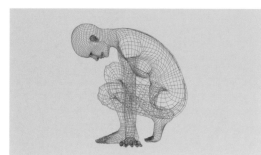

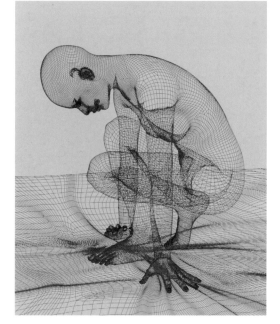

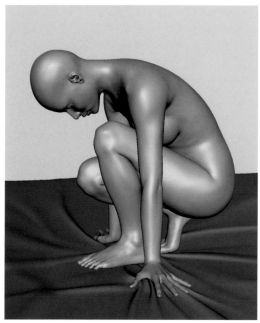

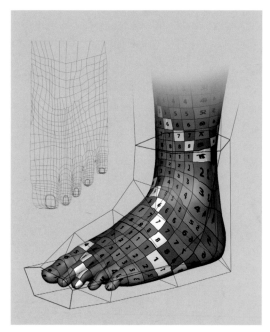

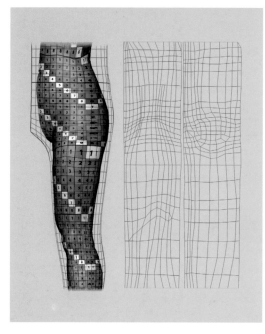

Look ma, no setup!

The first thing I do to begin posing her figure is to rotate and then deform the body so that the head is in the right place. Making the head the anchor point allows me to correctly distribute the weight and angles of the body down to the feet and hands. Once I have bent the torso to a nice arching curve, I bend both the right and left legs so that they are flat on the ground. The arms are the last part that I deform into place since the key in this pose is the balance of the spine, head and legs.

Finished pose with ground

Since I'm choosing to manually model her into the pose instead of using a character rig to do so, it's important that I pay close attention to the key deformation areas like the shoulders, knees and legs. One of the difficult things with this pose is balancing the amount of bend and compression that her torso and legs have while still retaining the right proportions.

Creating the UVs

Instead of blending between multiple planar projections, I project the UVs from a set of low res cages onto the high res mesh. The low res cages are tube-folded polygon planes which themselves contain inherent UVs. The great advantage of using this method is that it gives me complete control over both the way the UVs are placed in space and how the UV borders line up with the model. During the process of creating and aligning the UV cages, I keep a smoothed version in a separate layer. This allows me to toggle between the low and high versions as I work on getting all the seams and borders to line up properly. By starting from evenly constructed cages, the proportions of the resulting UVs always stay consistent before I project them.

Finished UVs on pose

Once I have projected the initial set of UVs onto the body, I go through the tedious process of cleaning them up and fixing all of the problematic areas. By assigning a different shader to each of the main body UV areas, I can easily select face and UV groups in addition to having a clear distinction between the texture borders. As I finish I consolidate some of the areas like the upper and lower legs, including the feet, into one. Here I try to create the most efficient and easy to paint UV layout. Since I'm doing most of my painting in 2D and generally using 3D paint for cleanup and seams, this step is essential.

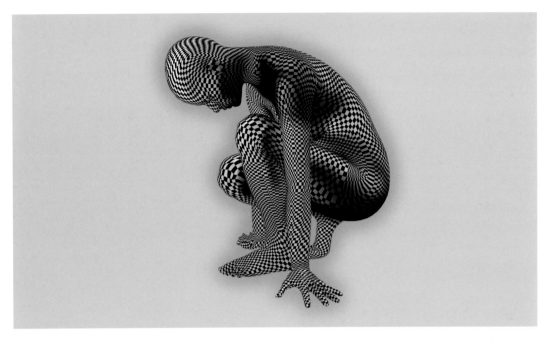

Creating a generic color map

I start by establishing a base color map. Since I've collected good photo references of skin, I spend time in Photoshop painting and cloning in all the areas I want to include as a 3,072-4,096kb map. As you can see, I've purposely added in veins, birth marks, skin discolorations and even some of the pinky skin which appears on certain parts of the body. Once I'm happy with where it's going, I try to remove any odd diffusely shaded areas and paint up the edges so they are tileable. I convert the color map to grayscale and begin to adjust the intensity levels to bring out the areas that are more extreme in value. On a separate layer, I stipple paint over the image, occasionally cloning, mirroring and rotating pieces so that I can get evenly distributed highlights.

Painting skin from references

Although I have used only hand-painted textures for the majority of my past work, I have learned that prudent and careful use of photo reference can really enhance the texturing process. When using photo references as a starting point for textures, the most important step is to make sure the diffuse shading and reflective highlights are painted out.

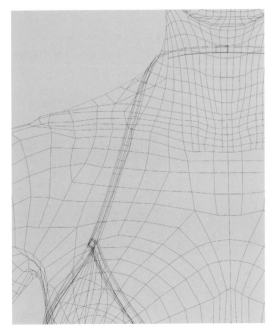

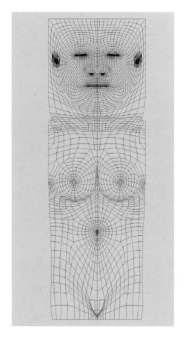

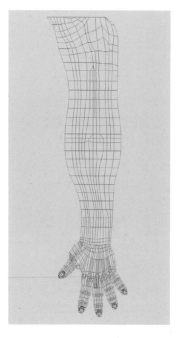

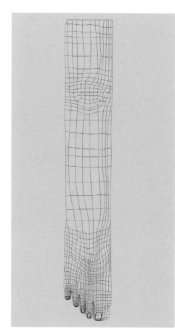

Final UV layout

Here I modify the UVs in space to create a UV layout that allows easy texture painting, both in 2D and 3D. I make sure that the seams between body parts line up nicely. As I am doing most of my painting in 2D and generally using 3D paint for cleanup and seams, this step is essential. Here I'm only showing one half of the UV layout (the other side is identical, except it's the backside).

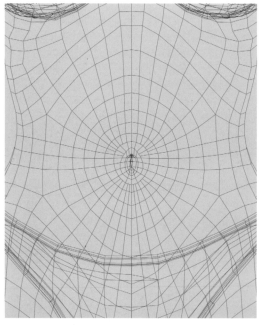

Diffuse shading be gone

Before the initial texture projection, I pay close attention to how all the texture pieces line up and the identifiable areas of skin. I focus on the key landmarks of the body like the belly, chest, groin, hands and feet, making sure the overall skin tone and main areas of detail are set. As I paint textures for different areas, I merge them into one large Photoshop document (about 8K). I then make different adjustment layers and continue to work on color-correcting them. When I'm happy with the overall balance, I do two initial texture projections onto the body: front and back. From this point on I begin the 3D painting process, painting in the gaps between the two main projections, cleaning up problem spots and adding extra detail where needed.

Shader work begins with a ball of wax, or skin...

When starting my shader tests on a complex model it can sometimes be difficult to see exactly what is going on. It's probably even more important when using a shader that calculates light absorption in addition to its diffuse shading. I attach my shader to a simple sphere and connect my generic color, specular and bump maps and begin to adjust how much they contribute. For the specular component I usually use an eccentricity range of about 0.334 and an intensity of around 0.4, depending on the intensity levels of the texture map. On the bump channel I set the filter to 0 and the bump intensity to 0.1.

Making use of subsurface scattering effects

At this point I also dial in how much the subsurface scatter layers will affect shading. I set my diffuse contribution to 60%, allowing the subsurface contribution to take the other 40%. My subsurface components are comprised of two front and one back scattering layer which contribute around 35-40% each. A key element is to try to achieve what I call 'shade coloring', which is the reddening effect that we see due to the blood layers inside the skin as light rolls into shadow.

 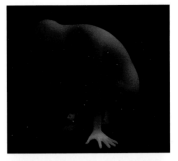

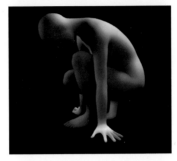 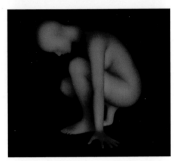

Double-layered specular pass and fresnel

Instead of making use of only one specular component, I have two specular components—one which controls the tight highlights and the other as the highlights fall off. Having two mappable speculars allows me to place my normal specular map in the wider specular channel and a version of the same map run through a strong noise filter for the tighter one. The reason for this is that specular highlights on skin look noisy and broken up at their brightest point. For the Fresnel component I set the intensity to 0.1, then apply the same noisy version of my specular map to the intensity control so that the Fresnel effect gets broken up.

Character lighting tests

Early on, I wasn't sure if I should use a combination of image-based lighting and ambient occlusion or just traditional lights. For this piece I chose to go with traditional lighting, letting the subsurface scattering component play a larger role in illumination of the model and skin. As you can probably tell, I keep the shadow maps fairly blurry and somewhat transparent, with their sizes at around 2K. This first test didn't quite feel natural enough for me, so I have decided to continue trying different things, including rendering different light passes.

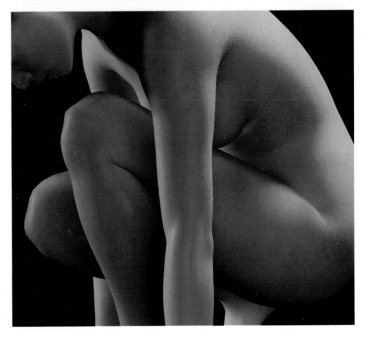

Rendering the ground

Before I get too far into the character test rendering process, I also render a separate pass of the ground model so that I can see how it works in conjunction with the character. Keeping the ground and character render passes separate also makes creating iterations more manageable. In fact, the same applies to rendering things such as eye parts, nails and other miscellaneous objects. Because cast shadows are often the complementary color of the light source that created it, I have colored my shadows here to a blue-purple tone that will help the character integrate with its environment.

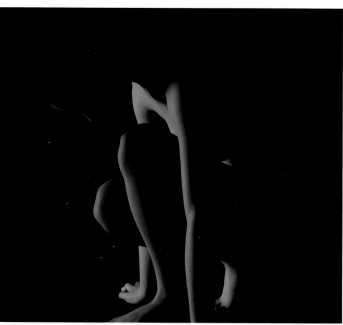

Rendering each light separately

A technique that I use to help me find the right lighting I want on my character is to render each of my lights separately and examine what each of them is doing. I also use both Photoshop and a compositing program, testing different mixtures of lights and adjusting their levels to find different possibilities. However, one thing to note is that each light pass must be un-premulted, or be divided by its alpha channel, so that when they are added together again they do not incorrectly add up over each other.

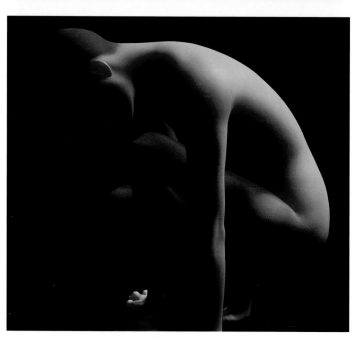

Continuing lighting tests

Here's another render test with an isolated key light from behind. At first I thought to have the key light source coming from behind her, but I'm still not comfortable with it and continue trying different angles. In this pass I have created a small polygon patch that is transparent, commonly called a 'light blocker', which partially occludes the light from hitting her left hand. Another way that blockers and small shadow casters are useful when modeling and rendering characters is to place them in the nose and eye areas to simulate and accentuate subtle shadows.

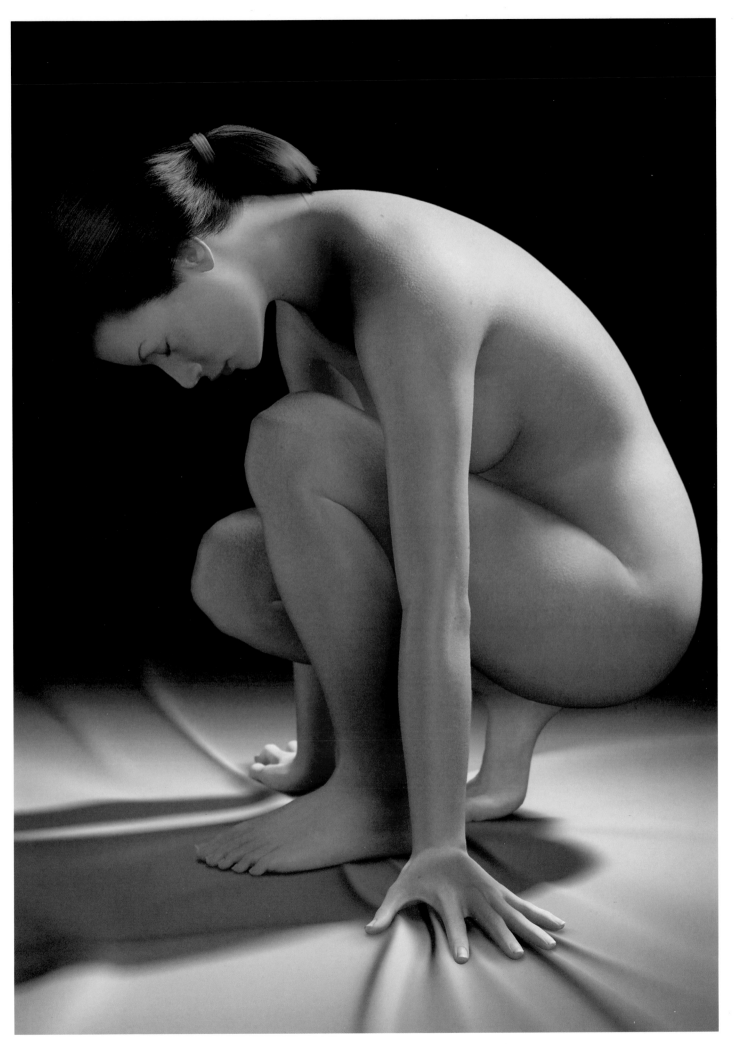

HUMAN MODELING: HAIR

Inspiration

I was inspired by the idea of making the hair short and sporty. To this end, I pulled out some of my hair magazine clippings that I saved from my old Final Fantasy hair development days and used them for reference and inspiration.

Technique

Hair is usually one of the things everyone avoids in computer graphics, and for good reason. In the past, it was always either difficult or impossible to create realistic looking hair and only companies that had developed custom hair software had any success. In fact, most artists had to model hair with either hard to control particles, hair textures mapped onto ribbon-like patches or unwieldy geometric tubes. Thankfully, in recent years there has been a great renaissance in off-the-shelf hair tools and hair rendering technology which has enabled artists to create hair and fur with greater ease.

Starting point

My starting point for hair is to create the primitive scalp right on top of the head model. I make sure the structures of the scalp pieces follow the overall hair growth, becoming denser in those areas that need more detail and less dense in those that don't. I like to think of creating CG hair like one would when creating a doll or a puppet. The hair curves grow outwards from the scalp pieces and directly influence the hair they generate by blending (or interpolating) between each other.

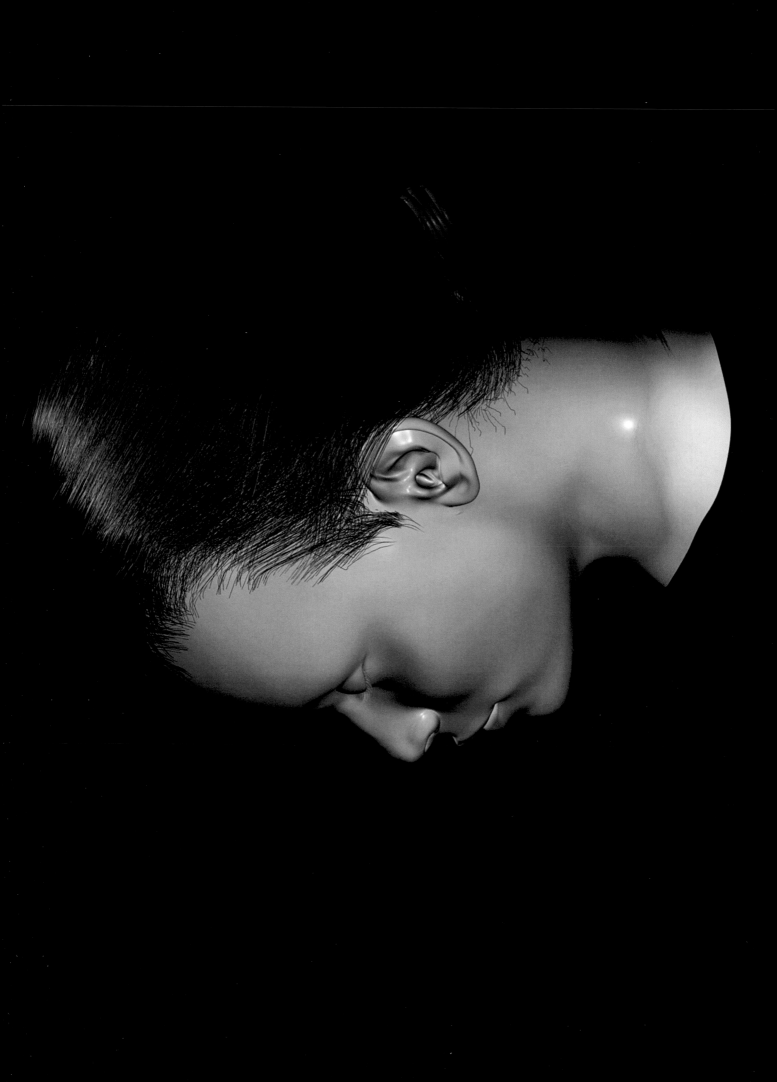

Building the main scalp from a sphere

I start by creating a one-degree Nurbs sphere which I cut in half along the x-axis, then orient horizontally since I want the poles to curve around the ears. The main scalp surface looks like a funny cycling cap right now, but planning how I want the edges to flow at this stage is critical.

Shaping the scalp over the head

In this example, you can see that I keep the head mesh as both a visual reference and a shell to model the scalp over. By keeping the scalp as a one-degree Nurbs patch I can more easily slide the control hulls around, giving me the edge directions I want. The key with this step is to get the amount of density I need on the scalp so that the hairline has the right shape.

Finished scalp pieces

Now that I have the main scalp piece modeled and in place, I model the secondary scalp pieces. I use an extracted curve from the back end of the main scalp to loft the rear neck fuzz surface and the rear ponytail surface. I do the same for the front hairline to create the bang fuzz surface. The reason I have separated some of the hair regions is because it allows me to make quick adjustments to the hairline areas of the hair without having to update the main hair mass.

Now that's a bad hair day

Since there are different hair systems out there using various techniques, I'm not using any dynamics or physics-based technique to create her hairstyle. Instead, after I generate the default 'chia-pet' hair curves from all the scalp plates, I begin the process of styling the hair.

Combing the hair curves

To do the hairstyling, I'm basically using my modeling tools and deformers to model the hair curves into the shape that I want. This method may seem painstaking, but it gives me complete control over the flow and look of the hair curves that generate the hair.

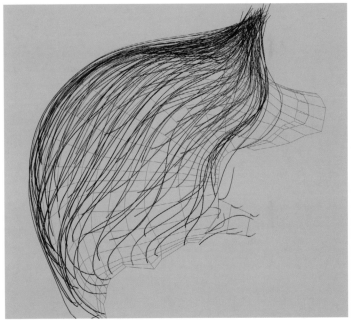

Detailing and styling the curves

After combing the hair curves into a general direction and style, I start to add the subtle details. Since all the hair generated out of the curves is linearly interpolated, having a good amount of varying curvature in the curves is crucial to getting a successful result. As you can see here, though most of the curves flow together, there are quite a lot of curves that bend against the flow, particularly near the hairline area.

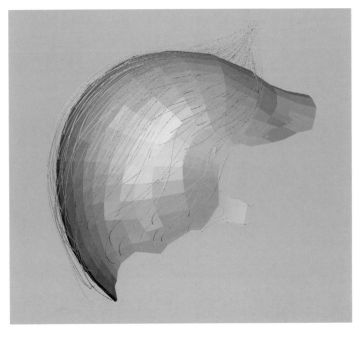

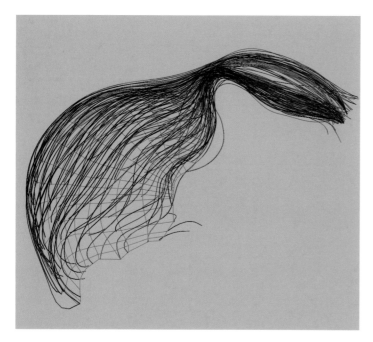

Adding the ponytail section

Now that I have the main scalp curves flowing and layered how I want, I select all of the end points and extend the curves outward along their normals. Once I have extended the curves enough, I go in and spread them out and adjust their positions so they form a nicely bunched and thick ponytail.

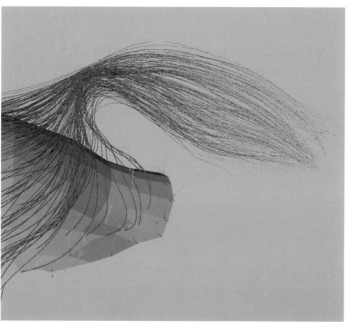

Neck fuzz and underside ponytail sections

It may seem odd to separate the back-inner part of the ponytail and neck hairs into separate hair components, but I need to be able to easily control and adjust the area without the bulkiness of the main hair mass. I make the rear ponytail plate and neck fuzz plate overlap each other so the different hair groups blend into each other.

Putting on the finishing touches

I add a small rubber-band to the hair by lofting a surface along a curve which I then wrap around the ponytail. Making sure the rubber-band looks tightly wrapped around the hair mass is very important since it is a key element to the presentation of the hairstyle. One of the keys to making the hairstyle look and feel natural is how I layer and adjust the bunching of the hair curves and the placement of the stray hairs around the head. To achieve the fuzz or crazy stray hair layer, I duplicate the main hair system and scale the hair curves so that they sit just above the main hair mass. The fuzz layer is set to only grow about 2,000 hairs in comparison to the main hair cap, which is around 80,000 hairs. In addition, I set the random scraggle factor higher and the bunching percentage lower than the rest of the hair. Finally, I render the hair with a copy of the same lighting setup that I use for the rest of my character. This gives me the ability to both frame the lights on the hair and offset the angle and intensity of the shadows cast by the hair.

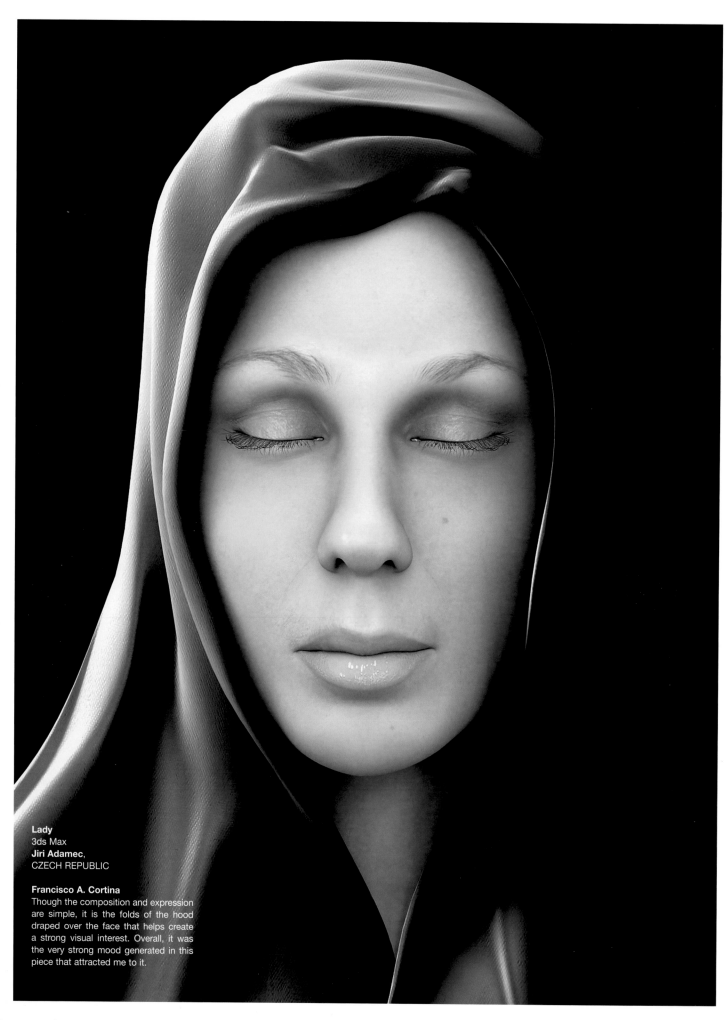

Lady
3ds Max
Jiri Adamec,
CZECH REPUBLIC

Francisco A. Cortina
Though the composition and expression
are simple, it is the folds of the hood
draped over the face that helps create
a strong visual interest. Overall, it was
the very strong mood generated in this
piece that attracted me to it.

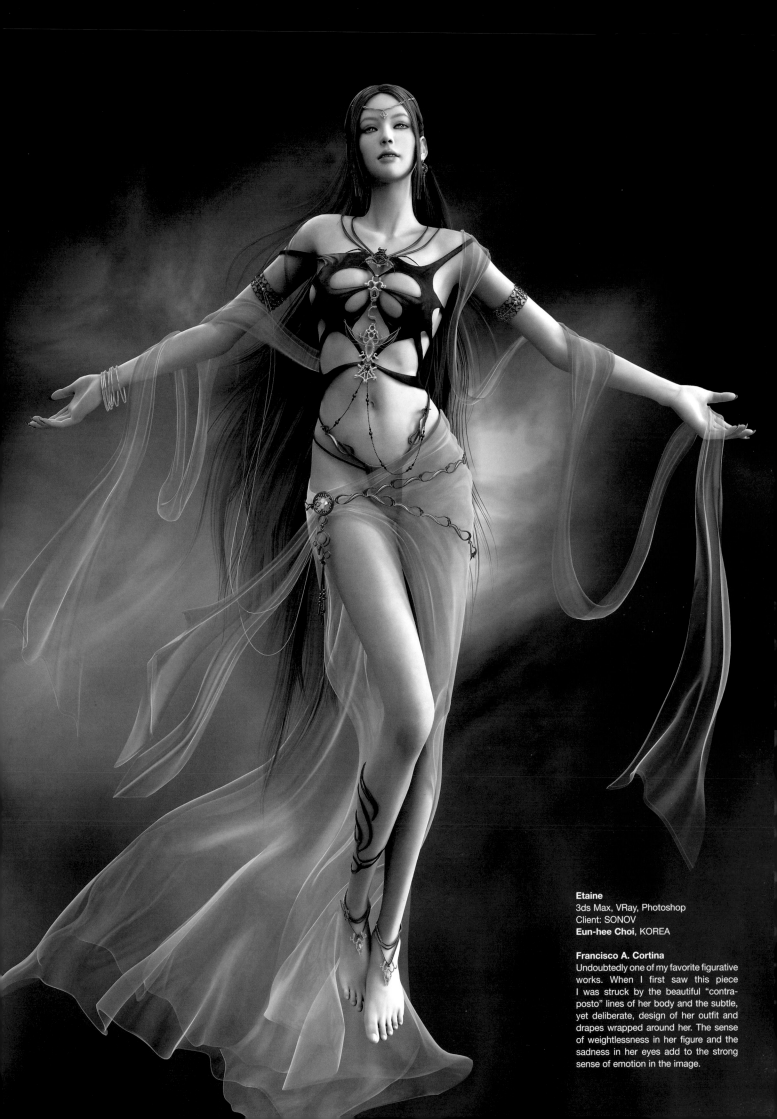

Etaine
3ds Max, VRay, Photoshop
Client: SONOV
Eun-hee Choi, KOREA

Francisco A. Cortina
Undoubtedly one of my favorite figurative works. When I first saw this piece I was struck by the beautiful "contra-posto" lines of her body and the subtle, yet deliberate, design of her outfit and drapes wrapped around her. The sense of weightlessness in her figure and the sadness in her eyes add to the strong sense of emotion in the image.

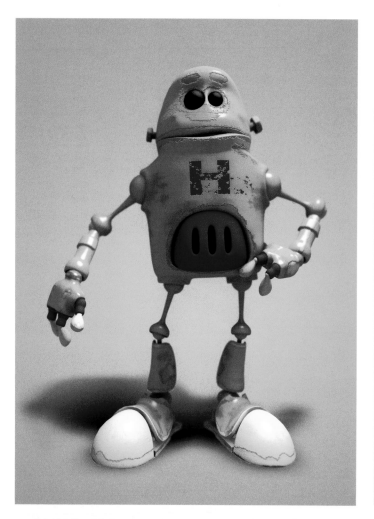

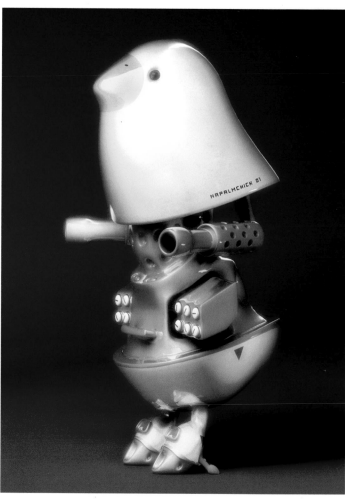

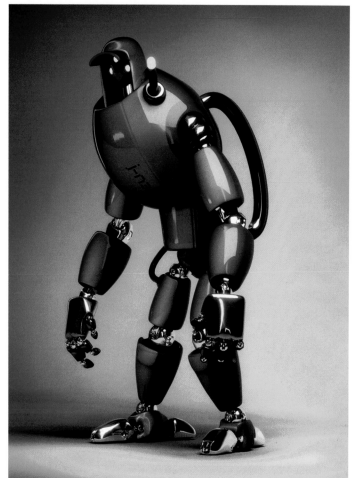

Robot
3ds Max, Photoshop
Juliano Castro,
BRAZIL
[above left]

Francisco A. Cortina
When I first saw this piece it reminded me of a puppy who was caught doing something he knew he shouldn't have, resulting in a guilty and puzzled look in his face. The excellent character design and human-like pose made me identify with this little robot with an attitude.

J-N3-R
3ds Max, Photoshop, Brazil r/s
Jorge Baldeøn,
ECUADOR
[left]

Francisco A. Cortina
For some reason, after looking at this character for a time, it began to remind me of a portable metal detector that could suddenly come to life. The very clean and simple body parts, in addition to the ball-jointed appendages add to this character looking like a futuristic toy.

Napalm Chick
3ds Max, Photoshop, Brazil r/s
Jorge Baldeøn,
ECUADOR
[above]

Francisco A. Cortina
I could not help but chuckle when I first saw this image. The idea of combining two opposite things like a pair of deadly machine guns and a baby chicken was not an easy thing to pull off, yet it worked great here. I think it was the blending and simplification of both the forms and colors that really made the character believable for me.

This Girl loves eating Tomato
Photoshop, 3ds Max
Wenxian Huo,
CHINA
[right]

Francisco A. Cortina
Creating an interesting and believable toddler is no easy feat, but this one really worked for me. The immediate striking feature of this piece was the sense of light and color in the composition and the baby's innocent, yet piercing, eyes. The subtle modeling and wrinkling on her hands as they hold the tomato, as well as the use of different texture types, served as a focal point for the composition.

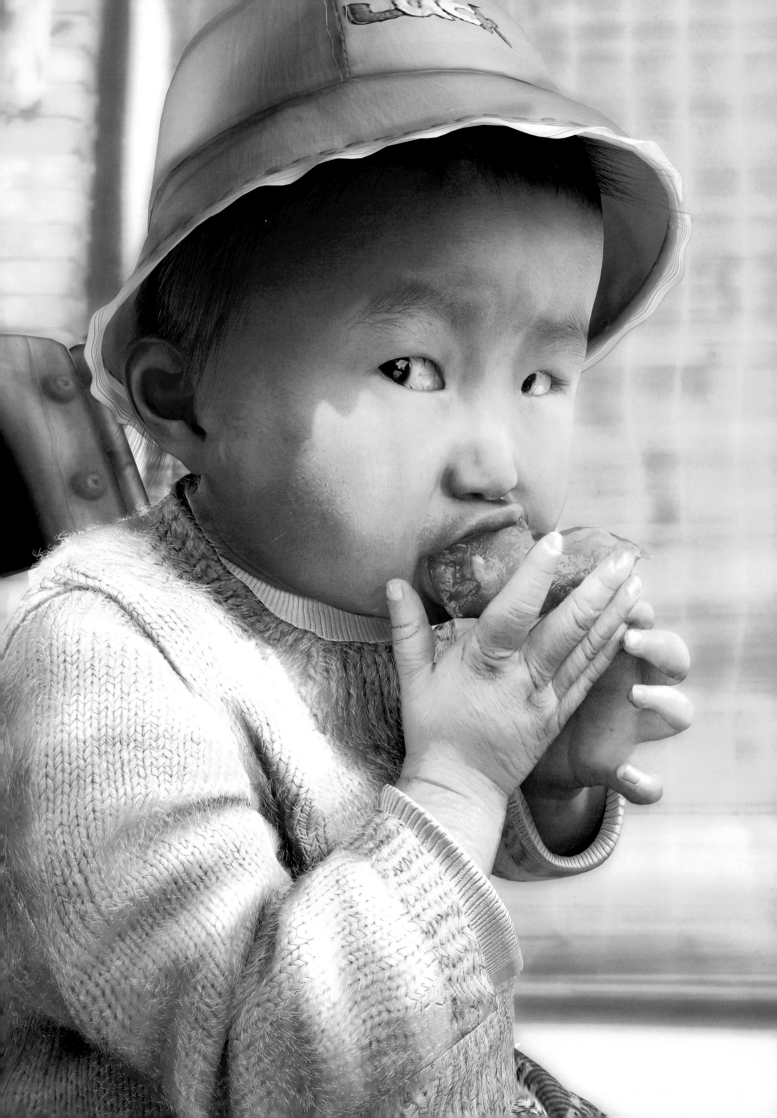

Nclfckr
3ds Max, Photoshop, Brazil r/s
Jorge Baldeøn,
ECUADOR
[above]

Francisco A. Cortina
This image reminded me of the Napalm Chick in its uniquely humorous design and crisp attention to both modeling and texturing. I particularly liked the vent over his head, which could be a useful feature for letting out some steam. Overall, the gritty, waxy and metallic feel to this character makes it both unique and attractive.

Tree Face
3ds Max, mental ray
Greg Petchkovsky,
AUSTRALIA
[above]

Francisco A. Cortina
The disturbing eyes and tree veins that form the facial shapes make this image really fascinating to me.

Devil series
ZBrush
Meats Meier,
USA
[right series]

Francisco A. Cortina
What I loved the most about these works (and Meats Meier's work in general) was the amazing amount of layering and constructive depth that was used to bring the character and subject matter to life. By modeling wires of varying thickness and careful, transitional use of more plate-like shapes, he has achieved a flow of forms that not only define the character's shape, but also create a beautiful roadway of lines.

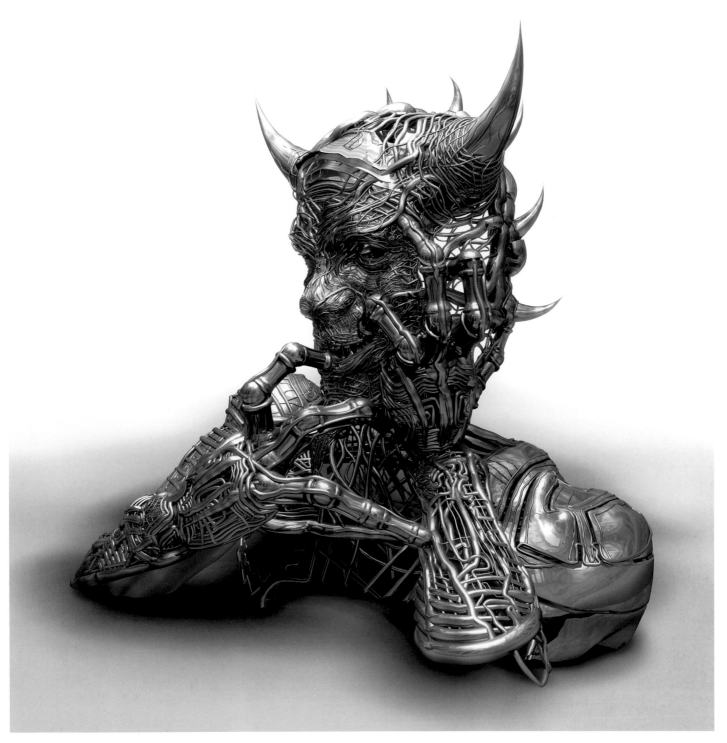

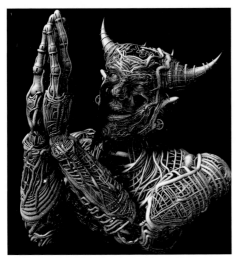

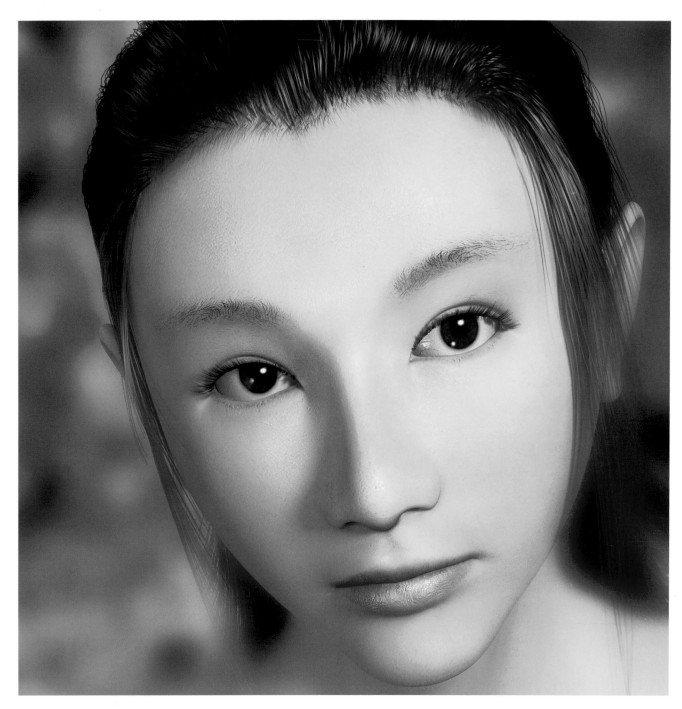

Love Asian
Softimage|XSI, Photoshop
Patrick Wong,
CANADA
[above]

Sandra
3ds Max, VRay, Photoshop
Mihai Anghelescu,
ROMANIA
[right]

Francisco A. Cortina

Her eyes are really what kept me interested in this piece. Most character-related pieces convey the first impression through the eyes and in this image it was the most important element. Modeling and simulating a very smooth face has always been a tough challenge, yet by careful use of lighting and the accentuated lip shine it seemed to work very nicely here.

Francisco A. Cortina

Replicating a person's smile has always been a very difficult thing to do. The key forms and contours of the face while smiling have been nicely and softly modeled. I particularly liked the subtle squint of the eyes and shape of the lips as they stretch over the teeth. Overall, this character exuded a complex feeling through her smile and also conveyed a sense of apprehension in her expression.

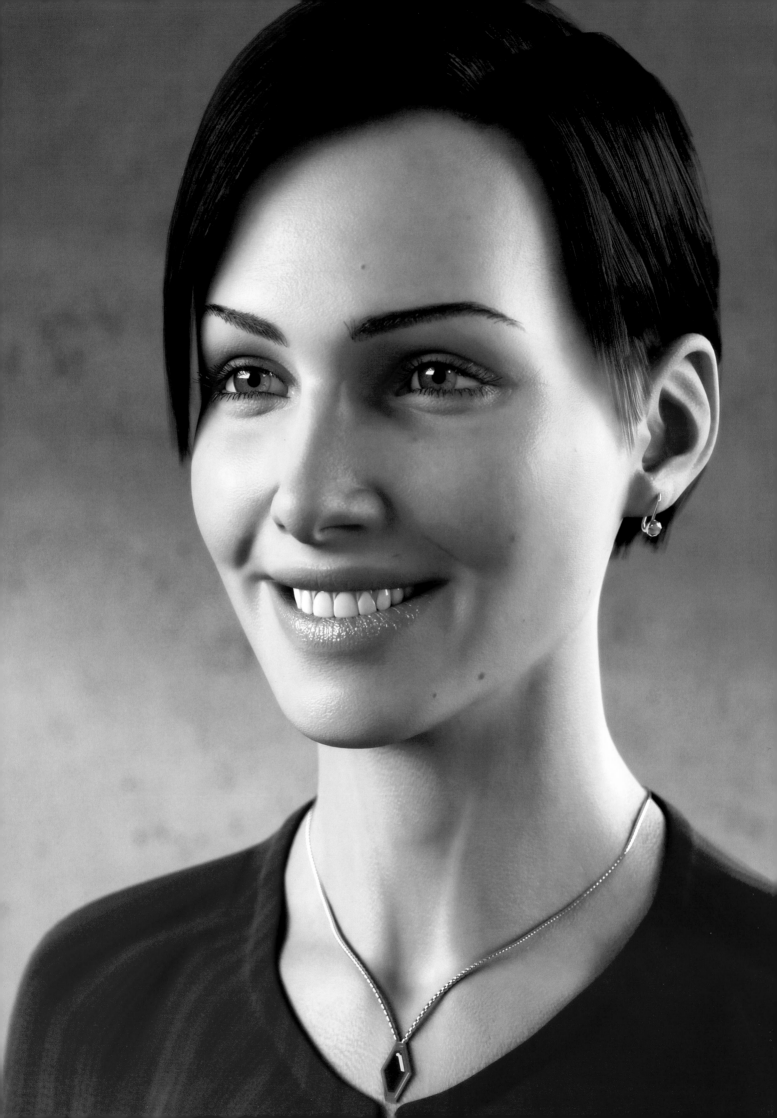

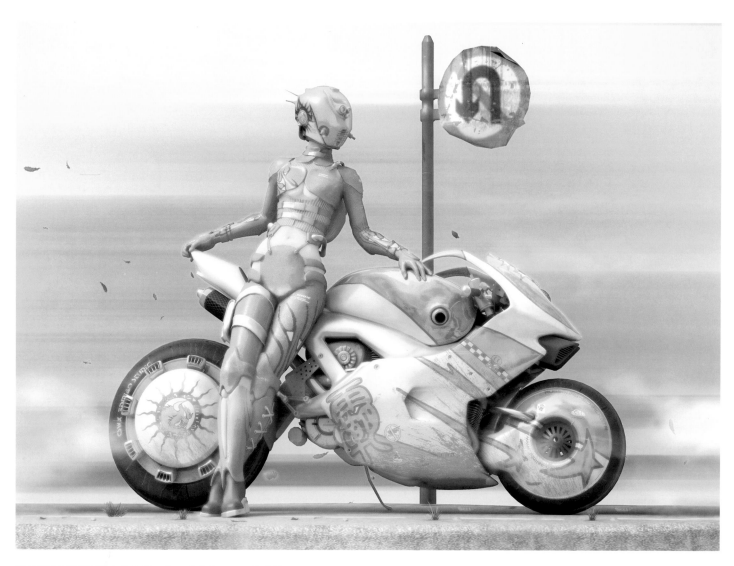

Cyclone Girl
3ds Max, VRay, Photoshop
Miao He,
GERMANY
[above]

Francisco A. Cortina
The first thing I noticed about this image was how well the character model and design flowed with that of the motorcycle. From the yellow and green decal textures on the bike to the armor-like modeling on her body, it all worked together very well.

Sammy: Intergalactic Troublemaker
3ds Max, VRay, Photoshop
Richard Rosenman,
Richard Rosenman Advertising & Design,
CANADA
[left]

Francisco A. Cortina
This was another piece which I found humorous because of the clever use of modeling and facial expression. The way the nose and lips protrude from the bulbous face and the strange frog-like textures that become more skin-like near the nose and neck really stood out.

Mechanical Venus
3ds Max, Photoshop
Hodong La,
KOREA
[right]

Francisco A. Cortina
Once I read the subject, I realized that it was somehow metaphoric to Boticelli's 'Venus'. However, I forgot the subject matter because I was more interested in how nicely modeled and purposefully designed this robot was. A nice touch was the careful use of color, which was kept mostly in the rusty red areas and the glowing green core, possibly alluding to the belly of Venus.

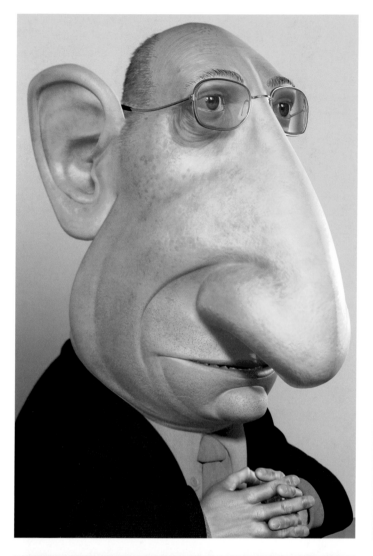

Pascal Couchepin
3ds Max, Photoshop
Fred Bastide,
SWITZERLAND
[above left]

Francisco A. Cortina
Although this character's gargantuan schnauzer was literally the most prominent part of the image, it was his eyes and glasses that were most interesting to me. I really enjoyed the stylized modeling of the face and how the lower mouth looked almost like a shelf under the nose. The carefully posed hands add to his tentative and unsure looking personality even though he is wearing a suit.

Schlitzy-The Eighth Dwarf
Animation:Master, Photoshop
Jim Talbot,
USA
[left]

Francisco A. Cortina
Shiltzy looked like a dwarf who had retired and taken up a new pastime of beer drinking.

The Fatman
Softimage|XSI, LightWave 3D, Photoshop
Omar Sarmiento,
SPAIN
[above]

Francisco A. Cortina
The part that drew my interest immediately was the nice modeling of his facial expression, particularly the mouth shape and how the teeth were somewhat visible. The eyes, darkened by the overhung brows, added to his attitude and the result was a very life-like tentativeness and reserved emotion coming from the character.

Aki's Eye
Maya, RenderMan
Image copyright Square USA Inc.
Steve Giesler,
USA
[right]

Francisco A. Cortina
When I first saw this image I had to blink and look closer to accept that what I was seeing was not a real woman's cheek. The very careful construction of the eye areas and clean, crisp texture detail are what struck me the most about it. To me it was and still is one of the most captivating images ever created in computer graphics and one of my favorites.

Prometeus
CINEMA 4D, BodyPaint
Marc Brink,
GERMANY
[left]

Francisco A. Cortina
I felt the most interesting part of this piece wasn't so much the character or the modeling, but the overall effect of the environment and subject matter of the piece. What drew me to this piece was the overall moodiness and grittiness and the unique sadness of the subject matter.

Knight Of The Temple
LightWave 3D, Photoshop
Fredrik Alfredsson,
SWEDEN
[right]

Francisco A. Cortina
Being a great fan of the medieval genre, I was very attracted to this image—not only for the character itself, but also for the settings and the almost hidden second character in the background. Overall, the level of detail in both the modeling and texturing, combined with the careful touches of age and weathering, make this piece a classic and favorite of mine.

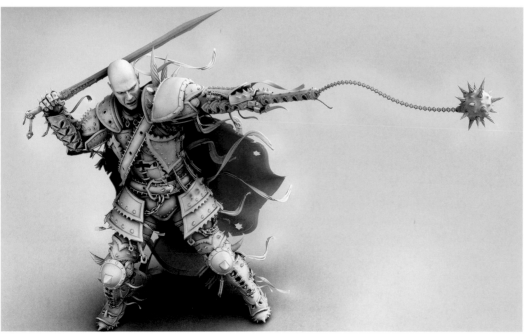

Alone on the Battlefield
3ds Max
Vitaly Bulgarov,
MOLDOVIA
[left]

Francisco A. Cortina
The carefully modeled details on this character's body really stood out and reminded me of a one of a kind collectable medieval soldier, in the style of 'Warhammer'.

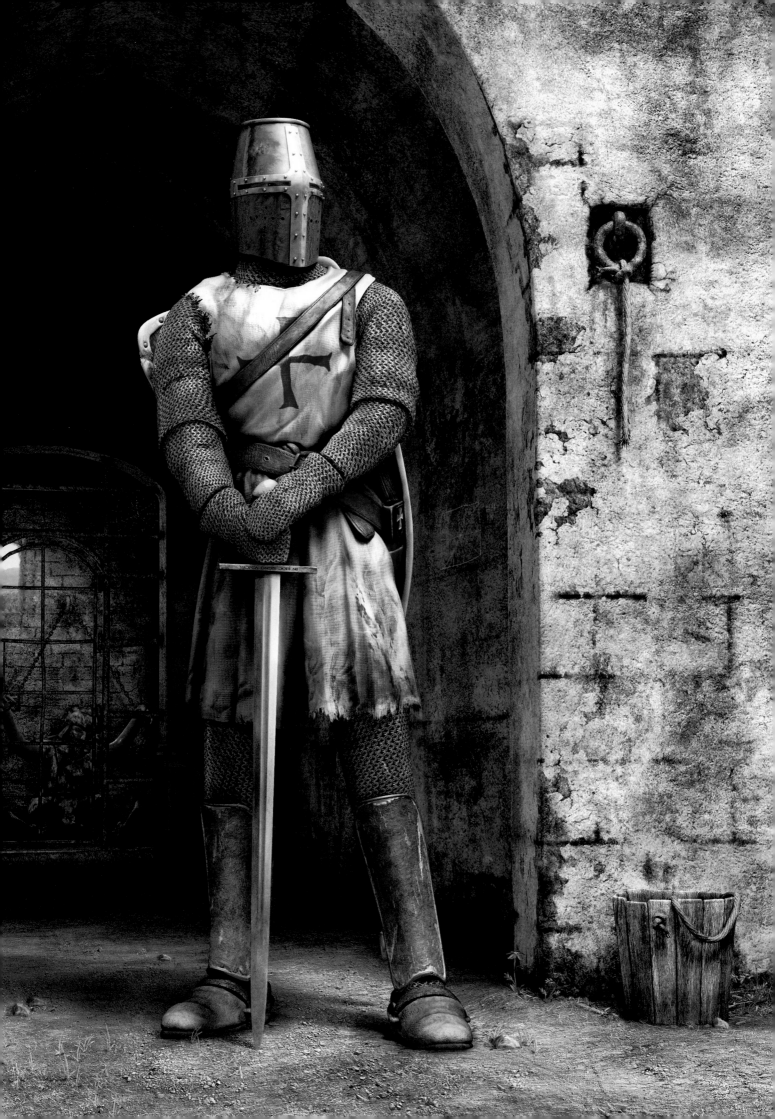

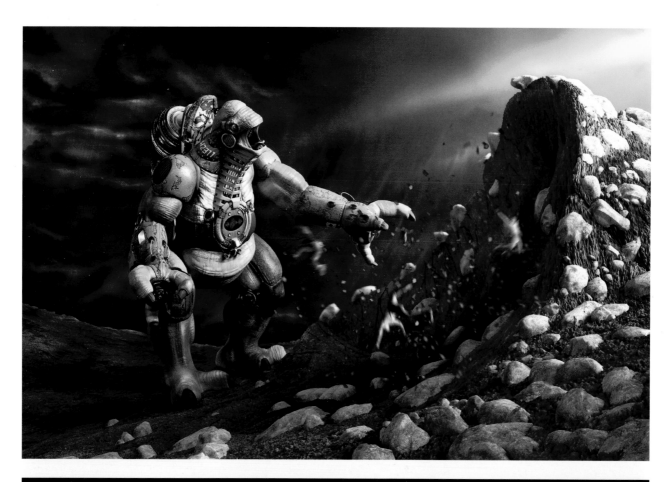

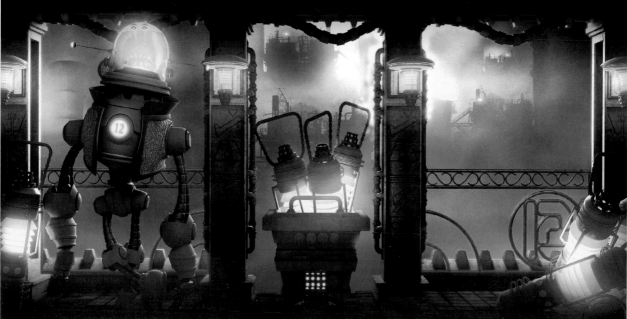

Wail
3ds Max, VRay, Photoshop
Jesse Sandifer, Green Grass Studios,
USA
[top]

Francisco A. Cortina
Though there wasn't a strong sense of pose or momentum in the character, I really liked the level of detail in the texturing and modeling of the alien. In spite of it being a character piece, I really loved how the rocks and dirt were brought to life.

The Space Docker II
3ds Max, Photoshop
Jerome Lionard,
FRANCE
[above]

Francisco A. Cortina
The sense of mood and depth created by both the lighting and fog helped create an interesting backdrop for the character, which seemed as though he was a part of the scenery. I found myself wondering if there were any alien faces inside the lamps of the factory.

Metamorphosis
Shade, Photoshop
Kazuhiko Nakamura,
JAPAN
[right]

Francisco A. Cortina
I thought about Magritte's 'Ceci n'est pas une pipe' (This is not a pipe) painting. Not a pipe, but also not a person here. Yet, with all the insects, carcass parts, bones and appendages were seen as a single unit, it comes to life. I enjoyed the high level of detail in both modeling and texturing work.

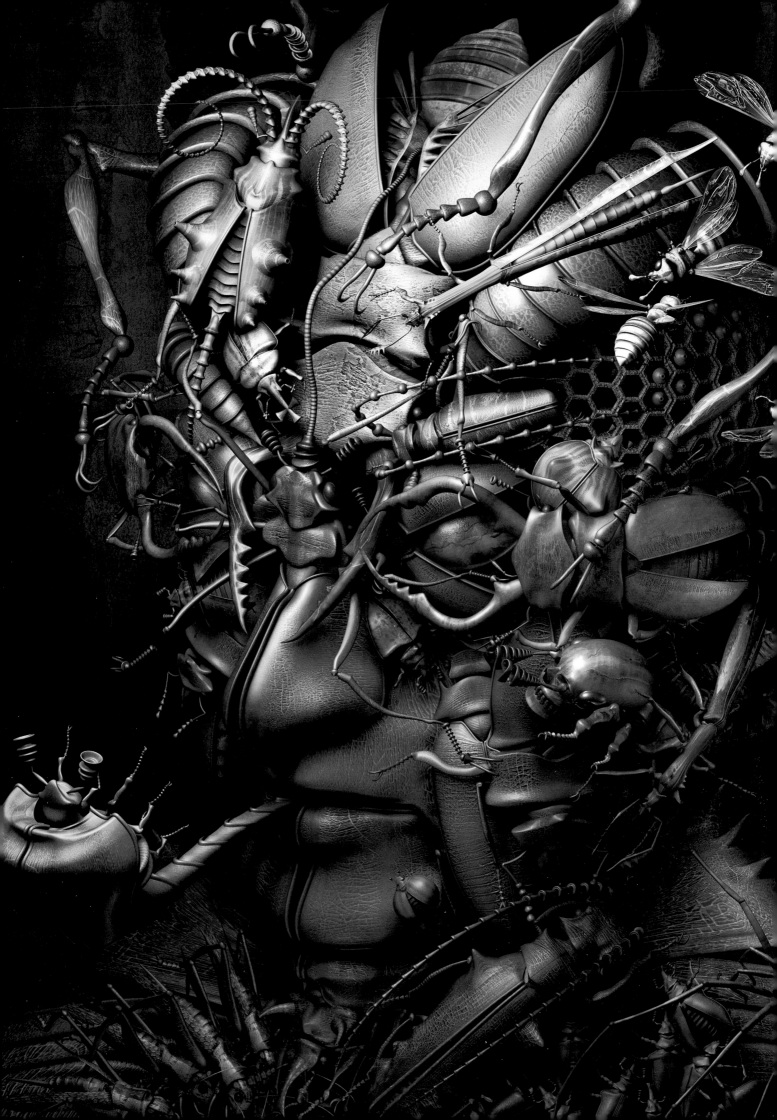

The Germ
LightWave 3D, Photoshop
Pete Sussi,
USA
[above]

Francisco A. Cortina
I really liked the careful modeling and subtle forms achieved here. Areas such as the chest and belly, as well as the lips and eyelids, were very nicely shaped to convey both weight and motion. The body seemed to create its own sense of gesture and it was as though he was about to jump and spin in the air.

Otis is Tripping
Maya, Photoshop
Rickard Johansson, Richard Blank
& Bjorn Albihn,
SWEDEN
[left]

Francisco A. Cortina
Similar to the Germ, there was a very nice sense of simplicity to the model, containing details in key areas of interest. A good example of that was on his face where the eye sockets were bloated and the skin sagged around his mouth as he was gasping for air.

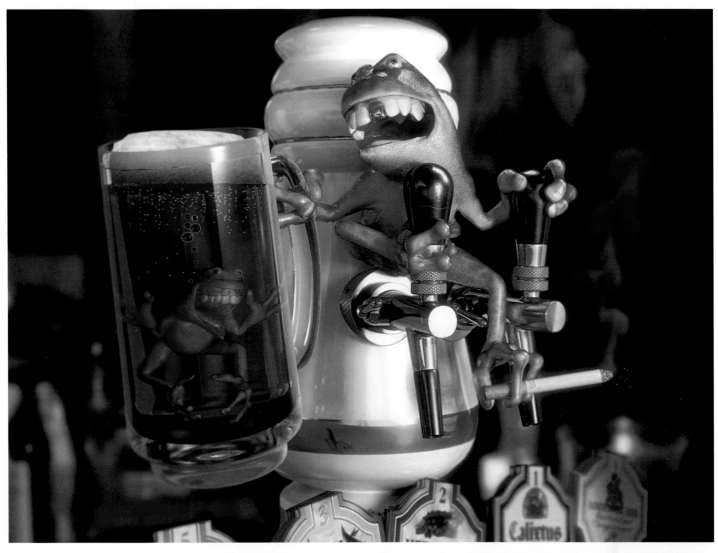

Frogs
Maya, mental ray, Photoshop
Igor Kudryavtsev,
RUSSIA
[above]

Francisco A. Cortina
I could not help but laugh when I noticed the crazy lip-less frog floating inside the beer mug of the main frog. Both the way the scene is modeled and how the textures were used to compose the scene were done very well. It's easy to forget that it really does not exist because it was so cleanly put together and the message is so comedic.

Boris: Alien Invader
3ds Max, VRay, Photoshop
Richard Rosenman,
CANADA
[right]

Francisco A. Cortina
What stood out to me with this image was the texturing on the skin and how well created the goo and liquid, which was layered on top of it, was. Overall, it had a humorous yet creepy feeling.

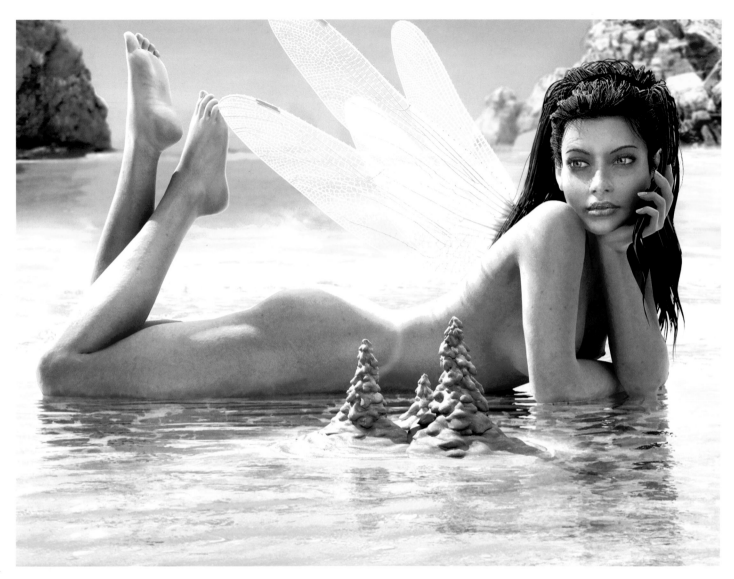

Waiting for Inflow (Lila)
Maya, Photoshop, mental ray
Andreas Hebel,
GERMANY
[above]

Francisco A. Cortina
The strong sense of reflected and bounced light onto her skin is what first attracted me to this image. Upon closer inspection, I began to take note of the nicely modeled body and pose, particularly her legs and feet which seemed to convey a sense of playfulness. Her face and hands also felt relaxed and natural and her body textures and lighting were very well integrated with the water that surrounded her.

Etaine
3ds Max, VRay, Photoshop
Client: SONOV
Eun-hee Choi, KOREA
[left, right]

Francisco A. Cortina
I loved the way her figure and dress models were integrated together. They conveyed a sense of balance and careful motion in both her pose and clothing. Like the first Etaine image on the earlier page, these two variations of the angel-like character also contained a nice textural balance between her soft skin and the lace-stitched outfit. Even though the images had a somewhat monochromatic tone, it helped promote a somewhat dreamy quality as well as the doll-like feeling of the characters.

STEVEN STAHLBERG

Steven Stahlberg is a co-founder of Optidigit, now partnered with VisualXtreme to form Androidblues, The Virtual Talent Studio. Steven is the head of 3D animation and art director of Androidblues in addition to being an artist, illustrator and animator. After completing his art studies in Sweden and Australia, Steven worked ten years as a freelance illustrator for leading advertising agencies and publications in Europe and Asia. Steven is internationally acknowledged as a world class digital artist and was the first artist in the world to have a virtual character sponsored by a major modeling agency (Elite) back in 1999.

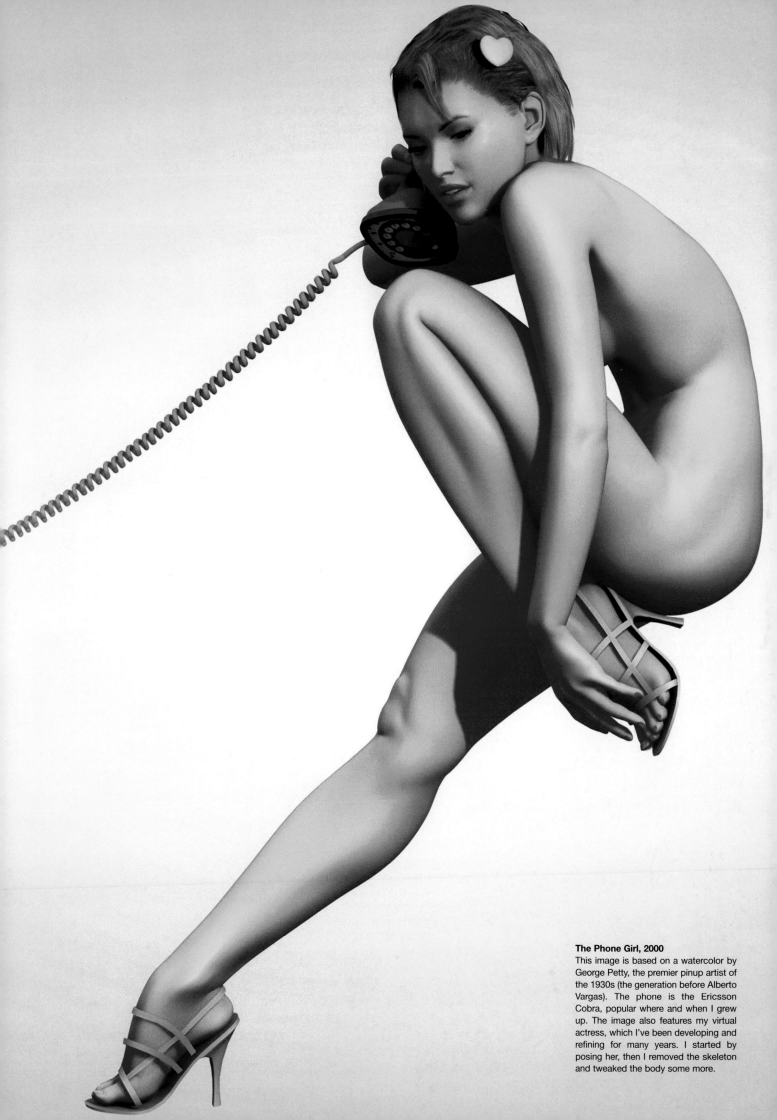

The Phone Girl, 2000
This image is based on a watercolor by George Petty, the premier pinup artist of the 1930s (the generation before Alberto Vargas). The phone is the Ericsson Cobra, popular where and when I grew up. The image also features my virtual actress, which I've been developing and refining for many years. I started by posing her, then I removed the skeleton and tweaked the body some more.

CONTENTS

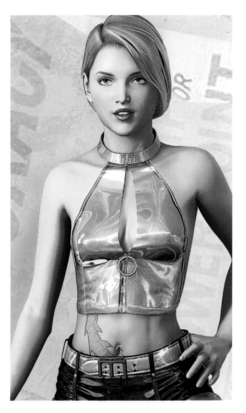

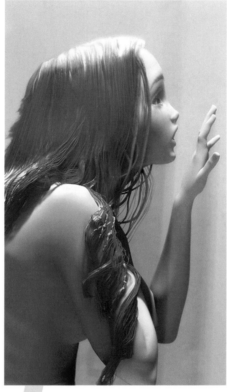

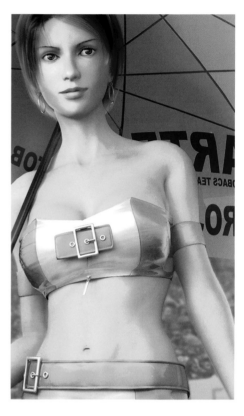

Background

I loved comics, like most of my generation. That was my first real exposure to professional level drawings and graphics. I used to lay on the floor patiently copying bits out of Herge's Tintin and Carlos Gimenez' Delta 99. I also read a lot, mostly science fiction. I rarely left my room voluntarily. Back then animation on TV was crap, but in the movies it was great—I remember that Disney's 'The Jungle Book' made a huge impression on me, artistically. Very early on, my love for movies was born. I was particularly entranced by such classics as 'The Sea Hawk' with Errol Flynn, 'Ivanhoe' and 'The Prisoner of Zenda'. I think I always thought, as far back as I can remember that I'd be doing some kind of profession to do with graphics when I grew up. I always drew a lot, ever since I could hold a crayon, and I always loved to do it. If you knew my family, you'd see it's rather obvious I have it from my mother, and she has

it from her father. So far this interest is missing in both my own kids, but who knows, a lot of artists didn't start until they were much older.

Creativity

I've always had more (and too grand) ideas than I could possibly finish. I'm not sure exactly how one trains creativity; probably simply by using it daily. Creativity (imagination, fantasy) is a very straightforward muscle, like the bicep; one single simple exercise repeated over and over will suffice to make it grow. My studies were more focused on technical matters, and observational skills (as is usually the case). I did one-year in a more 'fine-art' focused school in Australia, which in addition to the all-important Life Drawing, taught oil painting, charcoal, printmaking, and art history. Then I did a two-year 'illustrator' course in Sweden. As there are literally dozens of different

techniques and styles in illustration, and as I wanted to know them all, I worked very hard—right across all the holidays and weekends, sometimes very late at night. Those few of us who did that probably annoyed the security guards, as the rules said they had to check our IDs every night.

Commercial assignments

I remember I did a big bank vault door half-open, with the earth and space peeking through on the other side, a still image for an illustration job in advertising. That was in Alias Animator. For output I photographed the screen with my camera on a tripod, in the dark. Sounds strange, but it worked. I had a big screen, a dark room, and a yellow filter to counteract the blue shift. I did a couple other stills for my old illustration clients, then I found a job at a small local studio nearby. This was in Hong Kong, around 1994.

Going digital

I got my first computer in 1987—for music sequencing and composing (a hobby I kept up for many years). My first graphic computer was a PC in 1991, running Autocad. I was so disappointed in the difficult modeling and lack of rendering finesse (dithered dot matrix), I soon sold it. A little later I found SGI, and bought a Personal Iris bundled with Alias Quickmodel and Wavefront Personal Visualizer. The digital side didn't enter into my formal education at all—that came later and was completely informal. I had to learn all the 3D stuff on my own, with no Internet or third-party books (except the Renderman Companion, ha! Well it sounds funny, but it did help a little, in explaining the basic concepts of CG to me). But basically just the Alias manual. The local resellers were no help; they were soon asking me for help. I guess I progressed fairly fast at first, but then it slowed down as I also had to wait for my tools to mature. At first, I couldn't even animate anything, my hardware was so limited, and the software had no IK tools, or even bones. Then things started changing, improving, and gradually I devoured the new manuals and expanded my skills.

Digital tools

I've used 3d studio max a little in the past, but mostly Alias software. Now I use Maya and Photoshop, and a Wacom, and that's about it. It just works. I see no pressing need to spend money and lots of time to learn another app. I like to keep things as simple as possible, though I think I'll be getting into ZBrush one of these days.

Self-paced learning

I learned how to think in terms of 'tricking' the software to do what I wanted, to find alternate ways around all those limitations in the beginning. I figured out most of the stuff by myself—I had to—there was no advanced knowledge available anywhere back then. In this sense, it's easier today. But of course, today the pressure is stronger, and the manuals thicker. And the software still has as many limitations, just different ones.

Following the path

My career path was never a matter of any decision. When I was able to start doing it I did it. No questions in my mind about it. This happened gradually around 1993-94, as I went from a happy hobbyist to a stressed out professional.

Community

I dedicate almost half of my time to community-related efforts on some days with email taking the big chunk. Then the CGTalk forum; I'm a forum leader and have some duties there, and I also browse it for pleasure and for learning new stuff. It's the single best resource in the world for guys like me. On top of that, I also have some workshops happening there.

Projects

A typical commercial project starts with an email from a client, discussion, settling on price, signing contract and NDA. Then the work starts, and the clients give me feedback, usually in many iterations back and forth, until it's done and accepted and delivered. These projects are usually characters, often for game companies. For myself, I like to work in still images, with no thought to animation. This frees me from some restrictions, and I can mix 2D with 3D. Of course, I can work at my own pace. But, these images also usually feature characters, though they tend to tell more of a story. I've worked briefly for Glen Keane (Disney FA) on his Rapunzel project. That has been my most satisfying by far. I met Glen briefly at first, then later after I was done with my part I was invited to speak at Disney and I had the wonderful opportunity to look around their hallowed hallways (the incredible art that hangs there!), and to talk to Glen again and see what he was up to. I think it must be the most amazing experience of my career. The man is a genius, a true master, and such a nice guy. The amazing thing is he's not the only genius there. It's mind boggling for me how so much talent can fit into a single building.

Getting a foot in the door

The following may sound like no-brainers to many, but perhaps someone out there needs to hear it. First be sure about what you want, and how much work it will take to reach your goals. Then, train yourselves in traditional art skills, such as life drawing or sculpture. Any kind of drawing or sketching is better than no traditional art training, but I highly recommend some kind of structured program, either with an instructor, or check out the learning resources at CGTalk.com, in the Art Discussion forum. This is very important. Art skills take years to acquire, and you never really finish learning them. Software operation skills take months to acquire, and as the apps change or are replaced, you may have to keep re-training yourself constantly. This means that there's no rush to learn them; your priorities should be, art skills first, software skills later. The beginner who wants to become a modeler or lighter or texture artist, has to learn to observe and discern. Learn how to sketch, and to use reference properly. To do this you have two alternatives: institutions such as schools; or do-it-yourself. Both have advantages. Check out CGTalk sticky threads in General Discussion for more info on this. This is the beginning; there are many other things to discuss, like not letting people take advantage of your eagerness to find work, but the most important of all is the motivation and the proper training.

CG evolution

I think the GPU will start to make an impact soon, making feedback faster, and more interactive. Character modelers will hopefully be able to work with more advanced interfaces, like haptic feedback in a specialized input device. Stereo vision might help too. I think ZBrush shows the way for the future of modeling. We'll be less dependant on topology, and more free to 'paint' deformations onto the model—more like working in clay than translating points in xyz.

Future plans

I don't have solid plans for the future at the moment. I think I'm at a kind of crossroads. I'd love to get closer to the movie making process in the future (or at least a TV series). I've always loved story-telling in general, and movies in particular. At the same time, I seem to be slowly pulled towards teaching—we'll see what happens.

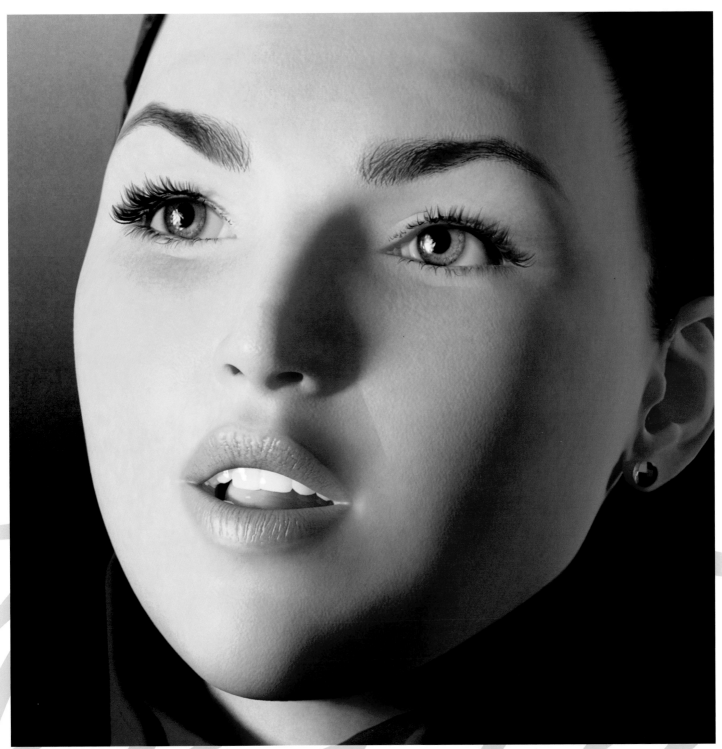

Skin test: A skin shading test using Francesca Luca's BumpCombiner and mix8Layer nodes.

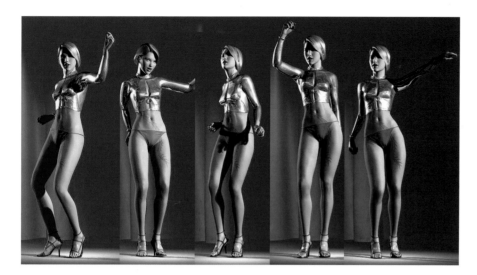

Rhayne dancing

This is from an animation I did around 2002 for the Rhayne project. Rhayne was a virtual singer invented by a real-life Canadian singer-songwriter. As with all the other 3D here, this was done in Maya Unlimited. Problems with Cloth forced me to use less clothing than I first had in mind.
[left]

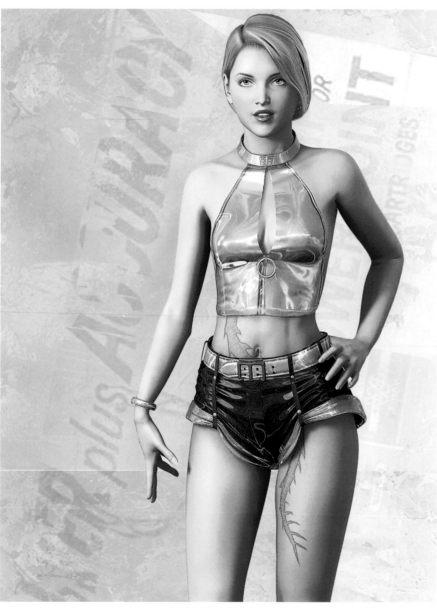

Rhayne

At this stage I was still working in Subdivided surfaces, with the hierarchy intact, and using Wrap deformers for rigging. This model was fully animatable, with jiggle deformers in the hair and thighs, and the face fully-rigged with about 40 morph targets.
[left]

Jealousy

One royal elven sister murdering another—the Queen—in a tragic tale of jealousy and envy. If you look closely, you can see the goblin prince sleeping in the background. He and the Queen had just married. This piece goes together with 'One Last Time'. It's the only completely 2D image here, painted from scratch in Photoshop.
[right]

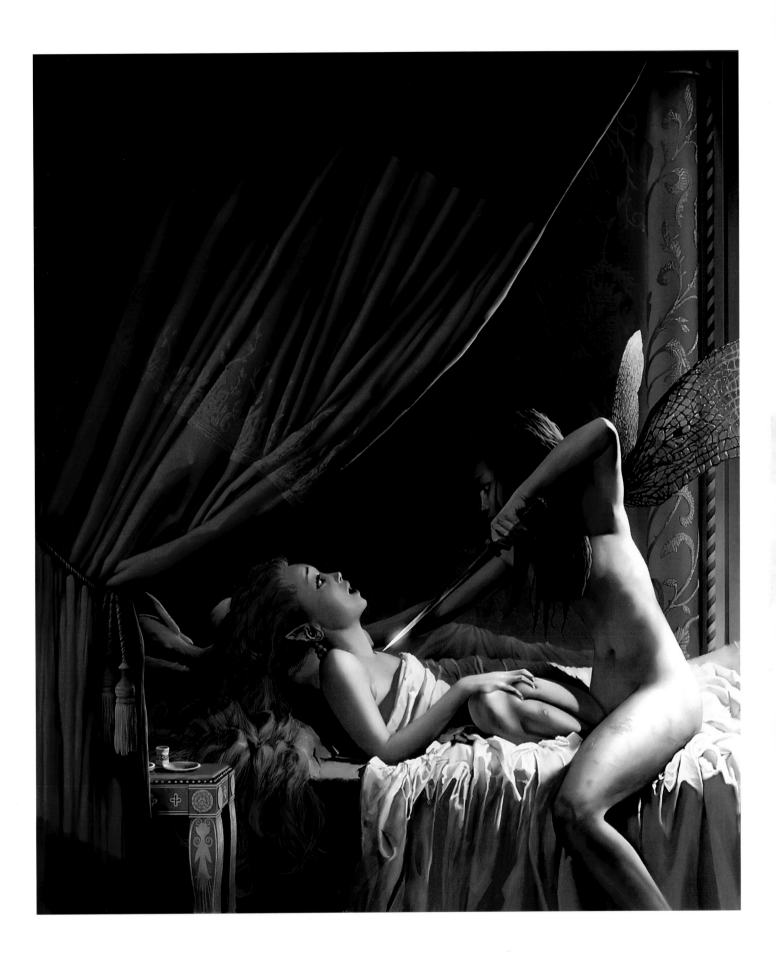

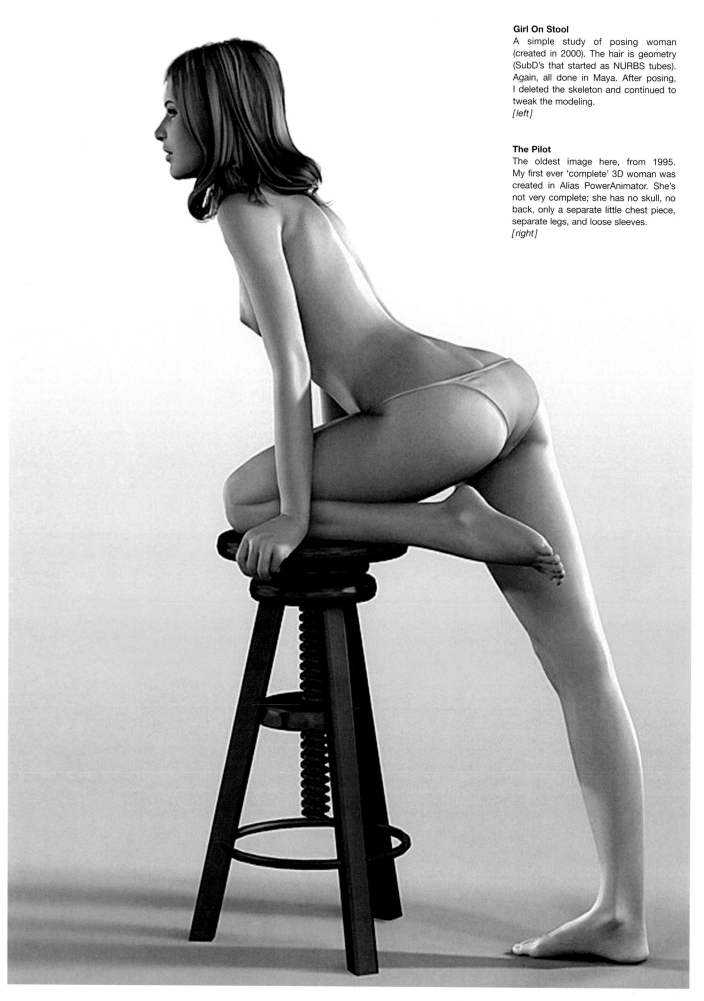

Girl On Stool
A simple study of posing woman (created in 2000). The hair is geometry (SubD's that started as NURBS tubes). Again, all done in Maya. After posing, I deleted the skeleton and continued to tweak the modeling.
[left]

The Pilot
The oldest image here, from 1995. My first ever 'complete' 3D woman was created in Alias PowerAnimator. She's not very complete; she has no skull, no back, only a separate little chest piece, separate legs, and loose sleeves.
[right]

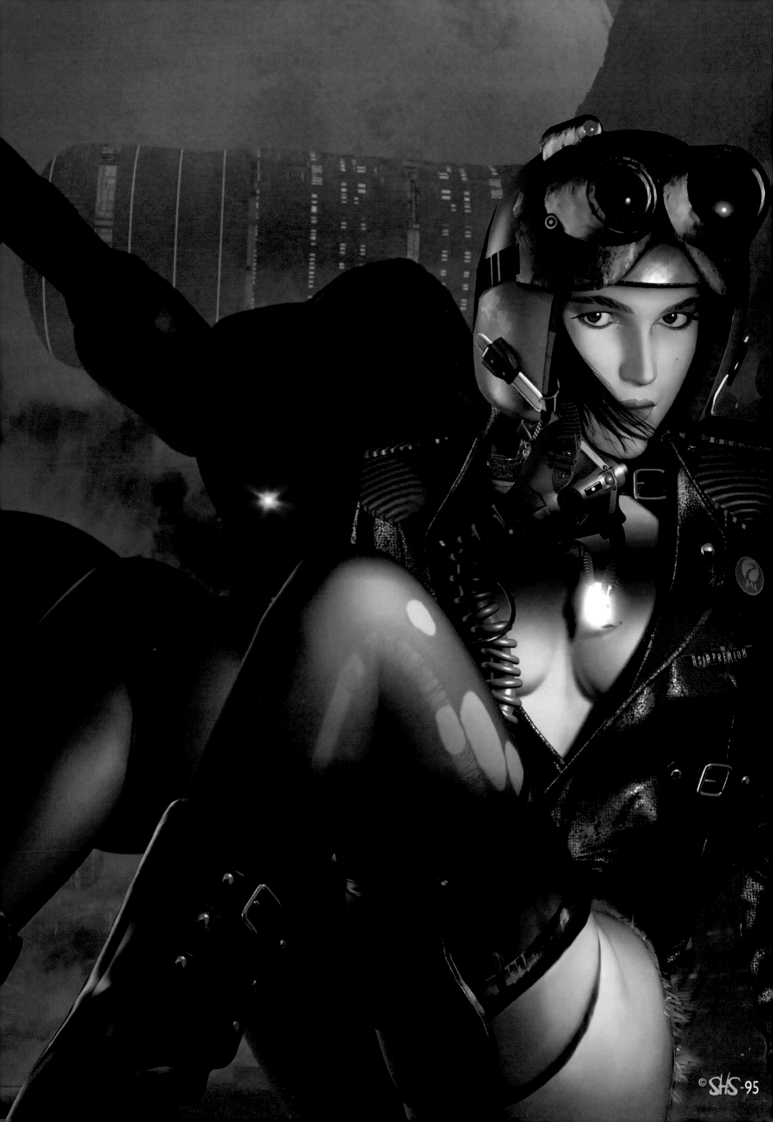

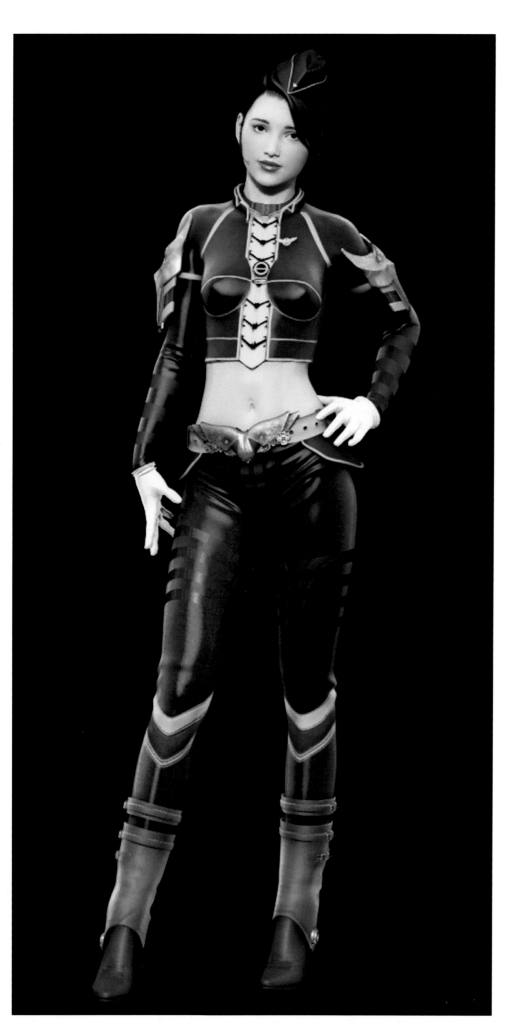

Aida Maya
This animatable virtual character was ordered by the government of Malaysia in 2003, to be a sort of 'Master of Ceremonies' at a fancy theatre in 'Cyberjaya', with a hemispherical screen and stereovision capabilities. We did one animation where she introduced the facility, and another to close the program.
[left]

Biker Girl
A remake of my older original from 1997. This one is from 2004. It's supposed to work with antigravity. The buildings started as 3D, then were heavily edited in Photoshop. The sky, clouds and distant buildings were all painted.
[right]

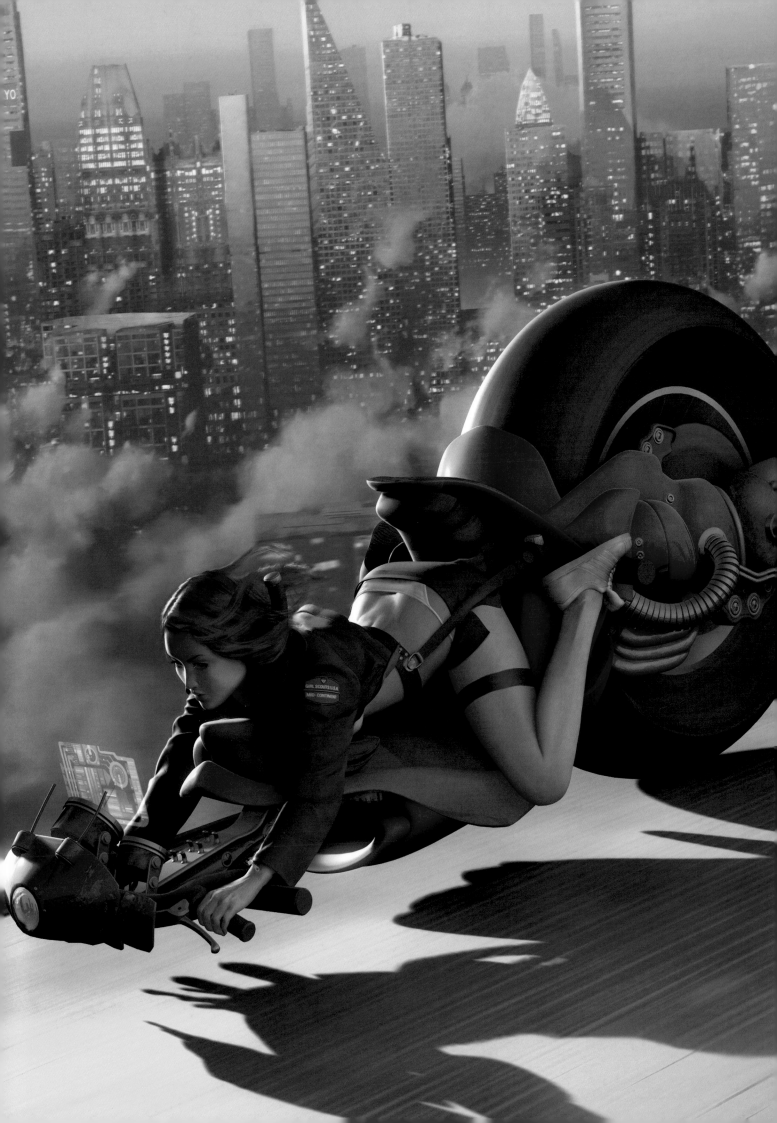

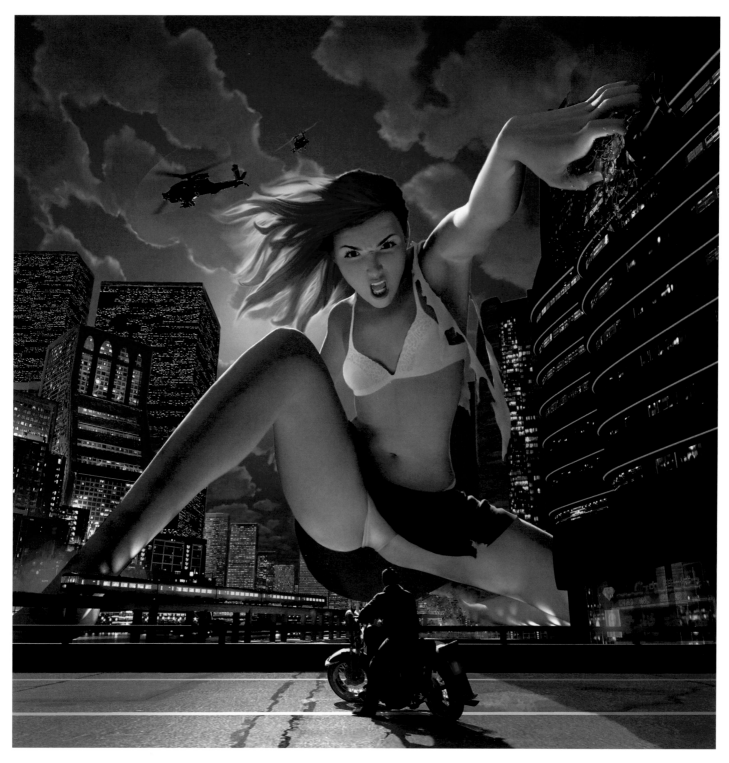

Psycho Girlfriend
Mostly 3D, with some 2D retouching on the hair. The background is all 2D.
[above]

One Last Time
This image was created in 2003. Long after this and another painting with a similar subject was done, a complete story grew around it. It was also used as the cover artwork for EXPOSÉ 1.
[right]

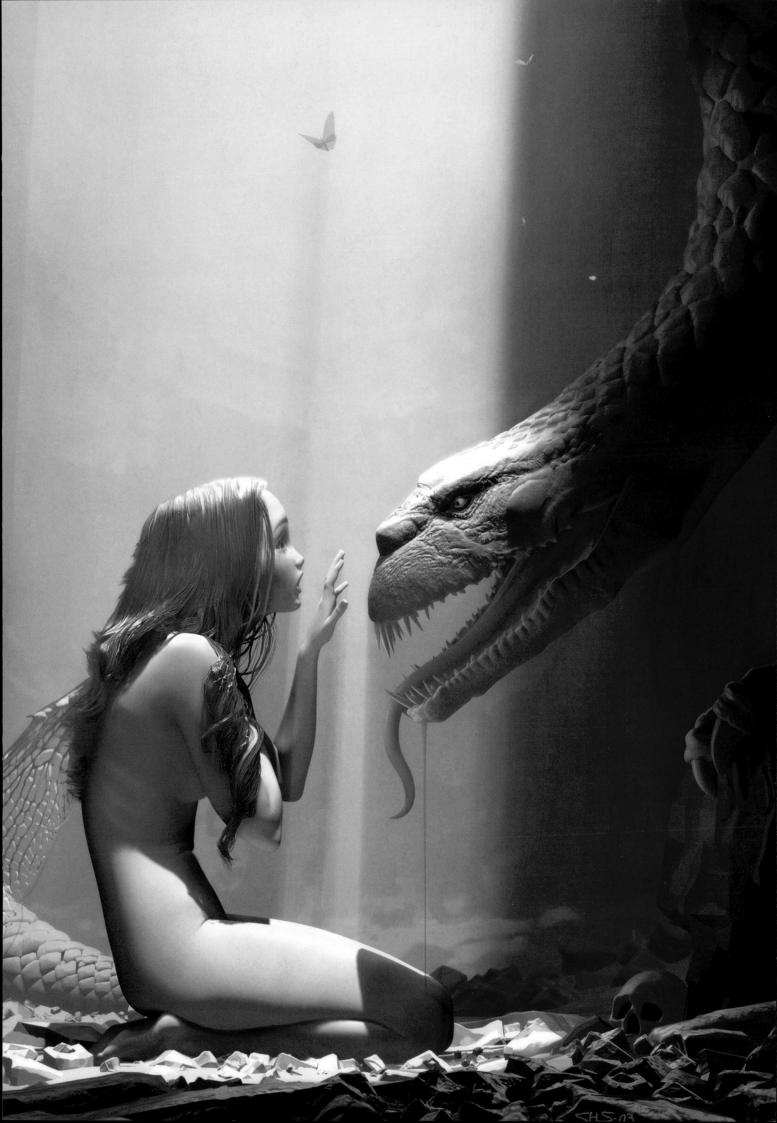

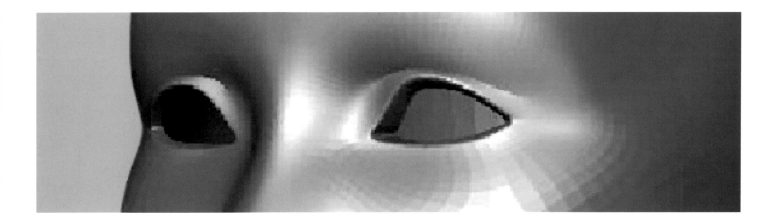

HUMAN MODELING: THE FACE

Subject

First off, I should mention that this subject is pretty much the hardest thing you can attempt in the visual arts. Beginners to 3D, who are also beginners to the whole field of visual arts, should be careful not to jump in unprepared, with expectations set too high. Without lots of practise, the result is usually not very good at all. Don't let that discourage you. Just go back to basics. Practise drawing. If you can, practise Life Drawing, otherwise do your best with a sketchbook on the subway, or drawing from photographs (no tracing, unless you're doing it after you're stuck, to find out what went wrong). Any kind of drawing is better than no drawing. Check out the Art Discussion forum on CGTalk.com—the sticky thread 'Art Theory Links and Tutorials' at the top contains enough advice and material for a complete art education.

The idea

If you already have a clear idea of what you want, skip to 'Sketch, sketch and sketch'. Otherwise, here are some helpful hints:

1. To have a better chance to find one good idea, you should try to come up with as many as possible. Even the most talented people only use a portion of all the ideas they have. In any case, creativity is like a muscle—it grows more powerful with frequent use.

2. Fertilize or feed the mind. Read, and try to find unusual things to read. Go somewhere you've never been before, even if it's just around the corner. Try a new activity, the more different from what you usually do, the better. This has also been proven to stave off the onset of senility!

3. Increased bloodflow brings more oxygen to the brain: take a hot shower, do some mild exercise, or anything easy and repetitive (walking is ideal). Jogging works too, but you hit the sweet spot for a much shorter time, before the exertion becomes too much.

4. Learn to look at everything from a different viewpoint: turn concepts upside down and inside out, back to front. Say 'What if...' as often as you can. Learn to see details, to observe and notice.

5. Be bored: there's no more certain way to start the little cogwheels in your mind working—sometimes without us noticing at first—than to do absolutely nothing for a period of time. This is the reason why long distance travel is so good for inspiration—long periods of boredom, punctuated by explosions of novelty and stress and new experiences.

6. Schedule yourself. For example, decide to make five sketches before lunch.

7. Research: if you're focusing on a particular genre or subculture, study it thoroughly.

8. Bring a notebook/sketchpad wherever you go. This brings us to the following point.

Sketch, sketch and sketch

You need to decide exactly what you're going for, and the best way to do that is to draw it. The more worked and focused the sketch(es), the better the final image. This is one big reason why a traditional art education is vital to the 3D artist. Note: 'traditional' doesn't mean 'formal'. You can certainly also train all by yourself.

Reference

You need to find the best possible reference for your project. This sounds obvious, but it's usually underrated by beginners. Next to the initial idea, it's the most important step. If the reference is bad, the final image will not be as good as it might have been. It's not as easy to find good reference as one might think. Hunt for it like a bloodhound. Don't give up too soon, or even worse, never start (the most common mistake artists make). It's a little like the carpenter's mantra: 'Measure twice, cut once'. Or this old saying: 'One stitch in time saves nine'. One more hour chasing reference might save you from some VERY time-consuming changes later. Or it might mean that extra little edge that kicks the other guy's butt. So keep at it until you're reasonably sure you've found the best you can get within schedule and budget. It's almost an art in itself. It requires logic and observational skills, and juggling many parameters at once—the right angle, focal length, light, pose, resolution or clarity. Sometimes you need several references for a single object to cover all these issues. It requires artistic training, experience as well as having a clear image in mind of the desired outcome. For that reason I recommend to start sketching before looking for reference, but also be prepared to make new sketches during the search if better ideas occur. Use Google, libraries, magazines, your own photos, web forums, and last but not least movies. Pause and screengrab or photograph the TV screen. Build your own scrapbook library. The best reference is usually the one you shoot yourself. If it's practical, this is definitely the way to go: it's usually quicker; it's better (closer to your personal vision); and there are no problems with copyright.

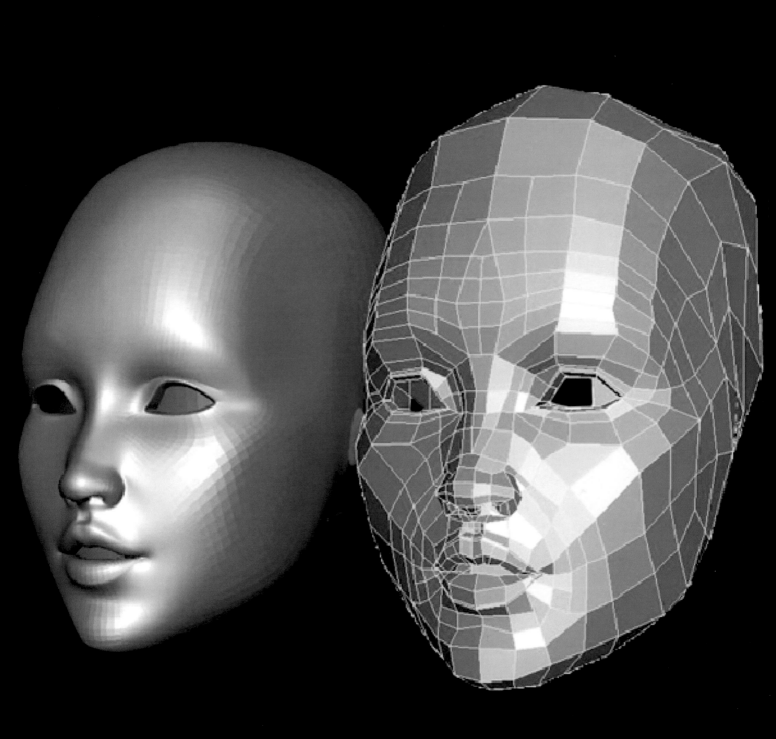

Real muscles

After gathering all the reference you need, the next step is planning the topology. This is a sketch of some facial muscles (based on a dissection photo). Note in particular the muscles that create the nasolabial fold (the smile-wrinkle): Zygomaticus major and minor; Levator anguli oris; Depressor anguli oris; Levator Labii; and Risorious. As you can see, knowing what they look like doesn't help in determining the shape or the topology of the surface or the nasolabial fold. The same goes for the wider but very thin sheets of muscle in the face, such as the Frontalis. The facial expression muscles are unique. Unlike most others in our bodies (including the jaw muscles) they're only attached to bone at one end. The other is attached to skin or other muscles. They are also very much weaker and smaller. Their only purpose is to signal emotion.

How facial muscles work

Imagine a thick sheet of foam rubber lying on a table, with strings attached to its underside. When one or another string is pulled, part of the sheet slides and wrinkles. The strings are invisible to us—all we see is the wrinkle on the surface. To get it exactly right we must study the outside shape of the sheet, possibly also the table, but not the strings themselves. My point is, it's good to know something about the main facial muscles, but don't think that the more you know about them the more realistic your face will be. That path leads to a dead end. Also, beware of incorrect anatomical charts, always check more than one source.

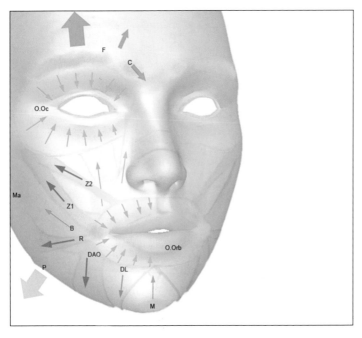

Main Muscles Chart

This chart shows where muscles are attached to: the skin (blue); the ring-shaped muscles (green); the muscles that oppose them (red); and the direction of the pull (arrows). Only the most important muscles are named: Frontalis; Corrugator; Orbicularis Oculi; Zygomaticus Minor and Major; Masseter; Buccinator; Risorius; Orbicularis Oris; Depressor Anguli Oris; Depressor Labii; Mentalis; and Platysma. The Levator Anguli Oris and Levator Labii are hinted at (by the nostril). Here you can clearly see what happens when B, R, Z1, Z2, and a few other muscles pull on the blue spot at the corner of the mouth. Fatty tissue in the cheek folds, roughly along a path perpendicular to the pulling muscles, creating a line similar to the outline of curtains pulled back by a string.

Topology

You really must work it out on paper first—it's just so much more efficient. Here's a simplified and exaggerated head. I've drawn red lines to highlight the major wrinkles, most visible only in old age or in facial expressions. These are the edges that have to be there, that have to be planned for in most realistic human (and many non-human) faces. This same topology can be used as a starting point for any human. Everyone has the same POTENTIAL wrinkles and folds. Not everyone presents them, and of course wrinkles may take slightly different courses across the face, but the variations are usually not large.

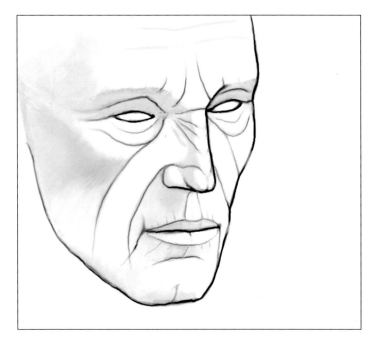

Sketching the edge loops

The blue lines indicate the next step. Start by extending the red lines in a logical manner, trying to connect them as simply as possible. The theoretical ideal would be a ring-shape, or loop (also known as the edge-loop method). Note that I consider that kind of optional, a nice bonus but not necessary (see Triangles and 5-sides). Trace lines along the areas of highest curvature (jaw line, nose, brows, lips, lids). Remember to include any wrinkles that will form in any expression. Try to do all this, without getting long, thin or very slanted rectangles and acute angles, in areas that should be smooth. These must be avoided unless they help to form a bump, wrinkle or such. Also try to avoid varying size of neighboring polys which also create bumps (unless you want bumps there of course). Try to stay as low-res as possible. At this stage, don't worry at all about triangles or 5-sides. Time enough for that later.

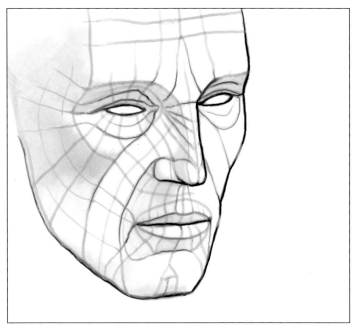

Outer eye-corner

Note that some areas are trickier to plan than others. For instance, the lateral canthi, the nostrils/nasolabial fold meeting, and the mouth corners. Here's a close-up of the right lateral canthus. The red lines indicate the general direction of the wrinkles in this area. In most people these wrinkles appear permanently only with age or lots of weather-damage. But it's important to follow this topology if you want a good squinting action. Note that the upper eyelid overlaps the lower a little, though this effect is hardly visible in the very young.

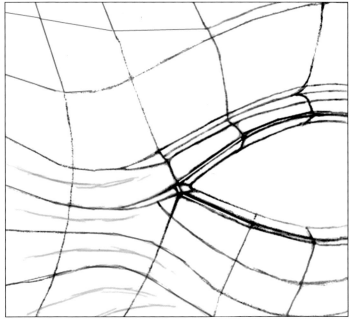

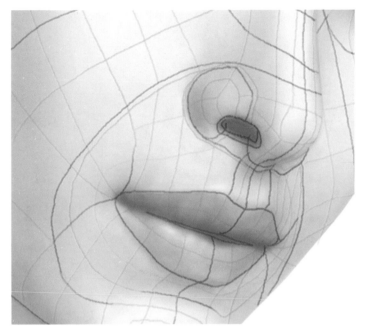

Nasolabial region

Here's a close up of the nasolabial region—a theoretical ideal topology sketched over a photo. Note that the red lines are the necessary ones; they have to be there in roughly these configurations, but the blue lines are looser and more a work in progress. They may or may not change during the actual modeling, or while testing expressions.

Topology checklist

When creating topolgy, keep the following in mind:
- As low-res as possible.
- The polygons should always be as chubby, or square, as possible in highly visible smooth areas—no long thin ones, nor diamond shaped. However, long thin polys are of course okay where necessary to form wrinkles etc.
- The direction of edges can't run across either a form in the neutral face, or a form in any of the expressions. The worst case is finding the topology running at 45 degrees across a place where you want to model a crease or ridge. That means you have to rethink and redo it.

Deforming geometry

For deformable geometry such as A, you need to think along two lines: first, the neutral topology B. Also, if A ever has to deform like C, you need to consider D. Note how the lines run along the edges of highest curvature (red tint), and how they're more closely spaced there.

Triangles and 5-sides

I don't bother to keep meshes all quads and evenly divided. I found that three and 5-sided polys can be very helpful, if you're careful. Non-quads result in much easier modeling and topology-optimizing; easier morph target creation; lighter model; and it's easier to achieve organic realism. Some renderers don't accept non-quads but even one Subdivision at rendertime will always make the surface all quads. Place these kinds of polygons only where you want bumps. Remember to also take deformations into account. The model may look nice in neutral pose, but you need to exercise all joints and try all the facial expressions to see where the problems are. It all depends on what the resulting smoothed surface looks like. Wireframe may look chaotic, but chaos is exactly what is needed to avoid the default clean, organized, straight and symmetrical CG look. This method is lightning quick in feedback, when animating.

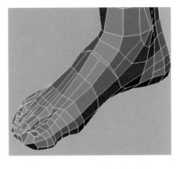
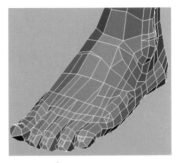
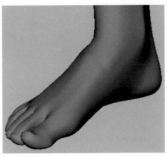
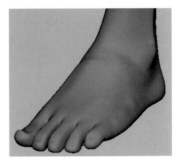

Tools

I prefer to model in Maya with the following on my modeling shelf: Transform along Normal; Extrude Face; Extrude Edge; Split Polygon; Merge Vertices; Edge Loop Split (with slide); and Select Loop, both from MJPolyTools (Mikkel Jans); Convert from Poly to SubD and from SubD to Poly; Maya's own Edge Loop Select (because the MJ SL can't select border edges); Average Vertices; Lattice; Sculpt Deformer; and Soft Modification.

Small example of sketching

Here's an example using a very simple object: an umbrella handle. As I mentioned, I usually start with a sketch. It makes the process so much quicker. If you don't believe me, go ahead and try modeling this now, without looking at the sketches below—only at the painting of the handle. Time it. Then do it again, using these sketches as a guide. You'll see what I mean.

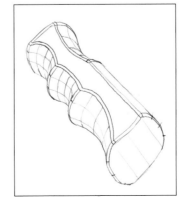

Sketching

I begin by sketching the minimum amount of edges that have to be there in order to achieve the proper curvature. Areas with no curvature get no lines at first. Then I try my best to tie together these necessary edges into a logical and clean mesh. The sketch took two minutes, the modeling would probably take about 10 minutes. Without the sketch it would probably take me much longer.

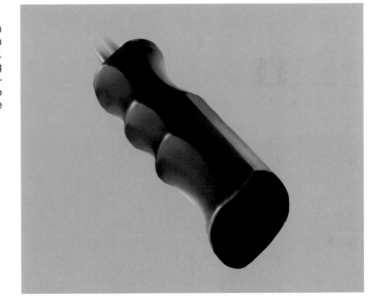

Modeling the head

Create a polygonal box. Scale it to fit your desired head. Increase divisions by expanding the Shape node in the Channel window, then enter 7-12-5 (or something close to it).

Highlight and delete faces

Highlight these faces, and delete them. Just make sure to leave a few edges between the eye-holes, and between them and the mouth, and at least one poly between them and the outer edge of the head.

Round off

Use Average Vertices to round off the cube. You'll see this loses volume, so Scale it back up to size again. This will be easier if you place your reference as a backdrop in the scene.

Jaw/chin

Select all the vertices of the jaw/chin, and create a 2 x 2 x 2 lattice on them. Scale it as shown. Use it on other parts of the face, whenever you have to move many vertices at once. Delete history to bake the change.

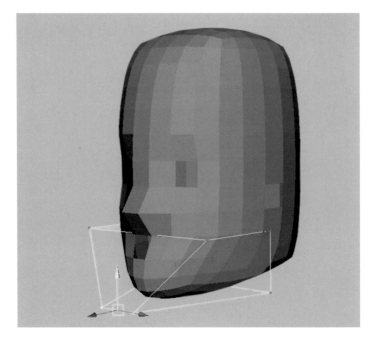

Shorten the neck

Select these edges and delete them, then delete any orphaned vertices. Do this either by selecting a whole bunch and pressing delete (which will only delete the right ones), or if you use the menu item Delete Edge the orphaned verts are deleted with it. The mesh comes down too far at the back of the neck, select these polygons and delete them too.

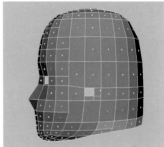

Shaping

Start shaping the model more and more into your reference head. I plan to create the ears separately, then weld them in later—it's easier that way. Ears are a pain to do, so many artists will simply cut the ears off an older model and re-use those.

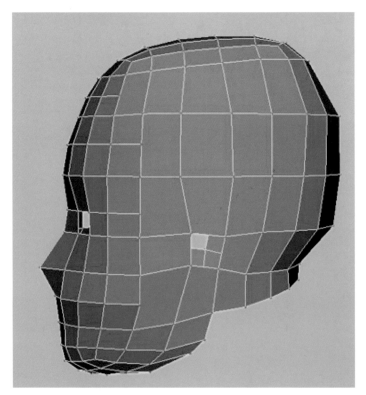

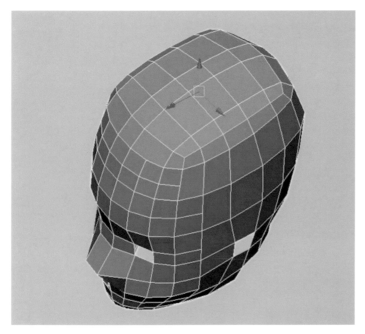

Round the head

Delete these edges (and the orphaned verts), round the top of the head by using Average. If you lose too much volume, expand by Translate along normal, or a deformer (lattice, sculpt deformer, soft mod).

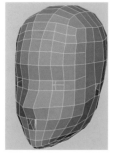
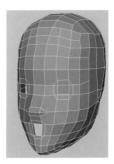
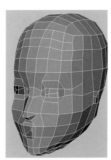

Split Polygon

Add new edges with the Split Polygon tool. Then move the new verts into place, something like what you see in these screengrabs.

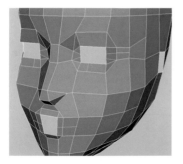
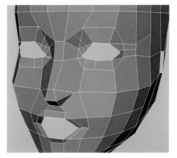

Add edges

Again, add these new edges and delete these highlighted old ones. Don't add too many new edges all at once, before you start deleting older ones. You'll become confused and start deleting the wrong ones, and lose too much volume.

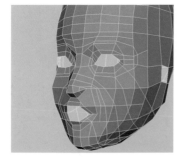
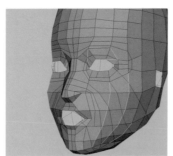

Grasping the idea

And again, add these new edges and delete these old ones. I'll show just a few more to clarify the principle. Which exact edges and steps don't matter, as long as you grasp the idea.

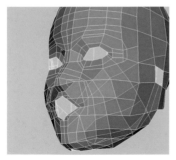
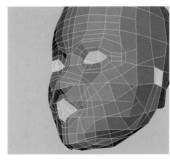

Getting the topology right

Add these edges then delete these. The idea is, it doesn't really matter how you start. Once you get to this stage if the topology isn't what you want, you simply change it. It's not hard, simply a matter of going slowly, in small steps.

Eyelids and mouth

Extrude the edges of the eyes twice, like this to create the proper rounded edge for the lids. Do the same for the mouth, like this.

Jump between Poly and SubD

After some more adding and deleting of edges I have this. During this later stage it's important to go back and forth often between the poly version and a SubD version. One quick and easy way is to put those two buttons on your shelf that converts to and from SubDs. Often you need to stay in SubD mode for a while to tweak, then convert the tweaked version back to polygons. Just make sure you convert back on the zero level.

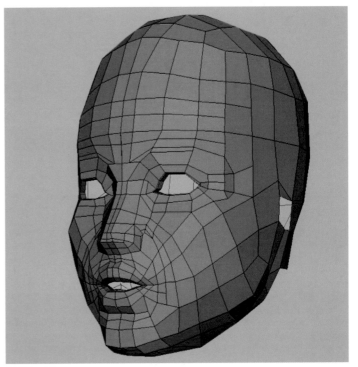

Done (for now)

Proxy on the left and smoothed on the right (still missing proper infraorbital folds).

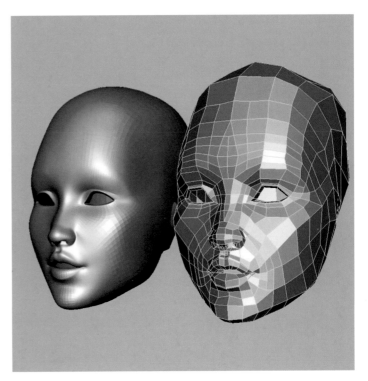

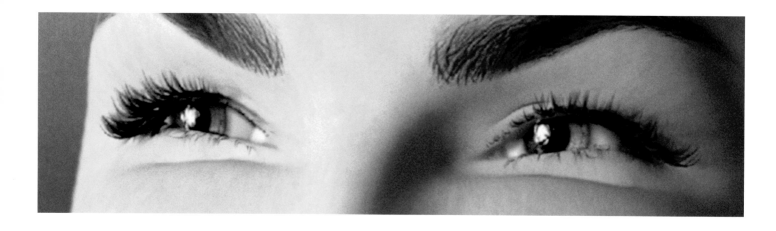

HUMAN MODELING: SKIN SHADING

Overview

Well, here we are again, back to searching for the Holy Grail. How to make truly realistic skin. It's like Zeno's paradox of Achilles and the tortoise, we keep getting closer, but in smaller steps. The following concepts are suitable for the medium to advanced 3D artist. I use Maya, but most of this is applicable to any 3D software, some of it even to 2D art.

Some terms I'll be using:
- HSV: Hue, Saturation and Value (Value is also known as Blackness in Photoshop).
- SSS: SubSurface Scattering (Translucency).
- Dayside: Where the key light hits.
- Terminator: The transitional zone.
- Nightside: Where the key light doesn't reach.

Observation

There are two main approaches to realism: one scientific; and the other more suitable for artists. The scientific way is to query what light-sources and material properties are there, and then trace the light's path, modeling its behavior as correctly as possible along the way. This is the method used by default by most 3D software, for the simple reason that programmers usually think more like scientists than artists. The other way is to start with the desired end result in mind, then work backwards, using any means to achieve it, no matter how strange or incorrect it may seem from the scientific point of view. As long as it works in the final image. Note that this desired end result doesn't always have to be realism either. This is usually called 'cheating', and is something I do very often—especially when the scientific method fails to produce convincing or aesthetic results on its own. In order to start with the end result clearly in mind, the artist needs traditional art training. Observation and observational skills are the key. Certainly, it may help to have some scientific knowledge about what's going on, but when using this second 'artistic' method, only to a certain point. We need simply to see, to study as precisely as possible, the HSV-variations across the surface in different kinds of light. Which point has what HSV? Particularly the relationship between different points. This is crucial, as small errors can make a big difference—especially certain kinds of error.

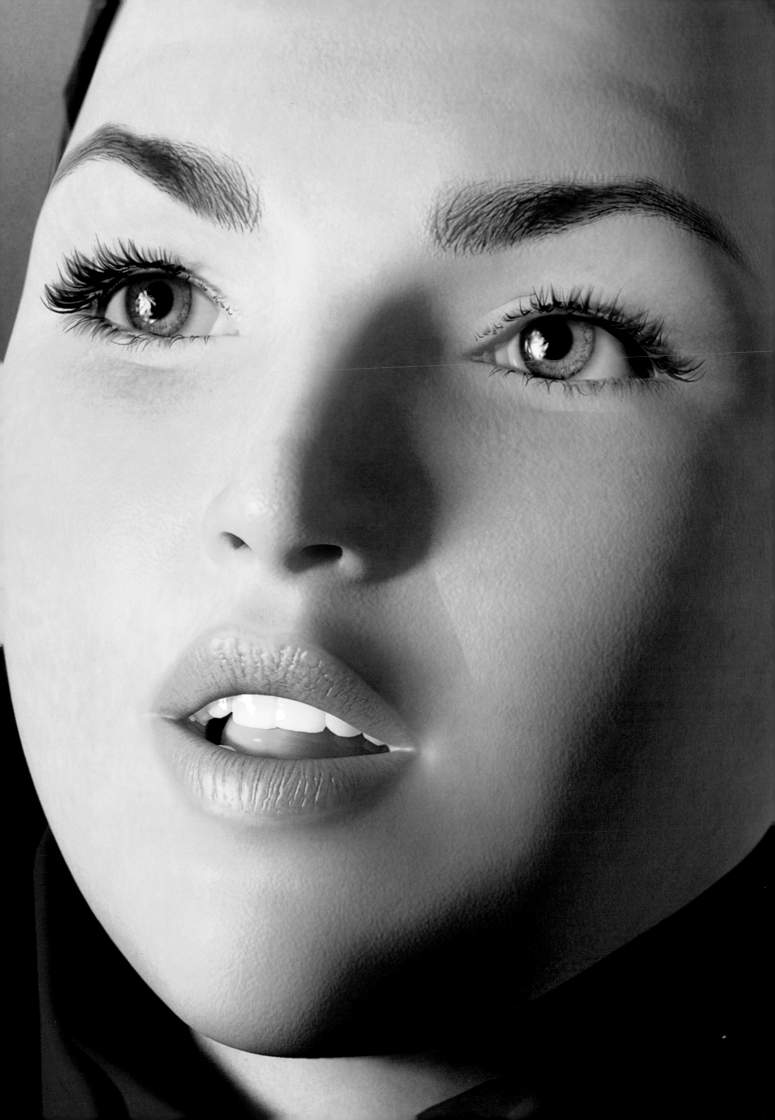

Default Phong

We'll start with a comparison of test renders of default Phong and default spotlight. On the left flat lighting, on the right glancing lighting.

Retouched

Next, an idealized version, retouched to look more like skin. I retouched this in Photoshop to get as close as possible to my desired end result. If we compare closely, or use a color-picker, we can see that almost every single pixel has a slightly different HSV number compared to the other image. How is the HSV differing? Note: the default Phong looks more skin-like with a: bluer, darker (and flatter) Dayside; and a redder Terminator. Also, comparing the right-hand images, we see that the glancing highlight needs to be wider and cooler. In fact, it should cover almost all of the dayside. Look closely and you'll see more differences, but these in essence are the main ones, stated as simply as possible.

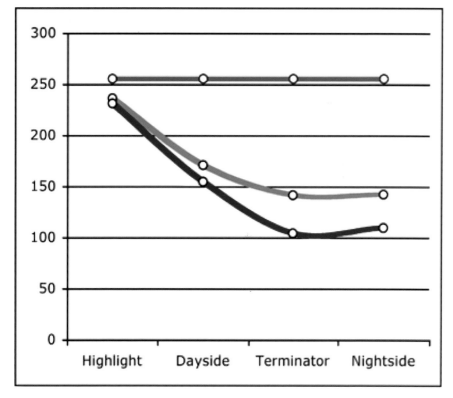

Table and graph

This table was created by Oliver Hahn. It can be a good tool to find out exactly what's wrong with our colors. Start by measuring the RGB at four points (Nightside, Terminator, Dayside and Highlight) on both your reference photograph and your rendering. Note: normally HSV is more intuitive but RGB is better here. Then, for easier comparison, so brightness doesn't matter, normalize one of the curves (here it's the red one). Put these values into a graph as shown. The normalized curve should be flat. Now you can clearly see where your curves are deviating from the reference. In this example, the highlight needs more blue and green (in effect becoming less yellow/orange and more white), and the Dayside needs less (becoming more reddish). You may need to do a few of these to balance any errors out.

Relative importance

The most important part of HSV to the human eye, generally speaking, is the Value component. But, when it comes to skin things are a little different. Hue and Saturation become more important, particularly their relationship (how they change along the surface, from Dayside to Terminator to Nightside). This is especially true if they're 180 degrees wrong. Let's look closer at Saturation, which varies the most.

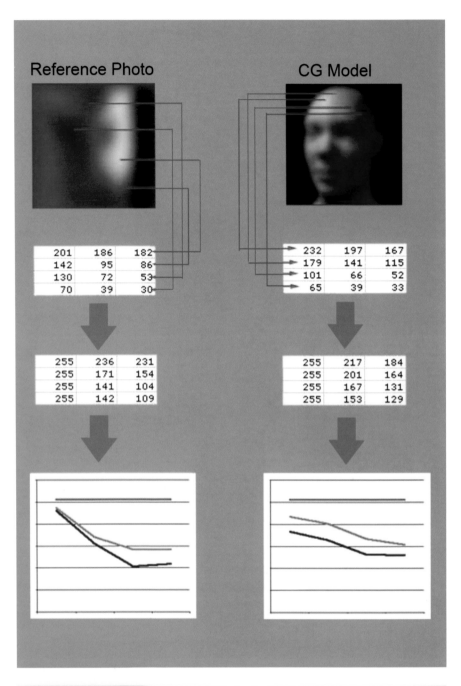

Saturation

The effect is easiest to see on large smooth areas of skin, lit by a single light in a dark environment. As you can see by the Saturation numbers, though it may not look that way at first to the unaided eye, the skin grows progressively less saturated from the darkest towards the brightest. This example is subtle. Other examples may show the effect much stronger. The Hue also changes from about 18 in the darkest part, to about 28 in the brightest—a definite cooling, and important to keep in mind.

Value

But skin still looks like skin when the H and S information is removed, and only the Value remains. The reason: H and S are more sensitive to mistakes. Value alone therefore stands a better chance to look 'right'.

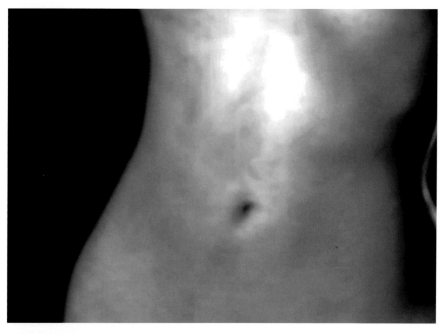

Suntan with polarizing filter

To demonstrate that Value isn't as sensitive to changes as H and S. Here's the same image with greatly varied Values. Depending on filters and processing, black & white photos of skin can look like this, and this is usually accepted without a second thought.

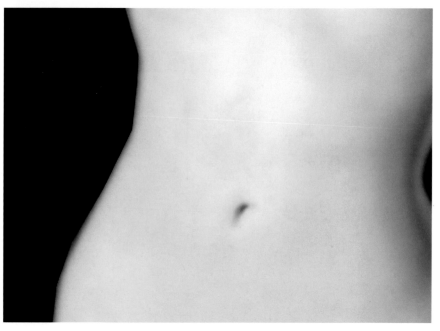

Pale skin, high key diffuse light

Black & white photos of skin can look like either of these images, and this is usually accepted without a second thought.

Lemon sherbet

But, add back the H and S, and vary them too much, and most people will not accept it as skin.

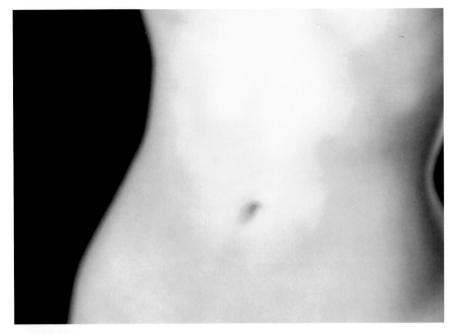

Marzipan

This means that we need to worry more about H and S shifts than V shifts, when we design skin shaders.

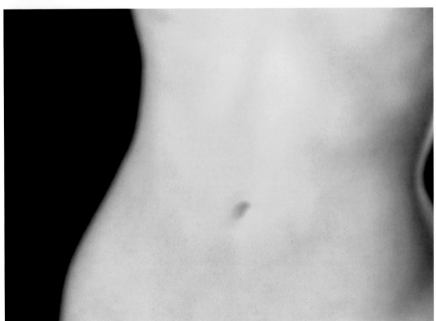

Colorizing

Another example of how getting the H and S relationships wrong can mess things up. This happens when black & white photos are colorized. Here we have the same H and S everywhere, and the effect seems quite wrong—unreal—similar to the previous default Phong example. The Hue of the highlights also change a little according to the light angle. The Hue of the flat highlight is almost always warmer than that of the glancing highlight—especially on skin and similar surfaces with a high fresnel tendency (stronger glancing reflectivity). This could be partly because there's bluish light coming from sides, top and back in most environments (the sky for instance). Certainly, we see this effect a lot in movies. For some reason cold lights work better as glancing lights, while the warm lights work better coming either from below, or as the key.

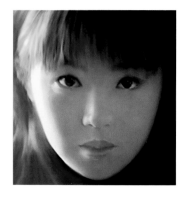
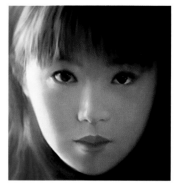

Hot/cold versus Cold/hot

This exaggerated comparison shows the effect—most people will usually find the example on the right more natural. Although the example on the left would have to be used if the lighting situation dictated it, say if there was a big fire behind the girl.

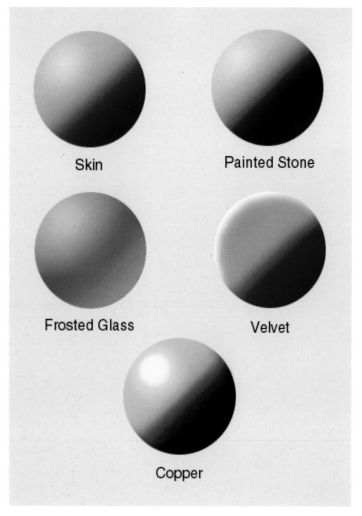

Skin

Painted Stone

Frosted Glass

Velvet

Copper

Shader comparison

A comparison of a few different materials with the same basic color scheme, quickly sketched in Photoshop. It's exaggerated to underline how simple yet important HSV relationships are. For instance, the highlight of copper is just a very saturated version of its base color. This is one of the most important factors that makes metal look metallic, and why we must counteract it in skin highlights. The stone has no translucency, so its Terminator is much less saturated than the skin.

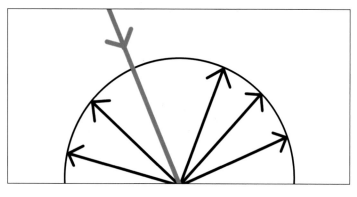

Faking Oren-Nayar on a Lambert

The Lambert shader is not the best choice for skin, nor for many other surfaces. It was originally a fast hack for all matte surfaces. It's a simple formula which just happens to look close enough most of the time, and it's really fast so has stuck around.

Intensity lobes

Oren-Nayar is better suited for most surfaces with any kind of noticeable random or nearly random microstructure. It's the closest approximation easily available to us today, and we don't really have that old speed excuse anymore. In the following images the red line indicates incoming light, and the hemispherical shape (lobe) indicates the strength of the resulting bounced light. We can see here that the Lambert response lobe is quite different from Oren-Nayar, especially at glancing light, where Oren-Nayer is much stronger around the edges.

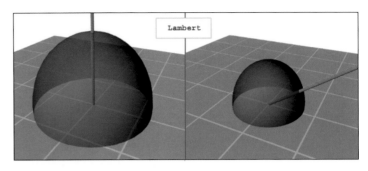

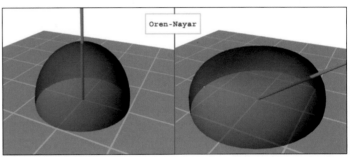

Make your own

Most apps have a default Oren-Nayar, though Maya does not so I've made my own hack. Create two Lamberts: one Clamp node and one Ramp node. It's easy to remember with a little mnemonic: LambertLambert ClampRamp. Connect them as they are here: the Out of the Lambert to the In of the Clamp, the Out of the Clamp to the Vcoord of the Ramp, the Out of the Ramp to whatever you like in the second Lambert. In this case it's the Diffuse. Assign this second Lambert to your surface. Make the ramp look roughly like the picture, I usually use Spike interpolation for this particular purpose.

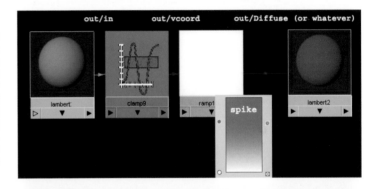

LambertLambert ClampRamp

Here's a default Lambert, an Oren-Nayar with Roughness 4, and a LambertLambert ClampRamp with the above nodes in the Diffuse channel. As you can see my Lambert looks quite similar to the Oren-Nayar.

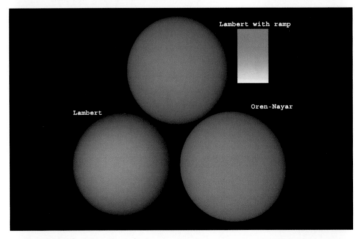

Taking it further

Now if you put another similar ramp (just copy it) in the Color channel as well of that Lambert, and use the colors you see here, you have the beginning of a skin shader. Note the reddish Terminator. This works with mental ray as well, and with any other shader such as Phong or Blinn (simply Lambert with added highlights). I know this little trick is a hack too, actually a hack on a hack. But it's more controllable by artists than either the Lambert or the Oren-Nayar. As an artist all I want is easy control (clear instant visual feedback) over the HSV of every pixel in my image, and this little ramp network can do that. There are other shaders in Maya such as the Ramp Shader that can do something similar, but again they are less flexible in some ways. By all means combine the Ramp Shader with this ramp network for even more control.

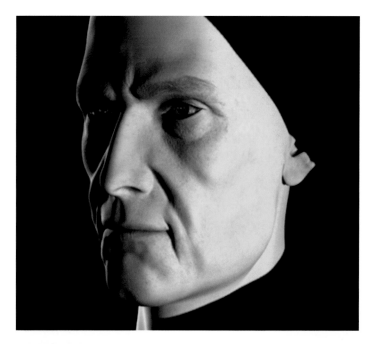

Faking translucency

This trick has almost become obsolete today, but I'll go through one way you can use the ramp network to fake translucency and get fairly close without using a true SubSurface Scattering shader. These can still be hard to control, and slower to render than this simple approach from way back in 1999. It's non-physical and therefore very fast (no raytracing needed). The following series of images can also be viewed as a tutorial in what makes skin look more like skin (two spotlights, rendered in Maya default). So, if you simply use a default Lambert with a skin-colored texture in the color channel, you end up with this. The Terminator is cyan-gray, the highlights orange—it looks metallic, especially if the light intensity goes up. So we need to make the Terminator warmer, sharper and brighter, and the Dayside cooler and a little darker.

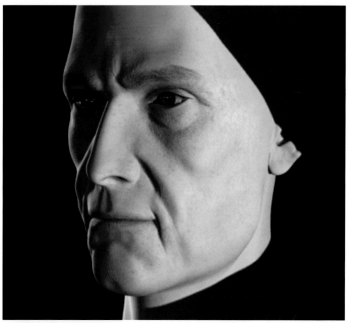

Red incandescence

You could try to redden the ambient or incandescence channels, then counteract that on the Dayside by making the color channel bluish (blue being opposite to orange). But, this doesn't work very well. When you get the Terminator as warm as it must be, the Nightside is too red, and the Dayside is very hard to balance to the correct Hue. So we need to find a way to limit this effect to only the Terminator. The best way is to make it dependent on the light-angle. Today we can do that in several ways: use the Ramp Shader; use one of the many cartoon-shaders available; or the network I've already detailed.

The first ramp

Here's the ramp used in the Color channel, just like before. If you want a texture in the Color channel, plug this into the Color Gain of that texture.

Second ramp

But this isn't enough. We still need to get that Terminator much more red. So go ahead and make another copy of the Lambert ClampRamp network and hook this one into the incandescent channel. It may be more convenient to layer that in a second transparent Lambert on top of your first skin-colored Lambert. For instance, I can use the same layer in many other layered shaders, and when I tweak one they all get tweaked. Now change the colors of the ramp to be black on the Dayside, dark redblack on the Terminator, and black (or very dark red-black) on the Nightside. The red is of course exaggerated here for clarity as you'll see if you try this. The highlights of skin are also very tricky. The specularity we get in shaders by default is very limited. If your software permits, it could be more realistic to use HDR image-based lighting, with diffuse reflections, and turn specularity off. Either way, the most important feature of highlights on skin is the fresnel effect—how they become stronger and wider at more glancing angles of light.

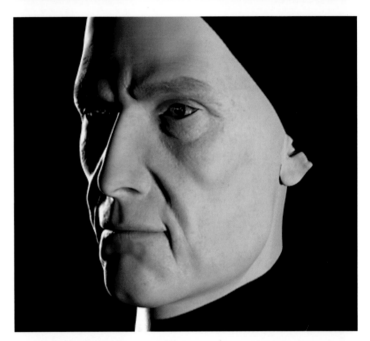

Highlights

Let's look closer at the GlanceSpec. You can see it at its strongest here on the left side of the face. It must become brighter and wider (and usually a little bluer) as the light becomes more and more glancing, finally flaring out into a long thin line in opposing light (to partially make up for the lack of real peach fuzz). The important thing is to map whatever parameters the Glancing Highlight shader has, for the size and color of the highlight so that it grows or shrinks depending on the angle of the incoming light. In Maya, you can use ramps to control this change with a good artist-friendly interface. Since I have another layer to handle the flatter angles, I make this glancing layer fade out to complete darkness before it hits noon (where the surface is perfectly perpendicular to our line of sight). In fact, both layers are always slightly bluish—any specularity on skin must be somewhat blue to counteract the default tendency towards yellow.

PhongE example

PhongE has three parameters to control the highlight. I mapped all three for a more pronounced effect. The SamplerInfo-node tells the Roughness, SpecColor and Size parameters to change depending on the incoming light. If the light is glancing, the Glancespec will show a very wide and bright (and slightly bluish) highlight; if the light is flat the Glancespec will show nothing. After the Ramp has been adjusted to what you feel works best, the only parameters that should be tweaked are the colors of the blend nodes, specifically the non-black ones. Leave the blacks the way they are (to fade the effect to zero at noon). When you test-render this shader, make sure you use two spotlights, one flat light and one glancing one. In fact, it's a good idea to move the lights around a lot during testing. Creating a short animation with rotating lights would be best.

TELLING A STORY: ONE LAST TIME

The story so far

'One Last Time' was created in 2003. Long after this and another painting with a similar subject was done, a complete story grew around it. The story was: Faery Queen Hannon decides to marry the goblin prince. The evening before her wedding she takes a nostalgic ride on her childhood swing (Image #1: 'The Blue Hour'). Her sister Wryed encounters the evil Dragon (Image #2, 'One Last Time'). Wryed makes a bargain for her life with the Dragon: she agrees to kill the Queen, and frame the husband for it (Image #3, 'Jealousy', p.73).

Inspiration

The idea for this 'One Last Time' came to me in a moment of boredom, as my mind started wandering. I was sitting, waiting for a friend to finish work, in an icy-cold empty and quiet movie theater. My friend was working on something technical in the back, with the projector. The initial inspiration was 'kinetic'— I sat low, hunched up, with my knees on the seat in front, and my arms crossed, because of the cold. Malaysia is usually quite hot, so I only wore jeans and t-shirt, and I hadn't counted on having to wait so long. After a while, my own pose sparked an idea, as I started daydreaming.

Posing

Everything seemed to grow out of the pose. It seemed to demand a certain type of character, a certain situation, a certain point of view, and a certain lighting. Isolated, with knees flat on the ground, it's a pose of vulnerability, fright, and submission. So I needed a naked fragile pretty character, reacting to some threat— a monster? The pose is really best seen straight from the side with strong directional lighting, either from the front or top.

Sketching

I jumped up and got hold of a piece of paper and a ball-point pen; when ideas strike I try to get them on paper ASAP. If I don't, I know I will forget them. Sometimes I will put a sketch away for months or years, before I use it; this one I felt had extra potential and I scanned it as soon as I got back to the office. My original purpose was always to make it 3D. I simply got carried away during the sketching stage, and took it all the way to finished in 2D. But, the point was to submit the image to a contest that would only accept 3D works (Animago and 3dFestival). In the end, I'm sure having such a finished 2D piece for reference was a big help.

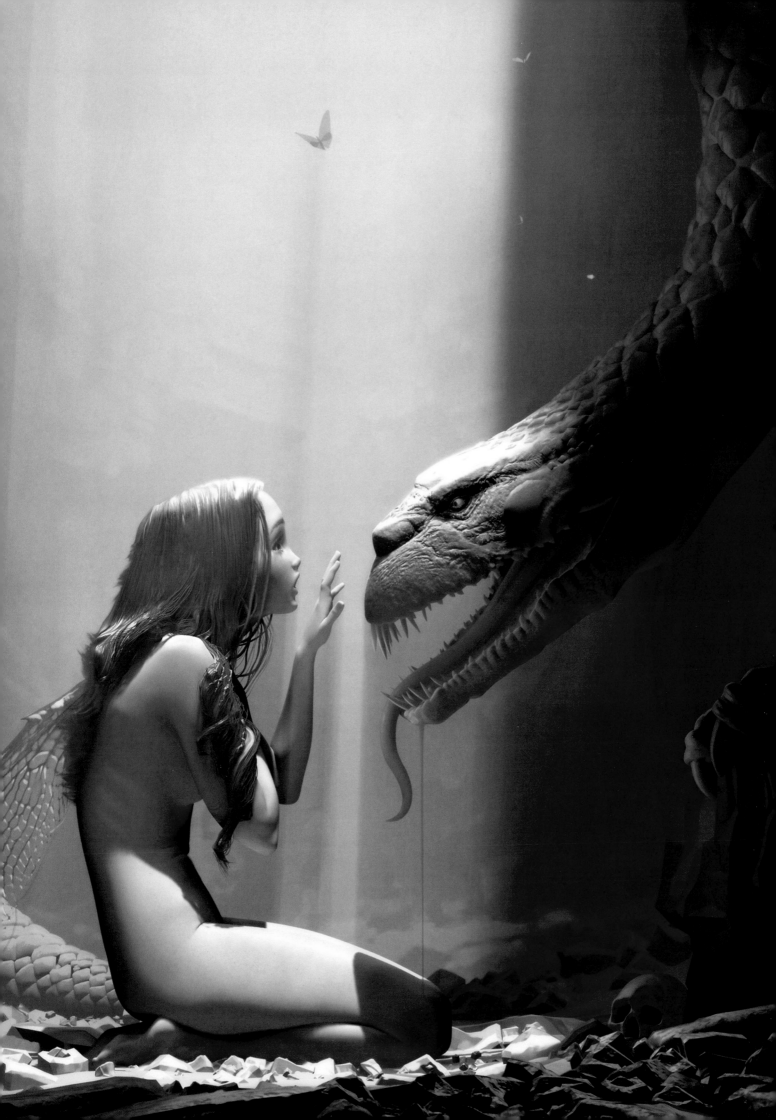

The sketch

I opened the sketch in Photoshop, used Cut & Paste to move pieces around, added another layer, and started to paint over it with my Wacom Intuos2 tablet. As you can see: the original monster was more humanoid looking; the girl had no wings and her hands were clasped; and there was a car tire in the background. I was thinking something Post-Apocalyptic at this stage. It's a really bad drawing, but remember, its only purpose is to document the initial vision.

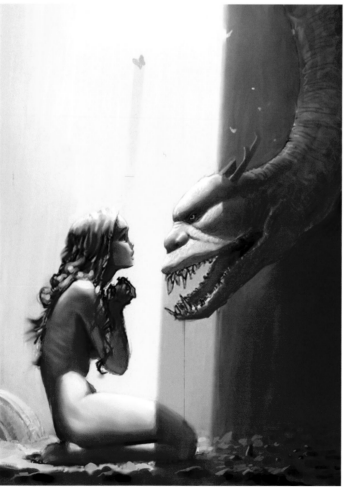

The painting

I started filling in colors over the sketch. By this time I knew I wanted strong midday sun coming straight down, and a strong translucent effect happening on her skin. This gave me the dual color scheme. Here, it started to look a bit like a Chinese dragon. I also added some butterflies, partly as a symbol and partly because the composition needed something there.

Help from CGTalk members

I posted a WIP on internet art forums, like Sijun.com and CGTalk.com. I received a lot of helpful criticisms and comments. Henrik Holmberg suggested that I make the monster less human, more vicious and generally cooler-looking. His suggestions are reflected in the final 2D painting.

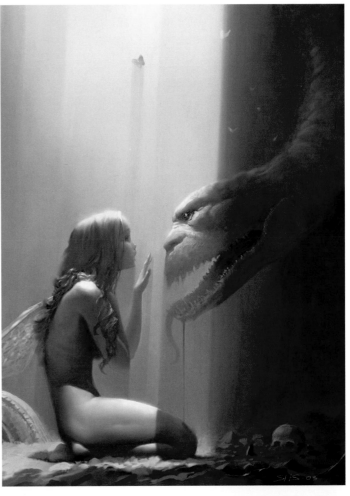

The final 2D painting

I changed the tire into the dragon's tail (so big he's wrapped around the whole cave). There are also wings on the girl now and a skull on the ground, leaving any hint of sci-fi behind in favor of full fantasy. The snake's S-shaped tongue echoes the shapes in her hair. Finally, a touch of Sharpen over it all. This all took about one week, part-time.

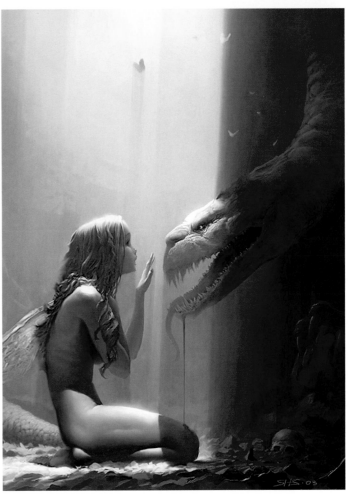

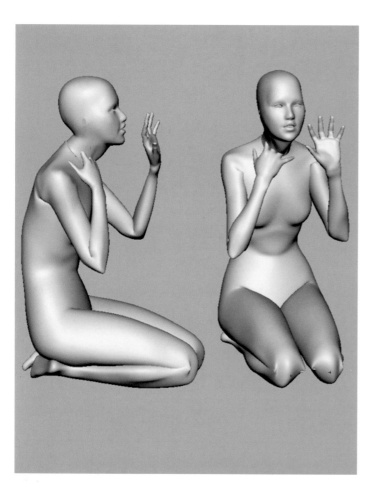

The modeling

I used the 2D image as a backdrop to get the 3D scene as close as possible. I used Maya, and SubDs for almost everything in the scene. I wanted to start closer to 'scratch' than normal on this one. As you can see, it lacked all detail and had very bad deformations. This was right after bending the joints into position. Then I deleted the skeleton and started the real modeling work.

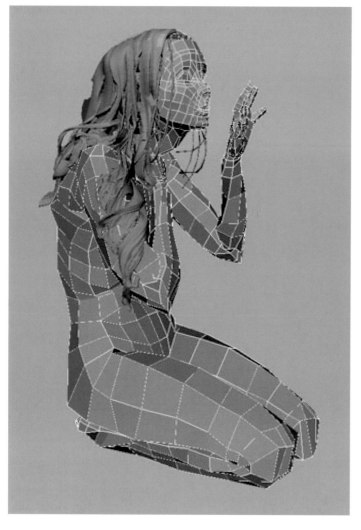

The final wireframe

Jumping ahead for a moment, to the end of roughly two weeks of modeling. I also completed a render of the composition with the character from this angle which can be seen on p.109.

First test render

I knew we wouldn't see her neck at the end, so I didn't worry about the seam, and her fingers penetrating it. I used a spotlight for the main light, and another red spotlight from below for the bounce light. Since this was a couple of years ago, my only option at the time was using the Maya default renderer. I used Depth mapping, not raytracing.

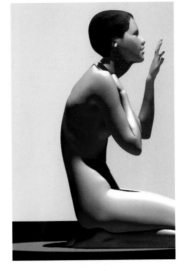
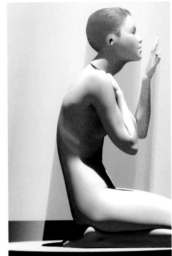

First test with fog

The idea to have fog in the image came early— a natural choice given the lighting situation. I kept the shadow-samples very low res during test rendering. A simple ramp in the background, just to get close in colors, makes comparisons between original and copy easier.

First hair test

This hair was just a left-over I was trying out from another image I'd created ('The Stool', p.74). It started as Nurbs tubes, which I then converted to SubD. It wasn't working, so I scrapped it. Here, I also added a red light hitting the elbow.

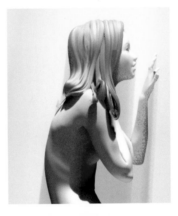
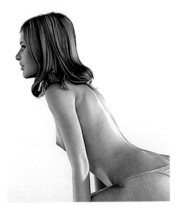

Starting the monster

I started modeling the monster. You can see Level 0 of the Subdivided surface, without the hierarchical detail which was added later.

Placed in scene

Using the image in the background, and the shadow falling on her leg, to position it. The red ground-light has been strengthened.

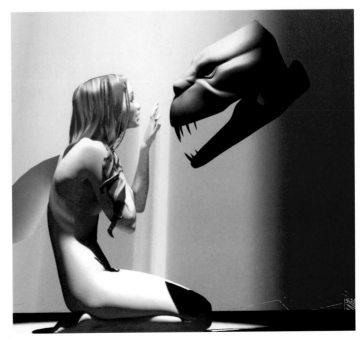

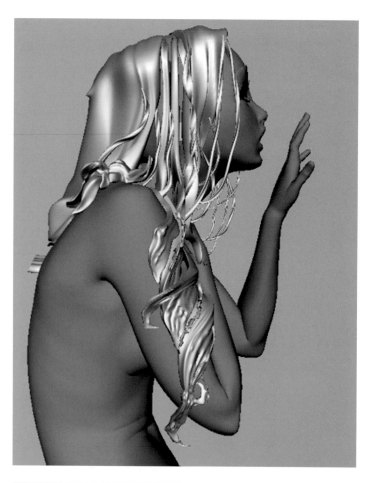

The finished hair

This hair falling on the arm was shaped into a rounded-corner S shape, sort of like a candle flame. I copied this basic shape five or six times down the arm, and tweaked them further. Most of the hair is SubD, but there are some polygonal pieces there too (the stringy, spirally bits).

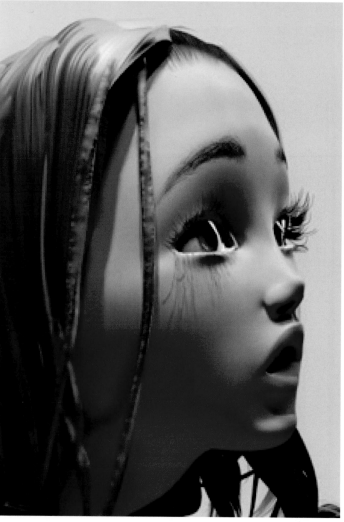

Refining the face

Here, you can see I'm progressively making the character's eyes bigger and her lower face smaller, to match the 2D image.

Further along

I finished the hair and then added the monster's body, drool, and made my first attempt at the wing texture. I then opted for a more detailed wing texture, adding more lights (red lights hitting the monster), a bump map on monster's face, and the end of the monster's tail.

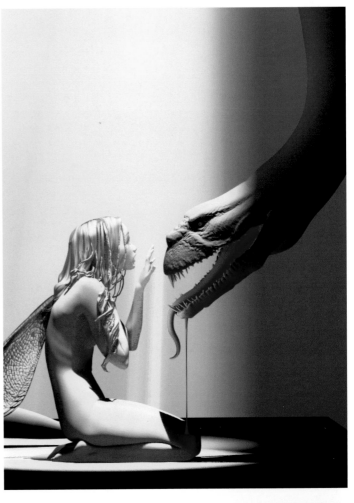

The 'misty' background image

The haze in the air between the girl and the monster's tail is a semi-transparent bluish plane, taken from the original painted version.

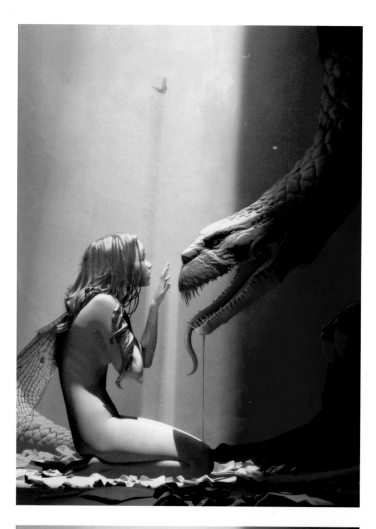

Extra details

I added layered background planes along with scales on the monster's body, and butterflies. I also started to add rocks (polygonal pieces, originally cubes with all hard edges). The 'feathery' hair bits are sprites, or transparency-mapped planes. The monster's claws aren't finished, and I still have the cranium left to do. The light is still too blue on the tops of both characters, and the girl needs to have a brighter highlight on the very top. I've also added even more lights (lightening the foreground to show up the rocks). The artifacts in the fog-light are due to low resolution, and I wasn't rendering very large—still it took over 20 minutes to render every test at this stage!

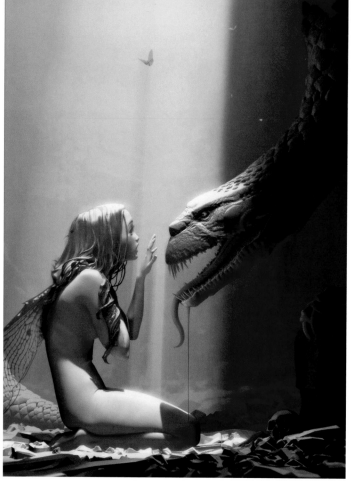

Almost done

I modeled the skull in the foreground in about an hour or so, with no need for much detail as it's dark in that corner. Inside the skull is a plain sphere shaded black to make the eye-holes stand out more. My reference was of a pre-historic skull I found on the Internet. I now have a total of 19 lights, 18 spotlights and one ambient. I added a little glow, and a slight blur in post. Almost done now, but for some minor tweaks like moving the skull down, add some more fluffy hair at her back. I also make the big rock stand out a little more heading into the most time-consuming and slow stage of the process. I was getting very tired of the image by this stage.

Finally finished

Here I add more local detail on individual rocks, make the skull less blue, and add many other minor details. The 3D version took two weeks of near full-time work.

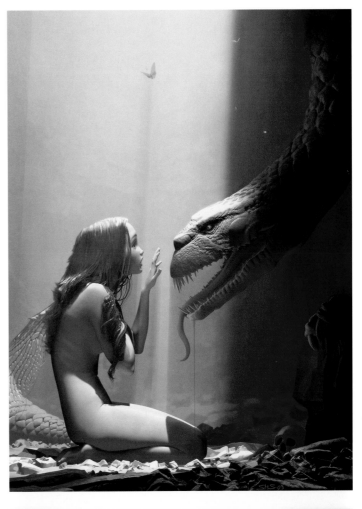

A different point of view

A view from another angle shows you how it's built up like a stage show, right down to the backdrops. Very little effort has been put into anything not visible in the final image. Of course, the eyelines in this angle are off, because I wanted to match the lighting in the painting, so the monster's head is moved to her right in order to cast a shadow on her leg. Later, for the final high res render for the book cover of EXPOSÉ 1 I did create a version with a little bit of Joe Alter's Shave & Haircut on some parts of her hair.

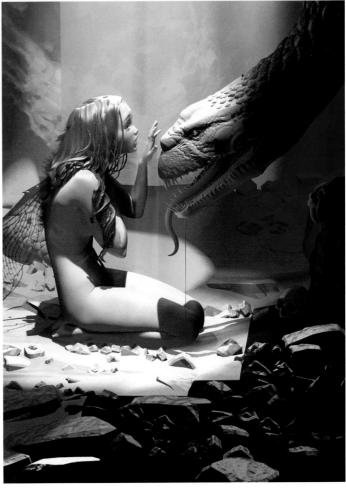

Beauty Monica
3ds Max, VRay, Photoshop
Mihai Anghelescu,
ROMANIA
[left]

Steven Stahlberg
She really is a beauty. The artist has achieved wonderful skin, a soulful look in the eyes, some very lovely hair, subtle wrinkles and realistic lips; taken together it all makes her seem very much alive.

Aviator's wife
3ds Max, Photoshop, Brazil r/s
Alessandro Baldasseroni,
ITALY
[right]

Steven Stahlberg
This interesting character has a very creative design of accessories and hairstyle, some excellent texturing (this artist is one of the best texturers I've seen), and flawless modeling.

Pig and Elephant
Maya
Michael Sormann,
AUSTRIA
[above]

Steven Stahlberg
Very funny and unique, both of them full of their own specific character. They have attitude, personality and life. And as if that's not enough, it's a nice rendering too.

Brusher Bailey
Maya, Photoshop
Jason Baldwin,
Reality Engineering
USA
[left]

Steven Stahlberg
Simple but great. This is a very cool and self-assured dude. A fun and instantly loveable character, perfect for a leading man in a comedy.

Track Day
3ds Max, Photoshop
Olli Sorjonen,
FINLAND
[right]

Steven Stahlberg
Here's some very careful and loving attention to detail; everything is very nicely executed: legs, dress, accessories, bike, textures, lighting and background.

Culturist
3ds Max, ZBrush, Photoshop
Pawel Libiszewski,
POLAND
[above left]

Steven Stahlberg
This artist has very good anatomical knowledge, and the modeling skills to translate that into a very realistic mesh. The black & white makes a refreshing change of pace.

Game Art: Marine
3ds Max, Photoshop
Tim Appleby,
UNITED KINGDOM
[left]

Steven Stahlberg
One of the best game characters I've ever seen. Clever use of UVs allows optimal texture resolution. But this would be impressive even if it was a high resolution character.

Imperial Glory
3ds Max, Photoshop
**Ivan de Andres Gonzalez &
Almudena Soria**,
SPAIN
[above]

Steven Stahlberg
Here is a great face, with a perfect expression. Pose, lighting and modeling is extraordinary and I love those cloth wrinkles. I can smell the gunpowder.

Sir Nigel
Animation:Master, Photoshop
Jim Talbot,
USA
[right]

Steven Stahlberg
Marvelous! The typical old man's skin, the face, the pose and expression all perfectly captured, with just a hint of interesting exaggeration. This guy really seems alive.

Nymph
3ds Max, Brazil r/s
Dani Garcia,
SPAIN
[left]

Steven Stahlberg
A wonderful sensual dream image, but what I like most is the depiction of the wet cloth. A very clever and skilled combination of modeling and texturing.

Dowager
3ds Max
Jiri Adamec,
CZECH REPUBLIC
[right]

Steven Stahlberg
Simple, pure, exquisite. The light, the modeling, the skin, the lips, the lace. Again, this character seems alive. A fleeting moment of life frozen forever. A work of art.

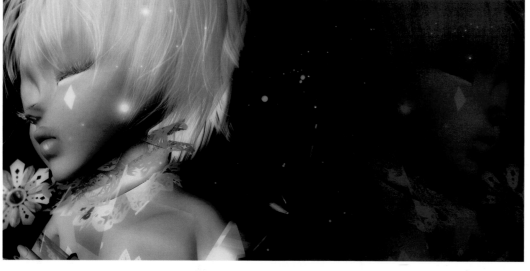

Fairy Tale of the Time
Maya, Photoshop
Ji-Young Choi, TwoDol,
KOREA
[left]

Steven Stahlberg
This is simply a very cool, very beautiful and highly evocative image, like a still from some movie—a dream-sequence perhaps. Really nice hair and face.

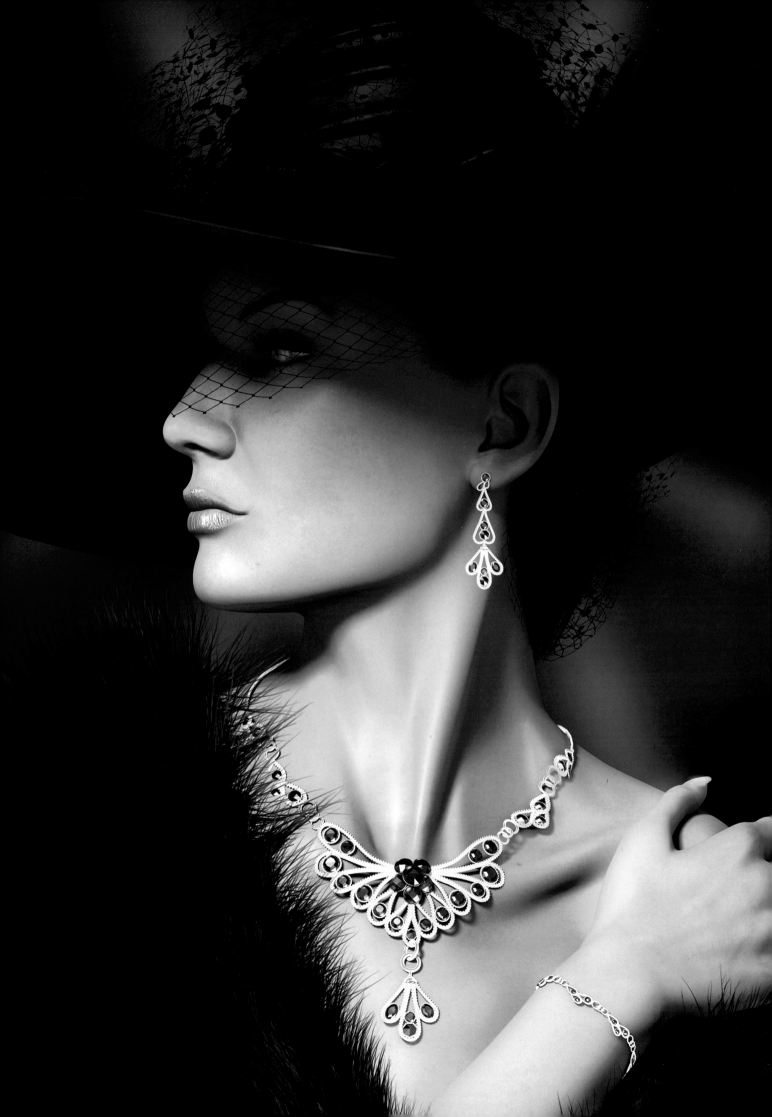

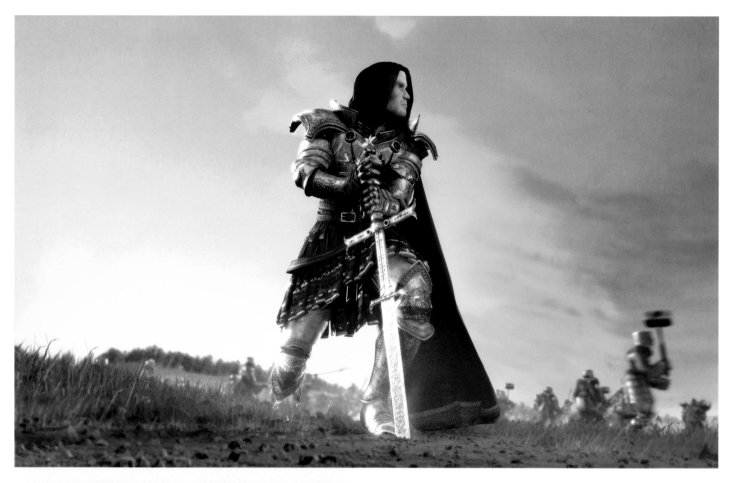

Prince Thrommel
3ds Max, VRay, Photoshop
Michael Tigar, Tigar Hare Studios,
USA
[above]

Steven Stahlberg
Smashing armor, weapons and clothing. Again, the feeling of aliveness, engendered by the prince's pose, expression, realistic environment, and the motion-blurred soldiers in the background.

Genghis Khan
Maya, Photoshop
Kampol Leelaporn,
THAILAND
[left]

Steven Stahlberg
This is a very skilfully created model. It's also well designed; it looks authentic without being too close to boring reality.

2nd Phoenix
Maya, Photoshop, Flash
Thitipong 'Pao' Jitmakusol,
USA
[right]

Steven Stahlberg
Very realistic, wonderful outfit. The background is absolutely lovely, and fits perfectly. I like that she's not a 'super-babe', but more a real woman of flesh and blood.

The Rebel Demon
3ds Max, finalRender, Photoshop
Marco Lazzarini,
ITALY
[above]

Steven Stahlberg
I just love the subtle veins on his bicep, the color textured ones, and the bump mapped one. The strap, his hair, the textures, all show inspiring attention to detail.

Blue Orange
3ds Max, Painter
Olivier Ponsonnet,
FRANCE
[left]

Steven Stahlberg
Olivier shows an impeccable eye for beauty—a big talent for 3D art. His signature: that touch of strange that sets your mind wondering.

Cassidy Sharp
Maya, Photoshop
Farzad Varahramyan (Art Director),
High Moon Studios,
USA
[right]

Steven Stahlberg
A very cool and classy comic-style female heroine. The artist was obviously enjoying himself on this one. Dressed to kill, literally. Miaowrr!

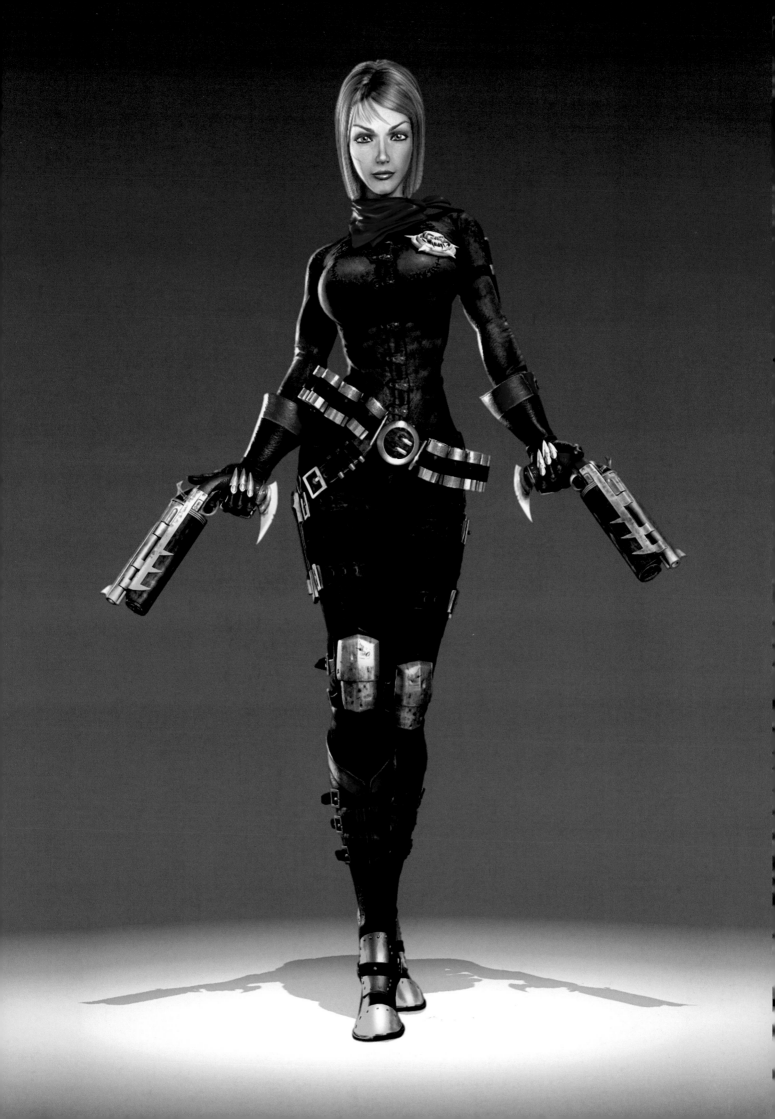

Iris la Rouge
3ds Max, Gimp
Thibaut Claeys, NarvalArt,
BELGIUM
[above]

Steven Stahlberg
This is a character whose name and clothing suggests a real and unique background story, as if she's straight from some movie or game. She's also a very and strikingly beautiful lady.

The Orc
SoftimageIXSI, Photoshop
Iacopo Di Luigi, Milestone,
ITALY
[right]

Steven Stahlberg
Astonishing! Yet again we see how impeccable attention to detail, technical skill and artistic talent can give that elusive illusion of life. A character of feature film quality!

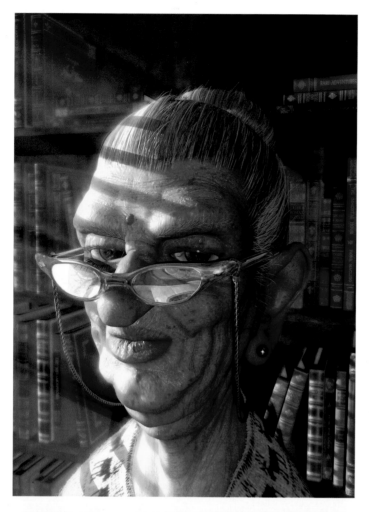

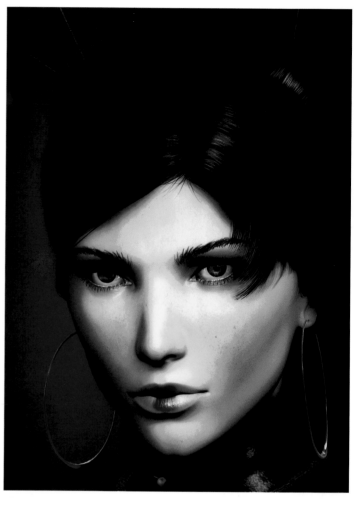

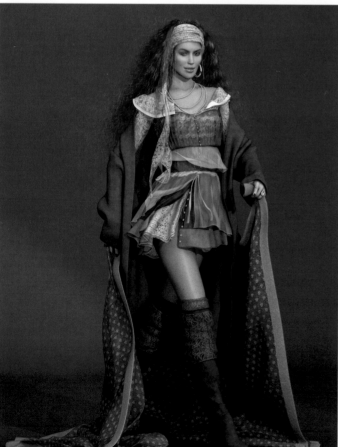

Ms. CrabApple
3ds Max
Tony Mesiatowsky,
CANADA
[above left]

Steven Stahlberg

It's very hard to create older people in 3D; it's also very hard to caricature features like this. This one is very well done; great skin, texture and lighting.

Laura
3ds Max
Georges Walser,
Client: UN Commercial
SWITZERLAND
[left]

Steven Stahlberg

Mr. Walser is one of the best cloth artists around. The richness and realism, particularly of the cloak touching the ground, is simply amazing. And it certainly doesn't hurt that his character is a beauty in her own right.

Jade
3ds Max
Olivier Ponsonnet,
FRANCE
[above]

Steven Stahlberg

Olivier again, this time less strange but no less beautiful—and still that element of the 'unusual'. The yellow-green light, the lipstick, those huge impractical earrings. Who is she?

Girl in Trouble
3ds Max, Brazil r/s, Photoshop
Felician Lepadatu,
ROMANIA
[right]

Steven Stahlberg

A very beautiful character, with a very real expression on her face. Even without the title we can sense that something is wrong. Cue the suspenseful music. Evocative and thrilling.

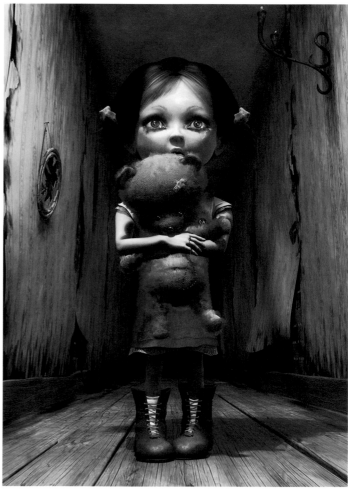

Sophia
3ds Max, Photoshop, mental ray
Xavier Le Dantec,
FRANCE
[above left]

Steven Stahlberg
I love this. Sophia reminds me of Moebius' work in some ways. Extremely beautiful and well-modeled character, great skin shader and lighting, and an elegant solution to the problem of 3D hair.

Beauty Bis
3ds Max
Olivier Ponsonnet,
FRANCE
[left]

Steven Stahlberg
Now back to safer, more peaceful subjects. This is one of the best 'cybergirl' characters I've ever seen; just look at the perfection of the neck and clavicles. Not to mention the hair, lips and eyes.

Fear
3ds Max
Olivier Ponsonnet,
FRANCE
[above]

Steven Stahlberg
Ponsonnet again. This one is loaded with emotion, with terror, primal panic and loads of empathy with the excellent character—it creeps me out! Very well done.

Merlad_blord
ZBrush, messiah:Studio, Photoshop
Timur "Taron" Baysal,
USA
[right]

Steven Stahlberg
Taron is one of my all-time favorite 3D artists. If you're not familiar with his work browse his website. He can work faster than anyone else too. When it comes to creatures and characters full of character, he's the man.

PASCAL BLANCHÉ

Pascal Blanché is Art Director at one of the world's biggest gaming companies, Ubisoft Canada based in Montreal. His most recent game project was 'Myst IV: Revelation', the fourth in the cult adventure game series. Pascal started on the path towards a career in art/design for games at the Art School of Luminy, Marseille. Following art school, he freelanced for TILT magazine, an early video games magazine and then worked in modeling, concept art, texturing, lighting and animation for various French gaming companies.

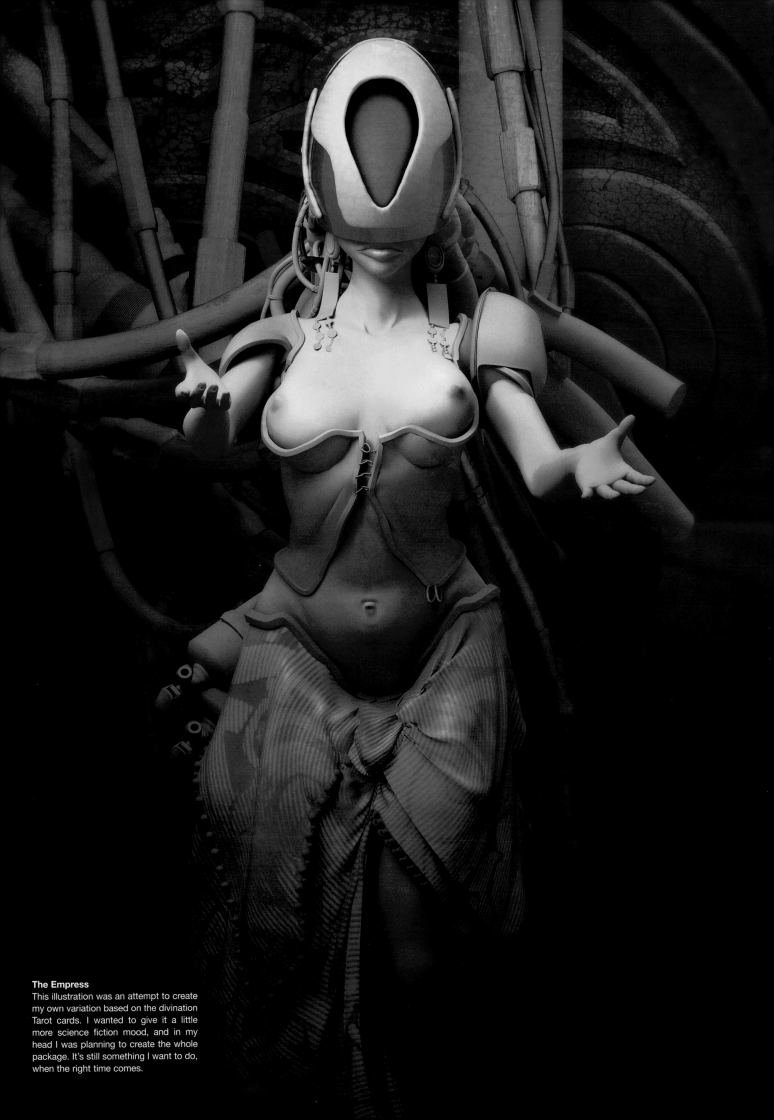

The Empress
This illustration was an attempt to create my own variation based on the divination Tarot cards. I wanted to give it a little more science fiction mood, and in my head I was planning to create the whole package. It's still something I want to do, when the right time comes.

CONTENTS

Background

As far back as I can remember, I always had a pen in my hand. In every classroom I'd be the guy in the back, drawing monsters on the corner of a table. School never interested me that much. I think my teachers knew that I would find something that would fire my imagination. I remember a mathematics teacher who let me graduate despite really bad results and telling my mother: "He likes seashells, not mathematics. I can't fight that!" My father was, and is still, addicted to black and white photography. I remember weekends in red rooms, watching all those magic white papers turn into portraits, landscapes, and insect close-ups. I was five years old, maybe less, but I think that I was somehow more receptive to framing and composition because of this early experience. Later, after my parents separated, we moved from city to city, never staying more than a few years in the same place.

I was a teenager, and not really talkative, so I spent all my free time in libraries, comic shops or movie theaters watching 'The Empire Strikes Back' or 'Raiders of the Lost Ark' for the tenth time. During this period, I was also addicted to anything related to stop motion animation. I was watching Ray Harryhausen's movies at two in the morning and making puppets from socks and ping pong balls. A big lesson I learned from my mother was that money never falls from the sky and that you have to work hard if you want to find your rightful place. I didn't have a clue about what I wanted to do with my life except the fact that I loved drawing.

Art school

I started my first nude drawing lessons at 16 years old. I had a pretty good background in photography and drawing when I applied to the Art School of Marseille (South of France).

I thought that Art school was about preparing for a job in the graphics industry, and that after graduating I would have plenty of opportunities. I was wrong! It took me a lot of time to understand the point of arguing about a stain on a white canvas. A classic education gives you a wide range of knowledge, but it doesn't teach you to think for yourself. I found myself in front people who expected me to talk about my drawings as if I already had fifty years of personal experience, and as if every act of creation had a deep process behind. It was kind of disturbing at first, but also interesting. The downside of this process was that you could keep working on the same little spot on the wall for the next five years, and nobody would interfere. I was starting to worry about the life after art school, and I decided with some other friends to use the expensive tools of the school to our advantage.

The group's main goal was experimentation. This was the start of a really instructive five years. We created tunnel effects with the video editing table; created lots of experiments around subjects like loop cycles, reel fake footage, visuals using sounds as guidelines and sounds creating images. We even made little shorts with clay characters using mixed medias video/CG.

Going CG

In 1992, I began to get more interest for my computer-generated images. I went to the Imagina expositions between 1992 and 1995 as a reporter for our art school, and they had a great impact on my imagination. I realised at that point that the computer provided all the tools needed to create anything I could visualize. My first computer was an Amiga 500, and I taught myself to use Deluxe Paint, Caligari and Real3D. I created my first animation in Deluxe Paint. It was 60 frames long with four colors (all that my poor 512K of RAM could take) representing a loop animation of zooming on a little eggman on a planet. When the camera reached his head, his head became a planet and so on.

Firsts steps

In my last year of art school, I started to send CG images to the galleries of video game magazines. In 1993, I managed to get my first job at Tilt magazine, the biggest French game magazine at the time. My job was not really creative—helping the photogtapher to frame the screens for shots. I managed in time to get some of my drawings published, most of them caricatures of the team. Then came an opportunity that I had to jump at.

The official illustrator was out for holidays, the magazine was doing its first publication in full digital process and they needed a full page illustration for their game test. I said: "I can do that". They asked me if I knew how to use a Mac? "Yup!" Photoshop? "Yup!", and I got the green light. Of course, it was my first illustration in Photoshop, and the one button mouse was a nightmare to use, but it was worth it. I managed to get more illustration work after that, and even my own column about CG drawings.

From clay to 3D

After a while, Tilt magazine closed its doors, and I found my first assignment in the video game industry in a little company called Virtual xperience. I worked with five other guys on a video game for three years. I started creating characters in clay, then used a digital camera to take a picture of each pose and reproduce the whole animation with an Amiga 2000. The result was not too bad considering the tools we had, but a warm summer literally melted our work. We remade the whole visual in 3D with 3d studio 4 (the DOS version of the actual 3ds max we know). I had to teach myself every aspect of the software, from modeling to texturing, then lighting and animation. After two years of hard work the game, 'Atripolis 2097' was nearly done, with almost 50 minutes of cinematics, a whole city entirely modeled and its little citizens running around everywhere. The boss came to see us and simply said: "Sorry guys, the distributors didn't buy the game. I'm out of money. It's over."

Learning curve

I continued to practice my 3D skills at another company called Katarsys Studios (four employees in a cellar in Paris). It specialized in cinematics for video games, where I improved my work in different fields such as editing, animation, lighting and modeling, of course. One of the great moments for the team was when we managed to get a booth at Imagina in 1996. Professionals of the industry were coming to watch our demo over and over on our little screens, asking: "Is this made with Silicon Graphics? Softimage?". We were happy to tell them: "Nope, PC and 3d studio, all the way".

Stupid invaders

I worked two years at Xilam Studios on an adaptation of a French kid's cartoon called 'Home to rent'. I was in charge of modelling the characters and lead cinematics. Thomas Szabo, the director and scriptwriter of the project was also one of the scenarists of the series. He taught me a lot including: framing and storyboarding; how to place a camera; and how to tell a story in a few shots. He was always coming in on Monday morning with a few strips, and would act out the whole cinematic in front of me: "And then he scratches the match and the rocket goes 'fiiiuwww' in the fireplace, and then you have this quiet shot of the stork on the roof and boom! Ha ha, excellent! Can you do that for Friday?" The game was full of gigantic locations and explosions. That's where I started to learn how to cheat in visuals. There was no time for full-time modelling. I was animating half the time and modelling what I had in frame, mixing up little recipes in After Effects to save time.

My best sequence was an escape of five alien characters from a secret base in the desert aboard a gigantic space rocket (the hatch was a mountain that was slowly splitting in two). Then a final laser-gun fight on the rocket's deck and finally the total destruction of the Earth and moon. Three weeks of work, lots of coffee, and my first game released!

Kaena: The Prophecy

In 2000, I decided to move to Canada with my wife Barbara. I worked for one year as an animator, then lead animator on the first French/Canadian full-CG movie—Kaena: The Prophecy (distributed by Sony). It was the first time that a production of this size was using only standard software and hardware (3ds max and PC towers). It was also the first time I had such a specialized assignment—animation. The level of complexity and quality was higher than anything in my past experiences, and it was a really tough job. I remember animating a scene with 10 humanoid characters moving at the same time and interacting with each other—a real nightmare! The final result for the movie was ok. It was sad when the production ended because with the experience we had, the second movie would have been really interesting.

Myst IV Revelation

I started work at Ubisoft in late 2001, as a character designer for 'Myst IV: Revelation', and one year later as Art director on the same project. The visual expectations were high, and I think that the team did a really good job. The game had a huge density of architectural environments, CG wildlife, live-video actors, rides, natural

Mars: An illustration I created in 1998, after reading the Martian Chronicles book—really inspiring!

landscapes, and visual effects like wind, water, and dust. As Art Director on the project my responsibilities were to maintain the visual quality and linearity during the whole two years of production. The Ubisoft Montreal studio had more experience in real-time scenes than pre-calculated scenes, so I had to first figure out with the help of the technical directors how to manage the amount of data and find visual solutions to help artists to achieve great results in a short time. The hard thing at first was to restrain myself and not jump in to make changes myself if I didn't like a result. I had to learn how to delegate and communicate my vision. Still, I managed to make most of the creatures from A to Z and some cinematics too.

Working in the game industry

I've worked in the game field for 11 years, and I still smile in the morning when I go to work. True, there are crunch times, frustrations when you don't manage to get what you want, conflict with people that don't understand your needs and preoccupations, or when you don't understand their concerns. But it's part of the job. Being in games is really about working with people. I still learn from my co-workers and each production has its own energy. I worked in tiny companies with five employees with all of the creative freedom in the world, but not knowing whether I'd get paid the next month. I now work in one of the biggest development studios in the world with: around 1,300 employees in the same building and still counting; three AAA games a year; a

huge structure and pipelines; and short deadlines. But, the work at the end of the day is all about passion. If you are a young CG artist or student willing to apply as a character modeller, the best advice is to practice traditional skills like drawing, painting or sculpture. You have to show some personal creations that demonstrate your creativity without paying too much attention to restrictions. Show some work that demonstrates your comprehension of the technical aspects of the job: low poly characters; displacement maps; and shaders.

Personal work

I started to display my personal illustrations on the web back in 1998. For me, it is a continuation of a long creative process that began way back in my childhood.

I think that 'being an illustrator' has always been my goal and still is. No matter what tool I use, it has to end with a decent illustration. I really don't know where I find the energy after a whole day at work to fire up my computer at home and do my own stuff. To me it's something vital. I need to always have this little window of freedom at night to explore new worlds. Most of the time I keep two nights a week for my illustrations and share the other days with my family and friends. It helps to restrict your own spare time.

The future

I plan to explore new fields in my personal work such as comics and short movies. The hardest part would be to find a way to live from it I guess. I don't really worry. Hopefully, it will come in time.

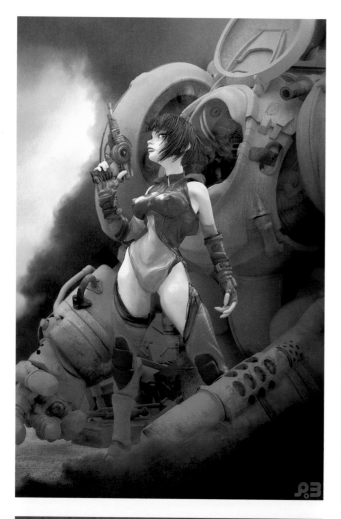

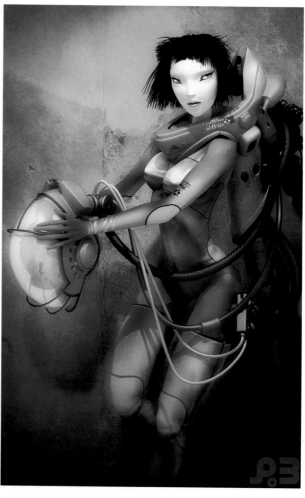

Armoredsuit

This is another illustration inspired by Sci-Fi covers and manga. I mixed those two main themes, half-rusty and old school, half-technological and sexy. It was really interesting to find a nice balance between the two worlds.
[top left]

Journey

Inspired by the odd, dark universe of Nihei Tsutomu. I like the way he drew his female characters. They look fragile and strong at the same time. Not the usual manga chick.
[above]

Mermaid

It started with a little mind game around the mermaid theme. Maybe my best work so far, you never know when it happens, but suddenly, there is a clear picture in mind and you know that you can make it right.
[left]

Arcanum XIII

An image built around dark ambience.
I wanted to create something that
inspired fantasy and lost civilisations,
but without using the usual visuals.
Perhaps H.R. Giger's 'Alien' design
work was not so far-fetched.

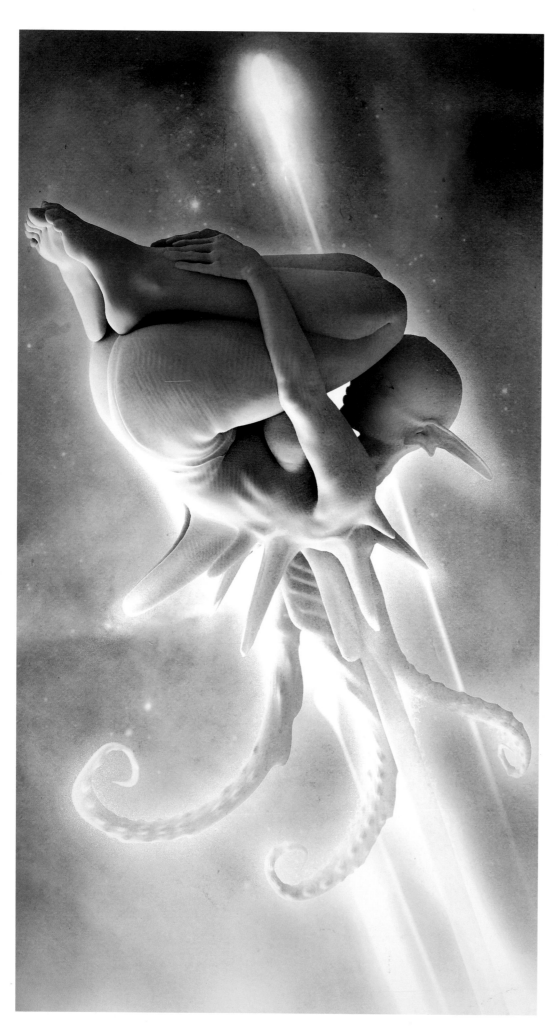

Spaceseed

An attempt to create another kind of science fiction illustration. I wanted to play around with a creature that lives in space, but without using any kind details that suggest technological life-support. Somehow it reminds me of a female version of the Silver Surfer.

[left]

Recon

Inspired by old 60s Sci-Fi covers and posters. They always try to retell the entire movie in the one image.

[right]

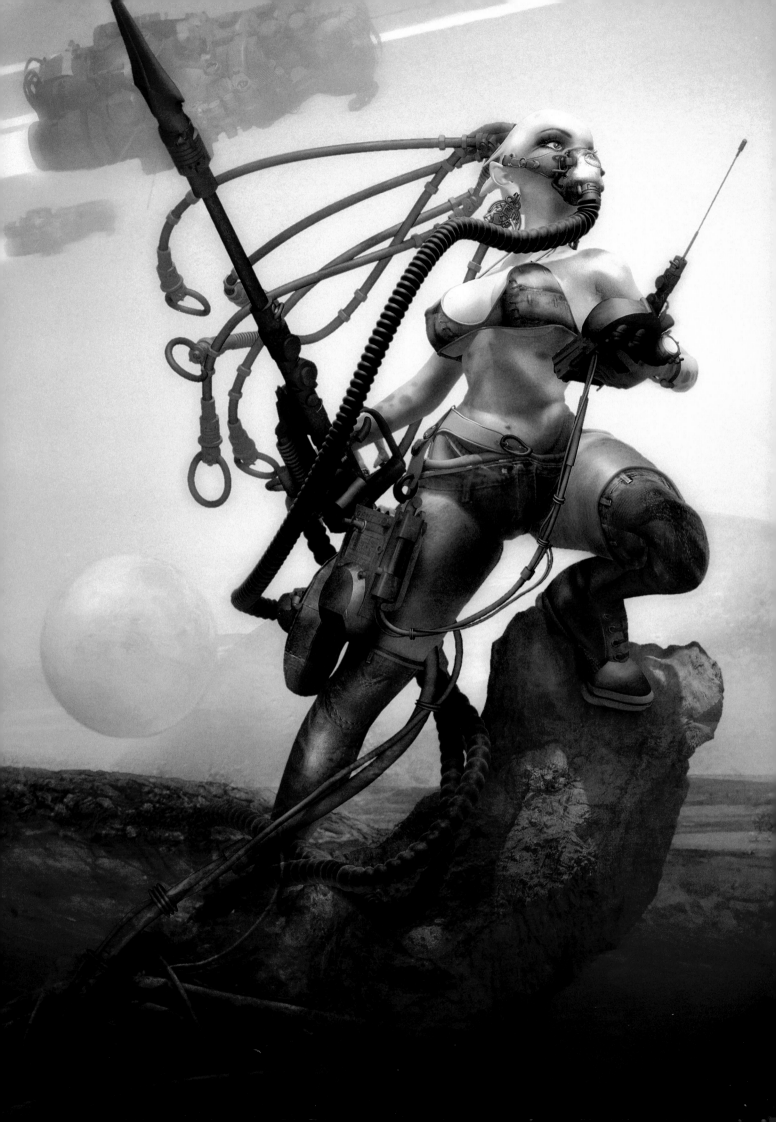

Darklord

Inspired by Brom and Frazetta's works. I wanted to do my own version of the devil or some kind of demonic creature, but have it still look nice in a way. I've never been able to create really spooky characters. I should work on that.
[above]

Refeuling

This character comes right from the first CGTalk Challenge. I didn't want to just stop here, so I created a scene that would add a little more storytelling and background for this illustration.
[above]

Snailmaster

Inspired by the works of Arthur Suydam and Sam Keith. I really like the way they both play with human anatomy, and their attachment for surrealistic characters.
[right]

Newbreed

I am a deep fan of Mr Jean Giraud, also known as Moebius. He is an artist with such inspiration and great ideas I knew that one day I would pay tribute to his work. This illustration is inspired by one of his most famous characters, Arzack. We don't see him in the illustration—we just see the shadow of his flying steed. The little girl just sits with her newborn companion, patiently waiting for the day when she will be able to fly too.

[above]

Gladiator

Another example of one of my favorite exercises: mixing genres. This character started with the envy to create a futuristic gladiator—a kind of super fighter for entertainment purposes. I have to admit that the designs of the ABC Warriors were not far away.

[above]

Ladydragon

Directly inspired by Frazetta's work, it is one of my early illustrations, and first attempts with Shag Hair. The jewels were created using Dingbat fonts (as described in my Creature Modeling: Mermaid tutorial).

[right]

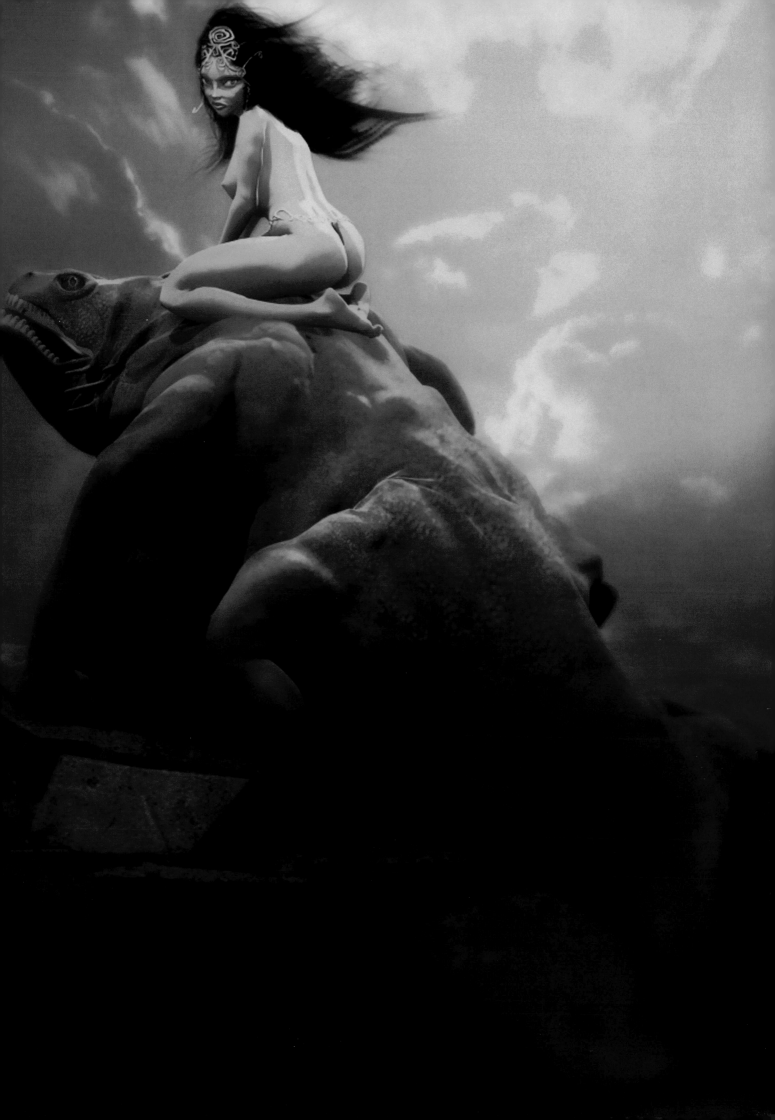

CREATURE MODELING: MERMAID

Inspiration

When I start a new illustration, I like to play with different ideas and moods, and mix them together to create intriguing characters that make you feel like you've already seen them before. I usually start with a statement like: "I'm going to make a mermaid". The next question I ask myself is how can I make it different and more interesting than a run-of-the-mill mermaid? For reference, I start with Google and filter what I like from what I don't. The more illustrations I find, the more I start to feel what is missing (from my own point of view). It's like getting inspired by subtracting ideas: "Nope, I don't want fishlegs. So what do I use to make her look like she has come from the ocean? Why a fish by the way? Why not a squid? Hey that's an idea!" For this illustration, I wanted to also create elements that would definitively associate her to the ocean world. I didn't want her to be mistaken for some extraterrestrial creature. So, I came up with the idea of the lightning jelly fish, the jewels and the background, rusty and old looking, like a part of a building from an ancient civilization.

Thinking about the pose

At this point my first tip in modeling a character would be to think about the pose first. It's a risk to create and model a character in IK (inverse kinematic) pose without thinking about some of the poses and attitudes your character will have for the final result. Think about it, it really helps a lot! I've seen so many characters that look good in IK pose and then after rigging it and putting the character in a basic pose, you think uh-oh: the shoulders are not large enough; arms are too short; or it really doesn't look like what I have in mind! Most of the time, your character design depends on what it's supposed to do and what it's supposed to be. For instance, think about the classic RPG (roleplaying game) warrior. Would he be thick with a massive axe? And if so, what would be the length of the arms needed to put it in this cool menacing pose with the arms raised above the head? So, just start by doing some little drawings to identify on paper what the overall pose will look like. Then block out a fast skeleton in the pose you want to get a clear reference of the proportions needed. You'll be surprised by the results of such process.

Box modeling all the way

Box modeling has become the most common term used for modeling with polygons. It groups different kinds of rules and techniques that help you create organic characters. Instead of starting here with a step by step tutorial about box modeling that would be boring and not really instructive, I will share with you the most common manipulations I use and why. I am a 3ds Max user, but most of the techniques I use can be found on other 3D packages, although sometimes by another name. The main thing to know about modeling is that you'll start really fast in low poly, and the more you go into details, the more work you have to do. I tend to be a little hasty and not much of a technical guy, so I usually try to get straight to what I want. Character modeling takes a hell of a long time. You could work a whole life on a character and always find new areas to work on. For my part, I always use the same three basic structures. Since I've been illustrating in 3D, each new project adds new details to the models I've created.

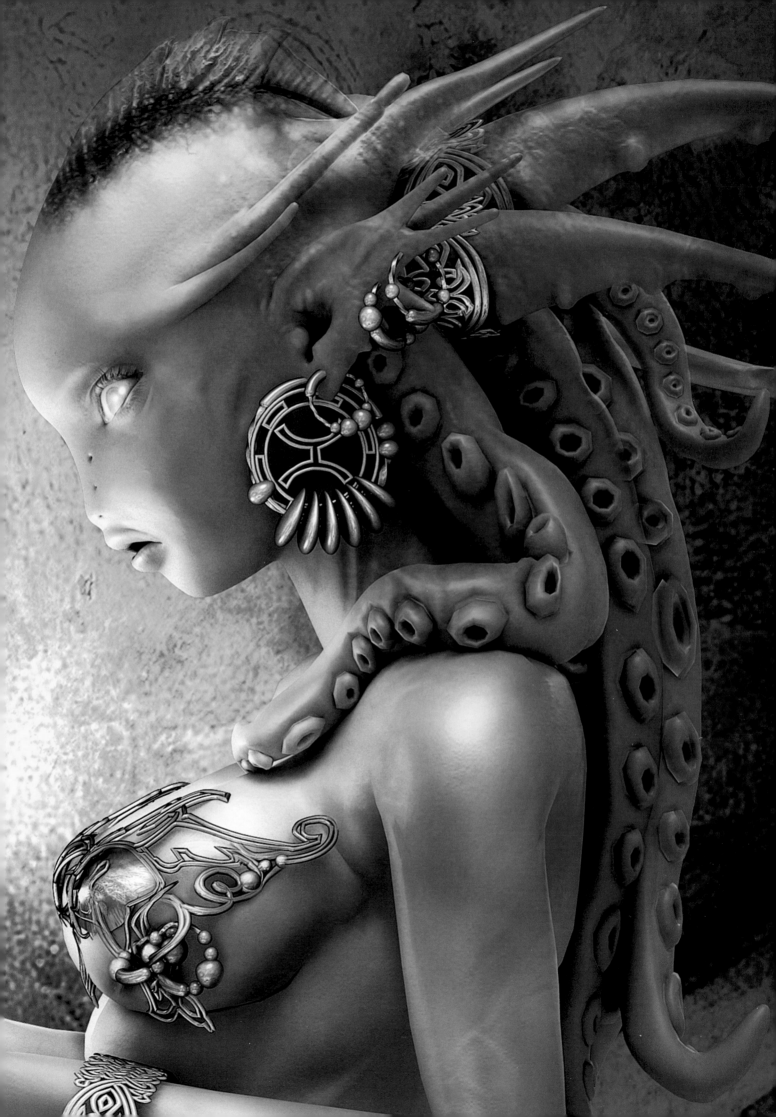

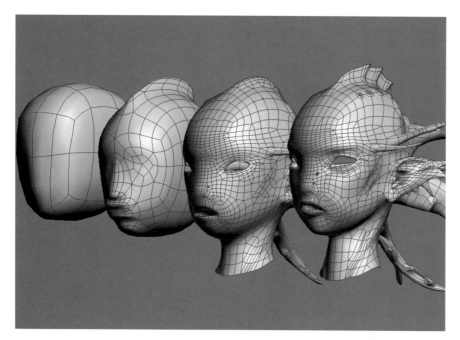

Cage modeling

I'll skip the basics of extruding faces, dividing an edge and moving vertices. The goal when you start from scratch is to get the first low poly cage of your character in the shortest time. Most 3D applications now allow you to view a higher detailed cage view in addition to the view that you're working in. This way it becomes really easy to get some general proportions of your character. At this point just make sure to refine areas that will be bent in your pose: wrists; knees; or elbows. When I'm done with my general proportions, I usually kill the first cage layer and start working on my higher poly resolution cage to refine the muscle details.

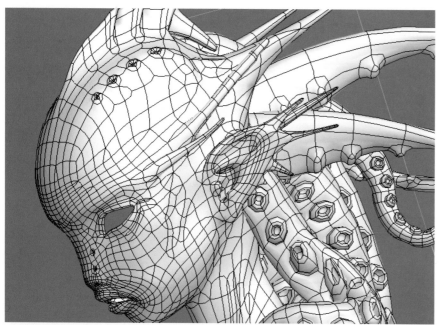

Edgeloops

This is the way you have to learn to think about your character mesh at the early stage of modeling. An edgeloop is a line of edges turning around your character's anatomy helping the whole structure to look more organic. 3ds Max is triangle-based. Basically, a quad can be oriented in two different ways, and you have to make sure that those invisible edges follow the natural orientation of your modeling. This is a really long but interesting process. For my part, I use the Turn Edges and Hide/Unhide Edges function to redirect the mesh in the orientation I need. You will have to work with the help of some anatomical books or illustrations found on the web to understand where your strong edgeloops should be. For instance, strong lines of edges should help visualize the shape of a muscle.

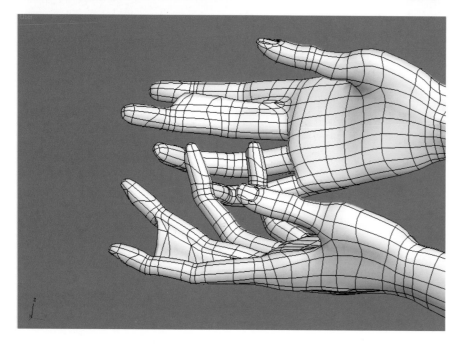

Fine tunning mesh orientation

Turning edges may be a little annoying, but it is imperative to go through this operation to make sure that your mesh is oriented correctly. Turning edges allows you to re-orient.

MeshSmooth

A good way to see the edgeloops more clearly with 3ds Max is to put a MeshSmooth on the top of your mesh and to activate the Isoline Display button. Originally designed to optimize the display while working, it is also a useful way to point out directly where the edgeloops go or stop.

Modeling details where needed

Always use strong photo references to work out the details you'll need for your model. Working on useless areas (those you don't really need to see) is way too time-consuming. Try to focus on details that count. In my opinion, character modeling is about getting a silhouette that stands out from everything else—something you will immediately identify, recognize and remember.

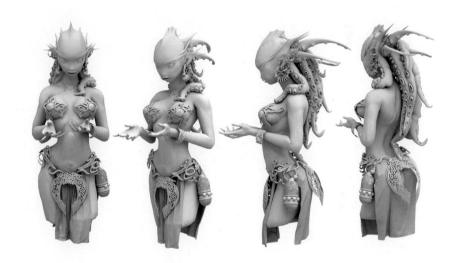

First impressions

I like to keep first impressions in mind when creating my models. What do I want to put bring out in this character? For the mermaid, the things you focus on right away are the tentacles, and then the jewels.

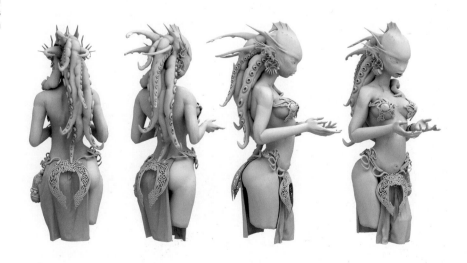

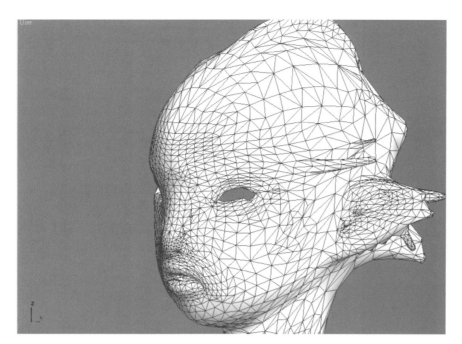

Tentacles: many in one

One of the many advantages of working with 3D packages is that you can easily create multiple complex shapes in no time.

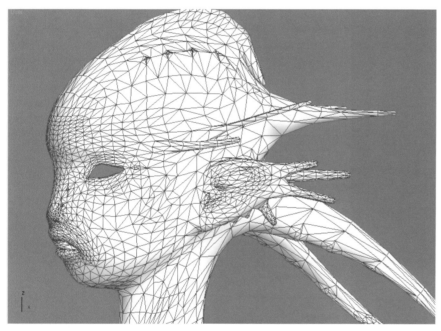

Simple primitives

Tentacles are a good example. First, I made a tentacle out of a simple primitive object, making sure that it had enough subdivisions for further steps.

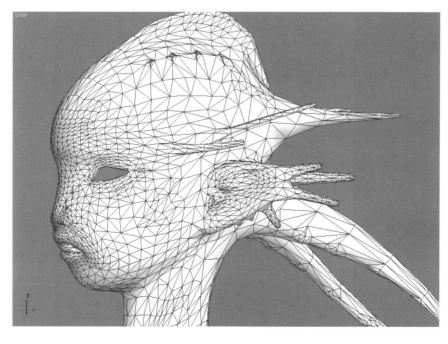

UV mapping

I also made sure to add the correct UV mapping at this point before moving on.

Deforming tentacles

I then created a spline with a few Bezier steps in order to deform the tentacle.

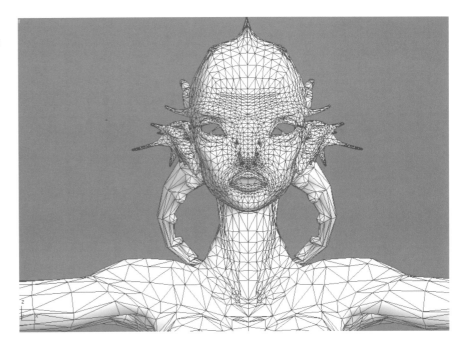

More tentacle deformations

In 3ds Max, I used the PathDeform modifier. It has useful options such as Turn, Twist and Stretch allowing me to play around with the shapes I wanted.

Many tentacles

Now that the tentacle has the aspect I want, I simply snapshot it, and play with the spline again so I can create another tentacle. In no time my hairy tentacles are done.

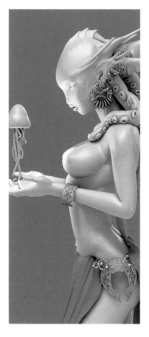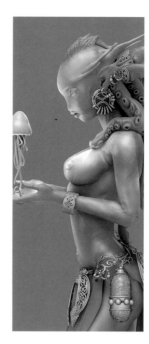

Texturing

I had a strong idea of what the final image would look like, so I made my texture coordinates right from the posed version of the mermaid. This way I could control exactly where I would place my details like the veins around the forearm, and where I wanted to use less definition. I never usually take that kind of shortcut when it comes to texturing, because the model won't work in another pose. However, it was an interesting way to work, and it really was like painting directly onto the body.

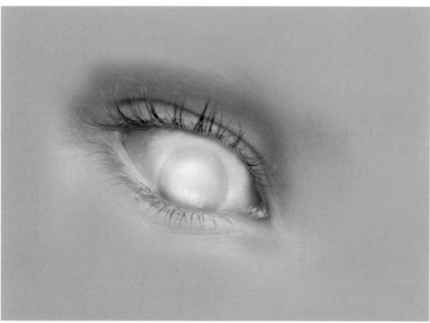

Texturing the eye

I added more specific details with extra texture coordinates around the eye area. I used a different face ID for the area, and used a mask to make the junction between the two textures seamless.

Cloth

Another handy tool that I use a lot is the cloth simulation. I have never been good with cloth modeling, so I always start from snapshots based on cloth simulations. To get the kind of effect I wanted for the mermaid I first created a copy of the model in the final pose. Then I kept only the geometry I needed for the simulation—the hips and the legs.

Geometry deformer

I used the hips and leg geometry as a deformer to create a simple plane with enough subdivisions to get nice details.

Snapshot

After playing with the simulation, I created a snapshot of the frame I liked the most and started tweaking little details that didn't work well.

Radial-based mesh

To get even more interesting fabric shapes, try out a simulation with a radial-based mesh.

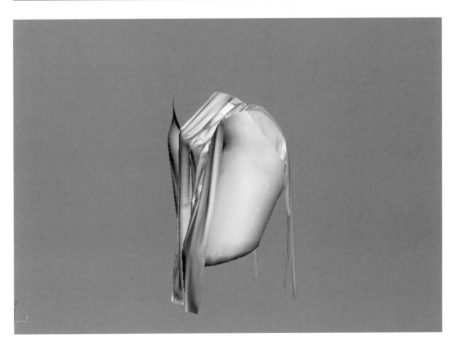

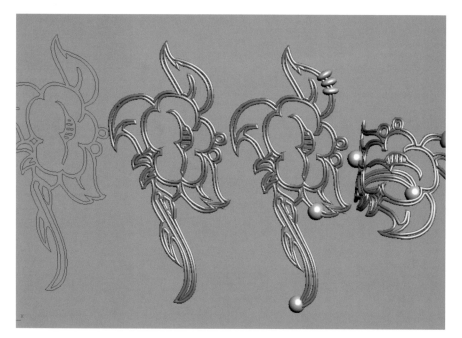

Jewels: not as hard as they look

Here's another tip I use sometimes when it comes to jewelry details. Have you ever noticed that there is an incredible amount of free dingbats available on the web? Dingbats are fonts that can have many shapes, from peanuts to Bart Simpson, but some of them can really come in handy. I created for myself a huge collection of celtic, frames, and floral dingbats that allow me to get really interesting shapes in no time.

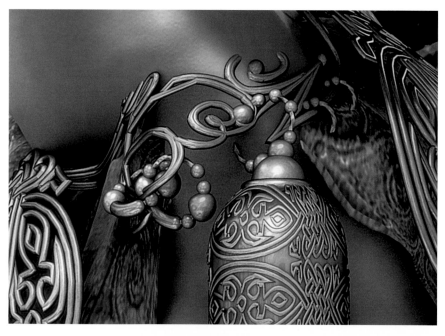

Dingbat jewels

Based on the Dingbat shapes and with some modeling and deformation added I created all the jewels I needed for the mermaid. There are plenty of other uses for those kind of ready-to-use materials. I'm sure you'll find some interesting uses too.

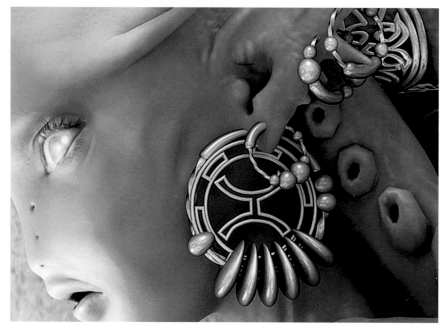

Earrings

Based on a variation of the previous technique, I created different kind of shapes for the earrings, adding sphere primitives, or twisted toruses. The idea was to get geometrical rhythms that could be seen from a distance. Don't hesitate to exaggerate shapes when it comes to small objects.

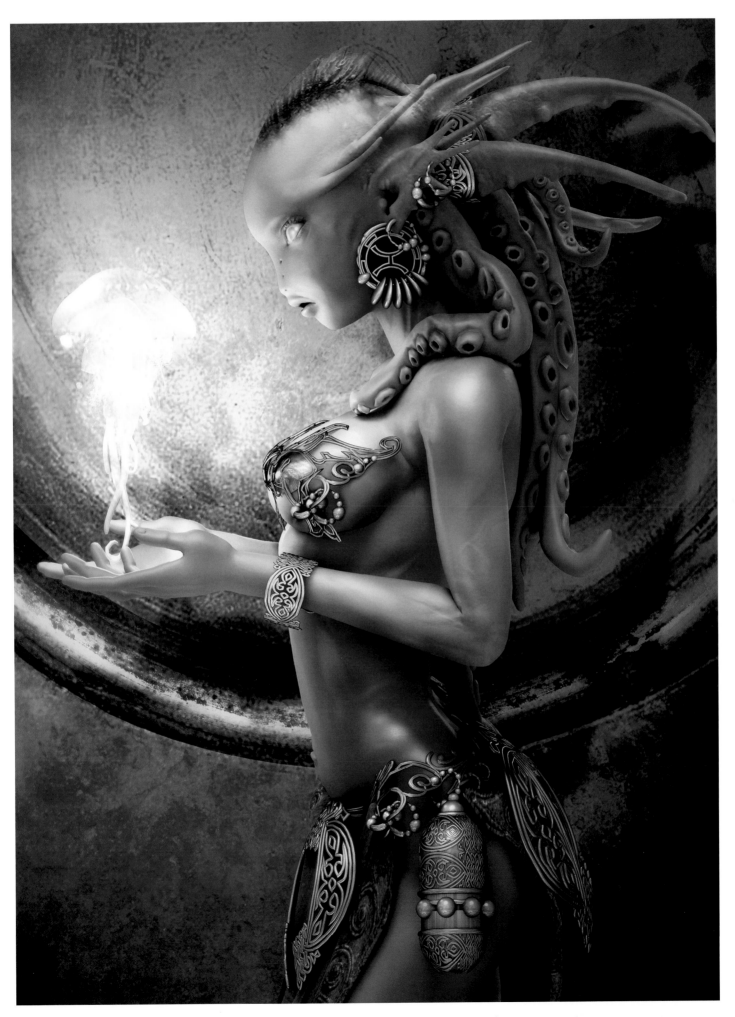

ANATOMY STUDY: STEEL

Inspiration

This picture was at first a pure anatomy study. I'm inspired by artists such as Corben, Bisley, Frazetta and Brom. I've always been frustrated by the limitations of 3D when it comes to anatomy subtleties. Have you ever noticed that no matter how long you work on your model, there is always a certain point where you find yourself stuck by the limitations of your 3D package? I am not talking about details but more about the flesh and bones feeling. Something a little more organic that we can hardly achieve with traditional modeling techniques.

Use reference

I always see models with structural problems and anatomy errors, and when I ask what went wrong, it appears that the guy never opened up a book to help himself. It is really important when you are creating a character to get a good and strong correct anatomy-based model. When your model is done, you can start to go crazy with deformations, exaggerations and additions. The good structure will remain at certain points and that's what will give your character a sense of realism.

Technique

I am absolutely not a technical artist. It took me a while to get into 3D modeling, and I have always been more obsessed by results than by ways of getting to the results. The way I see character modeling is a more instinctive way of working. So trust me when I say that box modeling is the more intuitive technique I used to work with until I got to bump on ZBrush. I think my optimum pipeline is now to mix a 3D package using box modeling and then finalize details with ZBrush, so I can keep the best of the two worlds.

Building from scratch

Using the box modeling technique, I created a basic structure, at a very low level of details, to break down the main shape of the model. What can't be shown here are the number of trial and error steps I went through to find this general shape. At this point, the most common tools I use are the Turn Edge option of the editable mesh and the Relax tool.

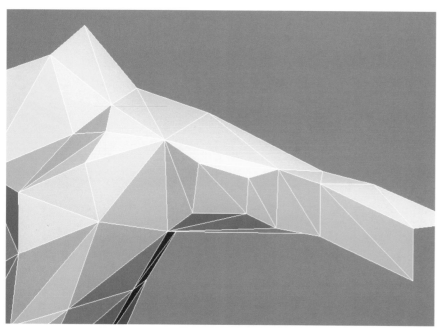

Exaggerating shape

I tend to exaggerate the shape of a muscle then I use a Relax to smooth all of the odd angles and I go back into extreme shapes, then repeat the process again. The Relax tool has to be used with caution as it always flattens your structure.

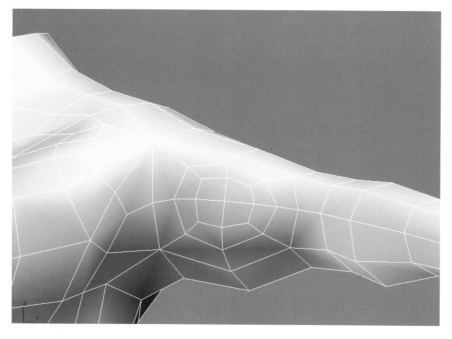

Big balls of muscles

Another technique I use a lot to build shapes is to move locally in Z soft selections of vertices. The result is that it pushes out the selection, following the selected vertex orientation—very useful to build up faster big balls of muscles.

Refining the cage

When you feel you've gone far enough with the low poly cage, add a subdivision or MeshSmooth on it and start to build up the details again.

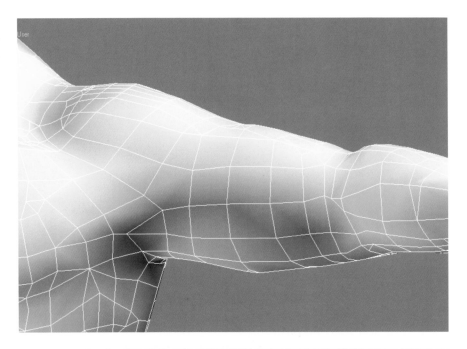

Refining the cage

While building up your model using this technique, you will notice that the cage becomes more and more linear (same space between vertices).

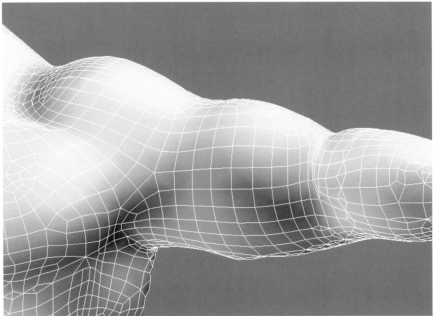

Refining the cage

At this point I start to squash the edgeloops around the bending areas like shoulders, elbows and wrists. It is also the moment I choose to display all the edges so I can see perfectly the triangles, and I eventually turn edges that don't follow the natural flow of the mesh.

Working on details

This is where the fun really begins.

Definition

Now that I have the general proportions I wanted (not fully and totally photorealistic I know), I can start to work on muscle definition and face details using the smooth cage I've just built.

Subtleties

It's easy to create nice subtleties following the cage, and it's also where I find the limits of this technique.

Setting up the pose

Before going any further into the details, I did a fast rigging and skinning of the mesh, using the built in Character Studio Skeleton and Physique modifier. After creating the basic influences of the bones deformation, I set my character into its final pose, and then I refine the deformation assignation so it fits with the new pose, correcting little errors here and there. Finally, I create a snapshot of the model and export it in .obj for ZBrush.

ZBrush magic

Well I have to admit that I've been impressed by the ZBrush experience. I've been following this package since its very beginnings, and was not quite sure how it could help me in my work process. But, when I saw the demos of ZBrush 2, I knew I would have to give it a try!

Fixing deformations

In this example you can see how you can remove all the deformations that went wrong when putting the model into its final pose.

Move tool

I was also able to refine the overall shape using the Move tool and push a little more of the general shape of the character to give him a nicer silhouette.

Even more detail

Now, by using the Drawing tool in Standard mode, Inflate or Pinch mode (transform options) and by using a large variety of brush sizes and brush z intensity, I started to literally sculpt the model without bothering with the cage.

Best process

The best technique I found was to start with a low resolution cage, refining general shapes, and the more I work on details, the more I work on high resolution cage.

Reshaping

By going back and forth from time to time into those different levels of details I was able to totally control my model, from reshaping muscles, to adding flesh wrinkles and veins.

Selling the pose

After exporting the model back from 3ds Max, I played around with different lighting and renderings to put more emphasis on the body definition. I added the steel bar and bent it into the final picture shape to add a little more story to the picture. It also helped to make more sense with the character's strength. Tension in the forearms looked huge, so he it had to really be something heavy to cause him so much strain. I used the Arnold renderer for the final rendering. Even if this renderer is still not available yet (I am one of its lucky beta testers), I consider it one of the most photorealistic renderers on the market.

Final presentation

Finally, I touched up my picture so it looked a little less cold and CG, by adding painterly effects and layers of dirt.

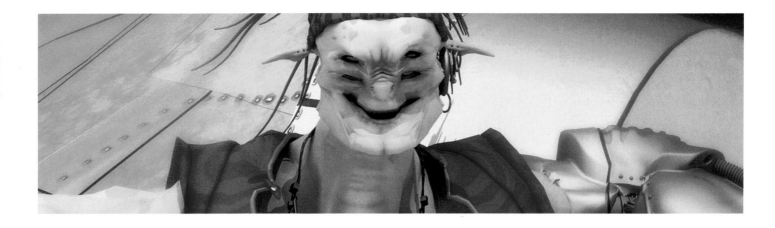

CREATURE MODELING: REFUELING

Background

The creation of this character has a funny story behind it. Back in December 2001, I was invited by two CGTalk members (Cerreto and Loganarts) to a character modeling contest. The rules for the contest were that each artist who entered the challenge would add their own characteristics to the character. It started with this description:

- Male;
- Thin and tall (my contribution);
- Alien-like;
- Big hands and feet;
- Have a tail;
- Pirate-themed;
- A prosthetic part;
- An item in hand like weapon, magic item or spoon; and
- Friendly looking

At the end the challenge (now officially known as the first CGTalk Challenge) we ended up with 34 competing members. Very quickly I started to think about a cool-looking alien air pirate. By trying to find something unusual and unexpected I came up with the idea of a four-eyed guy, with appropriate goggles. The required proportions would turn the character into some kind of streetfighter challenger, so I added stiff, rigid looking hairs. The Challenge was a great opportunity to learn from the other participants and share some tips. When the Challenge was over, I created a new illustration with my character. The story could have ended there, but a little bit later, Dean Fowler asked for rights of use of the pirate as one of the main characters for his Machine Phase project. Now the pirate has gone on to greater things with the name of Flytrap. God speed Flytrap!

Fusion and homogeneity

The interesting part in creating the pirate was to manage to get a decent looking character based on such a varied list of attributes. It was a really good exercise in character design, because often in the videogame industry you work in the same way. Game designers create a wishlist of what your character is supposed to be able to do, and you are in charge of making that character work. The main idea is to create a balance between each part of the character. Here is my tip: To get a good looking character based on so many specifics, pick just two or three ideas that you will exaggerate—the other items will follow. For the pirate, I put more emphasis on the thin and tall aspect, the alien-like aspect and the prosthetic part. By keeping the upper body naked, I managed to get an interesting contrast between the simplicity in the torso silhouette, and the complexity of the mechanised arm.

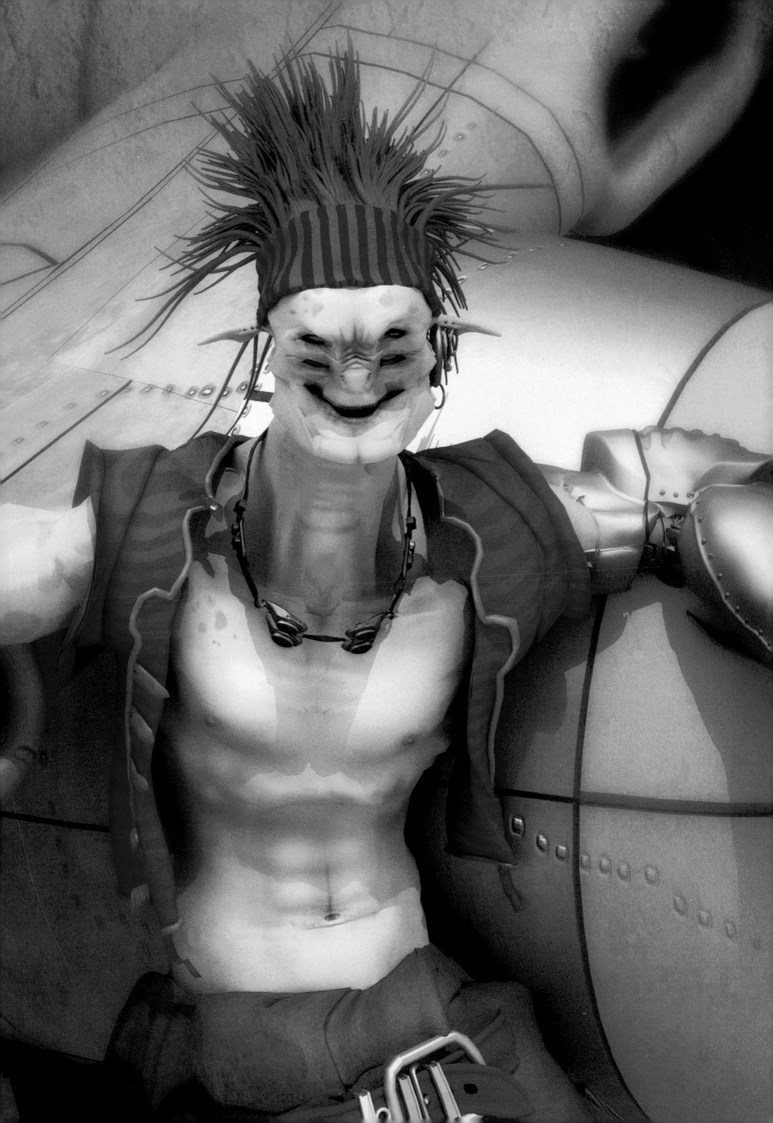

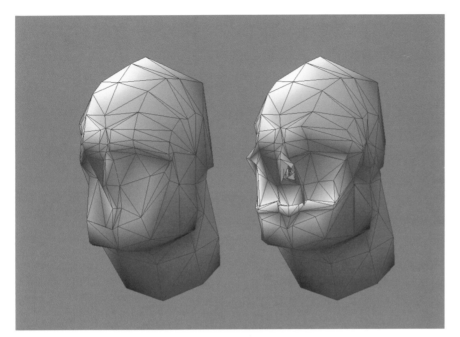

Modeling

From the start I had this idea of making a very expressive face with four eyes. Using the classic box modeling technique (going form a simple low poly box to a more complex structure), I started to play around with the general silhouette.

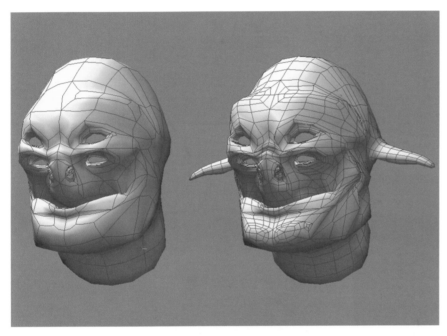

Four eyes

At this point aside from the four eyes ideas, I had no clear image of what the face would look like. So I made a bunch of trials and error attempts, but I would say that it was more as though the head came to life by itself rather than by intentional design. It's all about your personal sensibility.

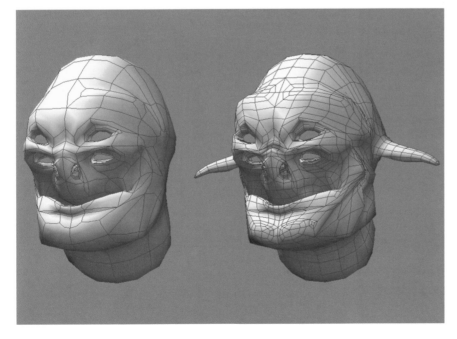

A friendly face

I like to have strong line in a face, and I also like to mix animal and human anatomy references. I don't know exactly why, but I think that I had the picture of a turtle and a camel in mind when making the face—creatures that do not usually inspire fear.

Making the hairs

For the hair I used the ShagHair plug-in. It is by far the most useful tool I've found when it comes to this kind of exercise. First, you have to create splines that will be used as guides for the hair generator. I usually use no more than five or six different sizes of splines. I place them where I need more control on size and aspect of the curve (around the ears, at the top of the head and on the back). I use the Shag Generator to create the hairs. I start playing around with the huge list of parameters, changing the curl, thickness, and number of hairs to create a variation of random subtleties to make the hairs look more real. I then create a snapshot of the hair system. It helps refreshing the display, and ultimately I can start to adjust things a little more. As a mesh object in Select Element mode, I can move hairs one by one, stretch them, rotate them or simply delete them.

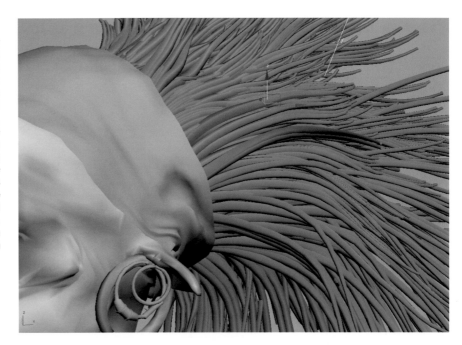

Making clothes

There are many ways to create clothes. For the pirate, I used two different techniques. The first technique I used for the vest was simply to build it from scratch. More precisely, I started this one from a capsule primitive.

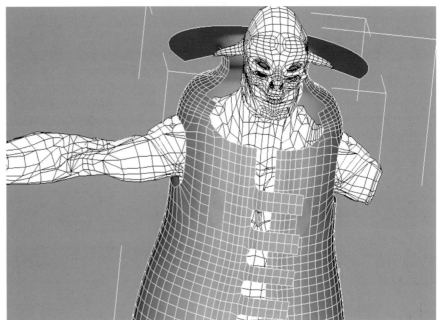

Made to order

I adjusted the capsule to the shape I wanted creating basic holes where I needed them to be. I then started to sculpt it by hand, moving vertices and faces around the body for a perfect fit.

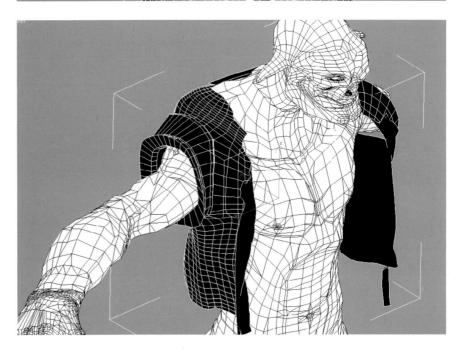

The vest

At a certain point in the modeling process, when I feel as though I've got the general look I want, I start working on details like the collar, handles and buttons. A little trick I used here (and that I use a lot in cloth modeling) is to select the open edges of the vest and create a spline from it. From there, it's easy to produce some new elements that will give more personality and realism to the overall silhouette. I start by creating a long cylinder with lots of subdivisions, and I add buttons to it. I then constrain the object to a PathDeform modifier, using the spline I created from the selected open edges of the vest.

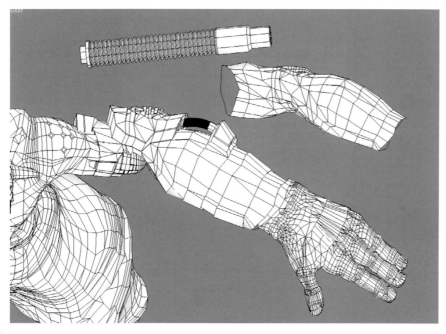

Mechanical arm

One of the most important rules you have to keep in mind when modeling is to use what you already have! The same applies here to the mechanized arm. I first created a snapshot of the left arm, hid everything else and started to extract pieces of the arm that would create an interesting combination of elements—elbow, biceps, triceps, and parts of the forearm.

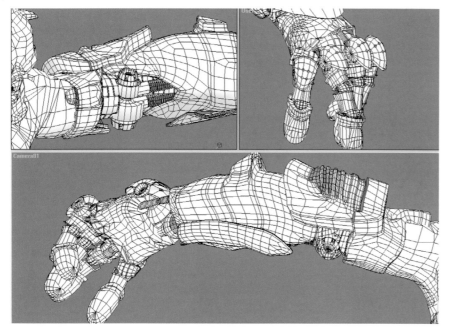

Room for details

I played a bit with the various arm elements, leaving areas intentionally open for more mechanized details. I used the exact same method for the hand.

Rotational angles

I finalised the mechanized arm by creating simple spheres and putting them in the areas where I would like to put my rotation angles. Finally, I polished the overall arm before going into details, adding wires, bolts and rivets.

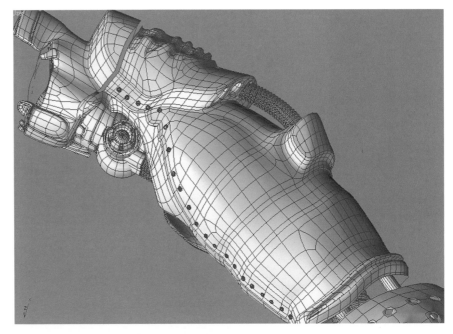

Reviewing the silhouette

When every part of the character is finally made, I go into a review process. It is funny to see how you can go wild with your modeling, and then you realize that things don't really work well together. It's is only at the end that I start to think of the overall silhouette.

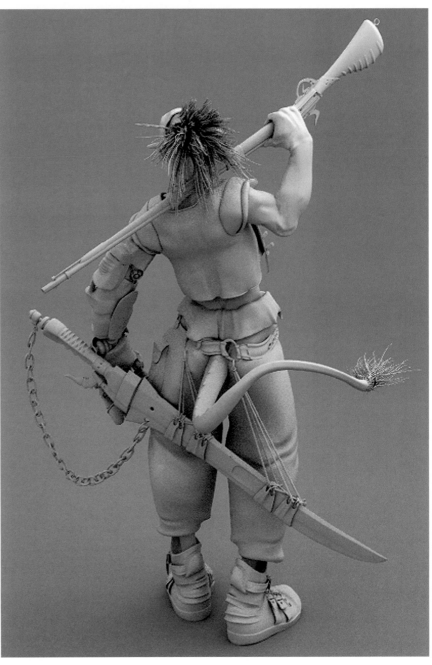

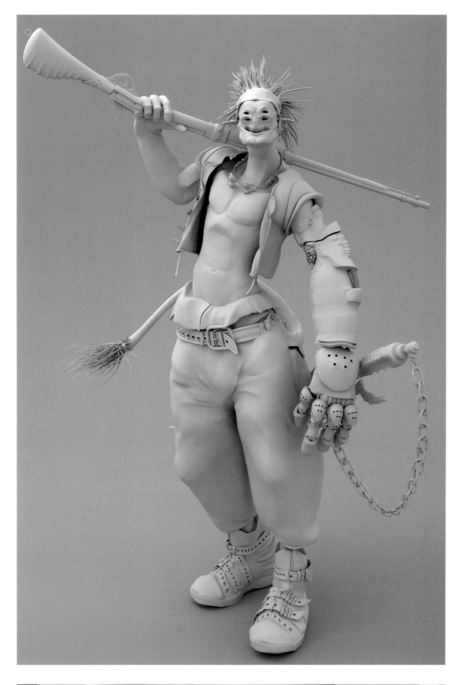

Exaggerations

At this stage, I tend to exaggerate the natural look of the character instead of fighting it. In this case, I made the mechanized arm, pants and boots even bigger. I lengthened the brushy hair even more, squashed the face so the body look even taller.

Details

A good model in my opinion is a balance between strong general shapes and a good amount of details. You don't need to go crazy on details to create an interesting character. Here for instance, I just added little holes in the hands and fingers to add a more mechanical look to the prosthetic arm.

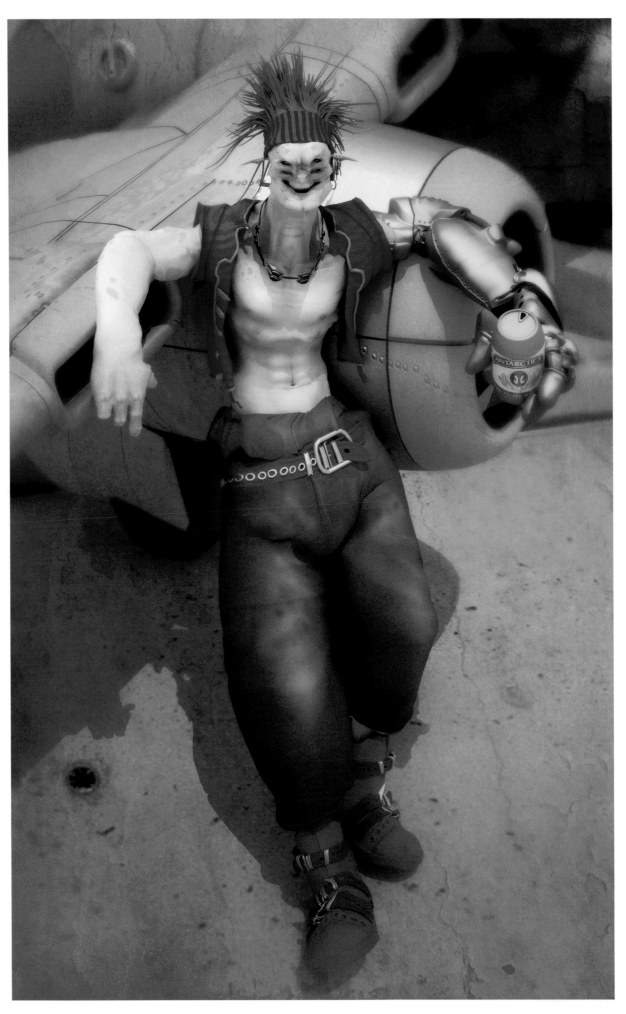

Piedad
Maya
Vladimir Minguillo,
SWEDEN
[above]

Pascal Blanché
The work is almost perfect in modeling and posing. A really sweet piece based on a classic sculpture theme. The subtle muscles and thoracic cage are really amazing, and the clothes are really well-executed.

Heady
3ds Max, ZBrush, Photoshop
Jocelyn da Prato,
CANADA
[left]

Pascal Blanché
I'm really proud to have Jocelyn in my gallery. He was one of my students in character modeling two years ago, and man, what an amazing achievement! What I really like in this picture is the way he reused the design of his character in his composition.

Chrysalide
3ds Max, combustion
Damien Serban and **Yann Bertrand,**
FRANCE
[right]

Pascal Blanché
I love the way Damien played with the automated algorithm of the software to get this impressive result. It looks almost like sculpture made of paper. I also know that this work is part of an animated short on the web, a must see!

Agent Liz
Maya
Jung Won Park, WEBZEN,
KOREA
[left]

Pascal Blanché
It's really hard to achieve decent modeling when it comes to more usual themes, like a pretty girl in leather clothes. Detail in this kind of work is everything, and here you can tell that there were lots of hours spent on this model.

Track Day Studio 2
3ds Max, Photoshop
Olli Sorjonen,
FINLAND
[left]

Pascal Blanché
Creating sensual women is something that only a few modelers can really achieve. Here's a good example of a great result on this subject, the girl has nice curves, beautiful eyes and the proportions are really well done.

Breeze
3ds Max, Photoshop
Shinya Ohashi, Shirogumi Inc.,
JAPAN
[right]

Pascal Blanché
Not always easy to find a good pose when you have created a nice model. I really like the way the curves of the hairs blend with the curves of the back and the dress. You really feel like there is movement in the air. That is also a good example of balance of tones, with the white skin and dark brown hair and clothes.

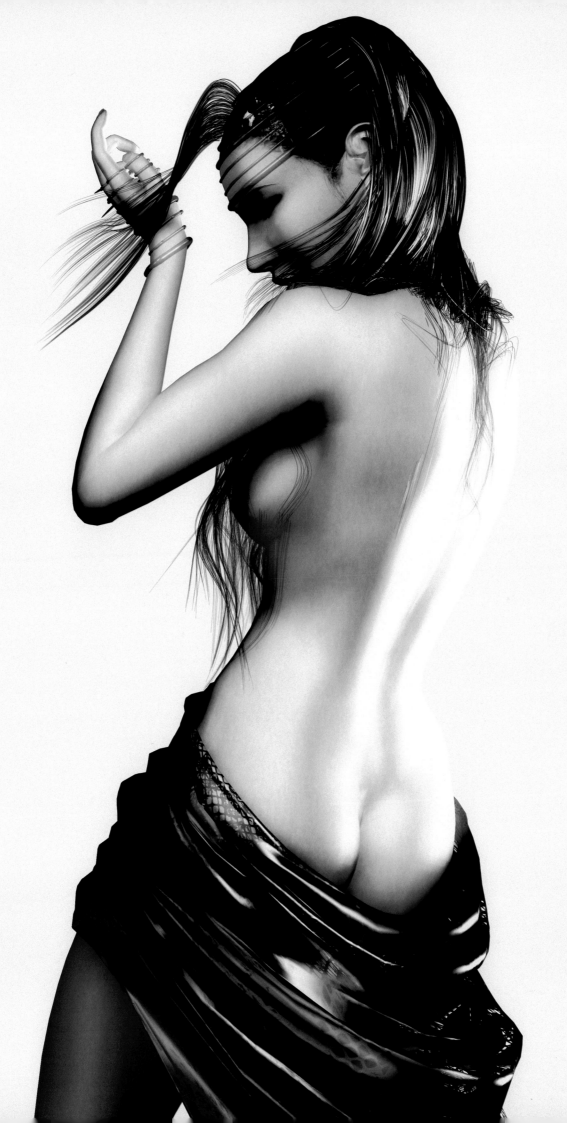

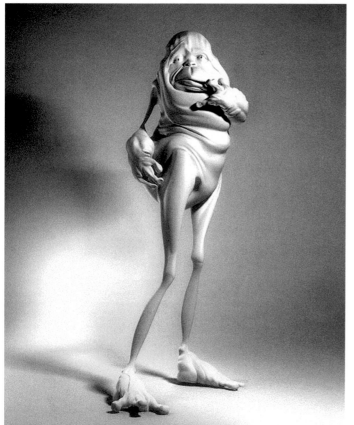

Serena
Maya, RenderMan, BodyPaint
Sebastien Haure, 3D Artizanal Studio,
FRANCE
[top]

Pascal Blanché
A superb picture about sensuality.
Sebastien did an amazing job on the
skin's realistic deformation subtleties,
and the face has a lot of character. The
chrome dragon adds a lot of power and
contrast to the whole illustration. Really
nice work!

Sexy Glubber
SoftimageIXSI
Marco Carminati, Domino Digital,
ITALY
[left]

Pascal Blanché
Marco did the illustration a long time
ago, but I still find it accurate. I like the
way he managed to make his character
so out of this world. Then again, the
artist managed to add details only
around the face, hands and feet and the
whole attitude gives it lots of life.

Troll
3ds Max, Photoshop
Jonas Thornqvist,
SWEDEN
[right]

Pascal Blanché
The work on the whole character here
really stands out from the usual works we
can see in this theme. The rhinoceros-
like skin really makes sense and follows
perfectly the skin deformation. Jonas
is a master when it comes to these
little details.

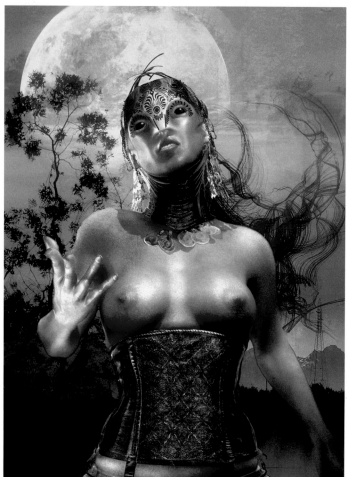

My Father
3ds Max, mental ray, Photoshop
Marco Lazzarini,
ITALY
[above left]

Pascal Blanché
Very nice work here on the deformations around the hand and the face. They look pretty much realistic, and the whole pose and lighting create a wonderful atmosphere.

Hoy the Adventurer
3ds Max, Photoshop
Jonas Thornqvist,
SWEDEN
[above]

Pascal Blanché
The natural pose and attitude of the three characters made me think it was a snapshot of a real animation. They look like they could carry a whole story, and I want to learn more about them. The colors and textures are very much like a children's book!

Kueotsa Profil
Maya, Photoshop
Loïc Zimmermann,
FRANCE
[left]

Pascal Blanché
I like the non-human face of the girl, and all the work on the clothes and jewels. Loic has his own way to create non-standard characters, and it is always refreshing to see new works from him.

Naughty Nick
Maya, ZBrush, Softimage|XSI, Photoshop
Loïc Zimmermann,
FRANCE
[right]

Pascal Blanché
Here again another work from Loic, with a different theme and mood. I feel some kind of bizzare danger coming from the attitude and eyes of this character. The skin is really nice and subtle, with hairs on the back, details in the hands and muscles you can feel under the fat. Great work!

My Uncle Cthulhu
3ds Max, VRay, Photoshop
Fred Bastide,
SWITZERLAND
[above left]

Pascal Blanché
I love when people mix bodies or genres together. Fred also managed here to play around with Lovecraft's mythos and create this very surprising and believable creature.

His Majesty Vega
3ds Max, Photoshop
Alessandro Baldasseroni,
ITALY
[left]

Pascal Blanché
Well, having been a big fan of Goldorack in my childhood, I couldn't let this rework of one of the main characters of the series go! Alessandro did a great job reshaping the face of Vega, and yet I can still recognize him! The details and overall look are great!

Prince Rivek
3ds Max
Thibaut Claeys, NarvalArt,
BELGIUM
[above]

Pascal Blanché
A classic theme and yet, somehow very different unique style. This is exactly what I like to create when it comes to character design.

In the Sun
3ds Max, Photoshop
Jonas Thornqvist,
SWEDEN
[right]

Pascal Blanché
This is exactly the kind of illustration I would be proud to create myself! Everything here is perfect, from the design of the character, the definition in details and lighting, with some storytelling coming from the scene. I love it!

The last Flight of a Mouse
Maya, mental ray, Photoshop
Igor Kudryavtsev,
RUSSIA
[above]

Pascal Blanché
I just love the funny look on the face of this little 'mouse'. You can tell immediately what is going to happen, and the general composition looks realistic.

Mad Constructor
Maya
Michael Sormann,
AUSTRIA
[left]

Pascal Blanché
A classic theme of the crazy scientist here. Nothing has been forgotten, from the glasses and rubber gloves to the clothes, attitude and crazy looking eyes. You can almost hear him scream: "It's aliiiiive!"

Small Invader
3ds Max, Photoshop, VRay
Fred Bastide,
SWITZERLAND
[right]

Pascal Blanché
Fred has created a really great picture here. The whole attitude of the alien and his surprised big eyes are pretty funny. The work on the textures is photorealistic. It looks like he took an actual photograph of it in its house!

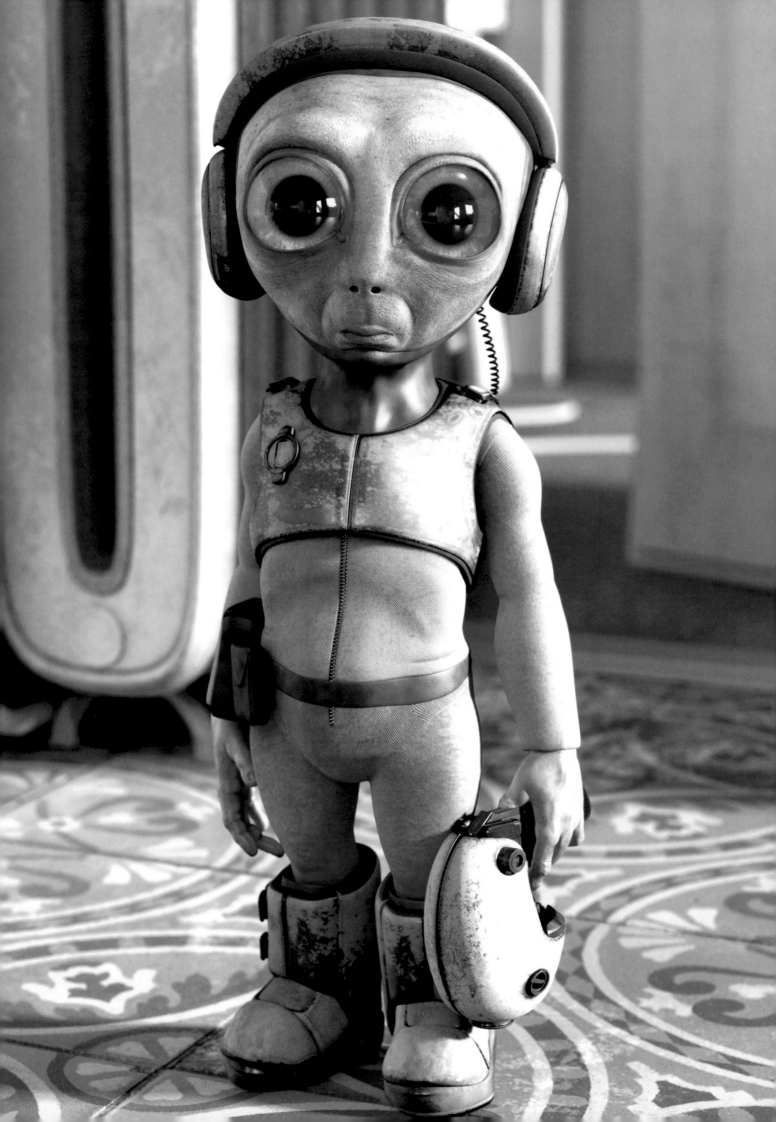

Tala
Maya, Photoshop
Farzad Varahramyan (Art Director)
High Moon Studios,
USA
[left]

Pascal Blanché
This is what I call a very good selling package. The body and attitude are great, almost comic-like, and the equipment says it all.

Tala & Cassidy
Maya, Photoshop
Farzad Varahramyan (Art Director)
High Moon Studios,
USA
[above]

Pascal Blanché
A great composition with lots of attitude. This is a good way to actually say all you need to say about the game: Guns, Girls and Action.

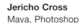

Jericho Cross
Maya, Photoshop
Farzad Varahramyan, (Art Director)
High Moon Studios,
USA
[left]

Pascal Blanché
I really liked it when they came out with a Vampire Far-west concept. The look of the character is very strong and has a lot of charisma. The whole silhouette is sharp and still really readable. Good work!

Death
3ds Max, Photoshop
Jonas Thornqvist,
SWEDEN
[right]

Pascal Blanché
Jonas did this character a long time ago, and I am amazed by how far he went on the details. The main character has a stong and powerful presence, and I like the way he came up with this idea of a tight long dress instead of pants—it really gives the model quite an unusual look.

Stumbler
Painter
Daryl Mandryk,
CANADA
[left]

Pascal Blanché
Daryl is a true inspiration for me. He swims in the same strange worlds I like to visit. His characters have always these interesting little twists that make them stand out from other works.

Assassin Kick
Maya, Photoshop
Loïc Zimmermann,
FRANCE
[right]

Pascal Blanché
This is for me the best work Loic ever made. I really like the dynamic of the pose and the multiple aspects of the whole design; half classic, half technological. Really a great illustration!

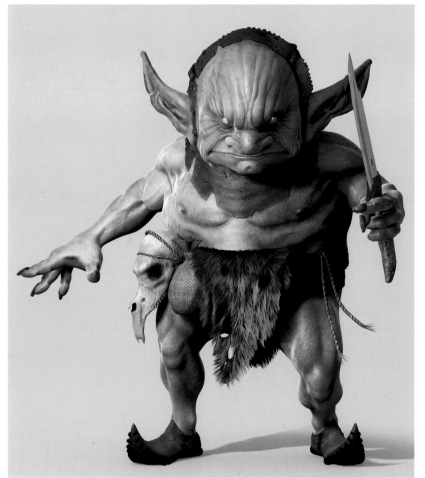

Forest Goblin
3ds Max, ZBrush, Brazil r/s, Deep Paint, Photoshop
Caroline Delen,
UNITED KINGDOM
[left]

Pascal Blanché
I love the worlds of Brian Froud, and this little goblin is a really nice tribute to his work. Caroline used a mix of applications with great results. This is maybe one of the most accomplished models I've seen for a long time.

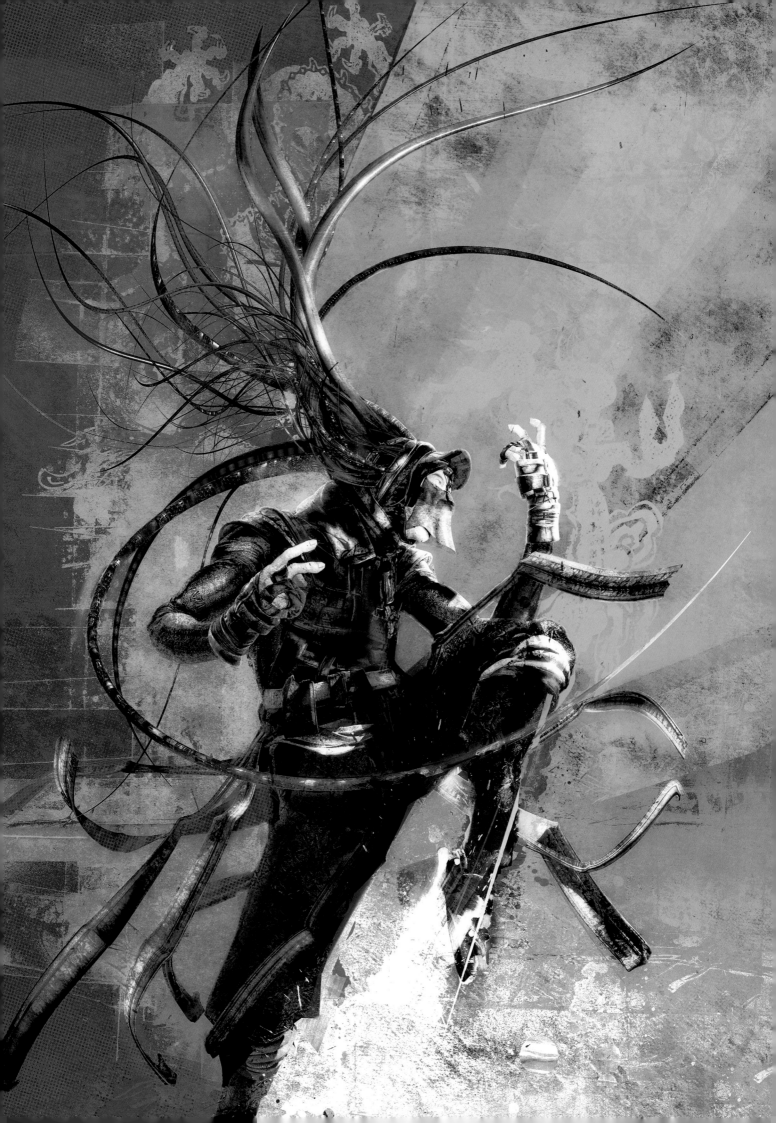

Tribute to Degas' Petite Danseuse de Quatorze Ans
ElectricImage
Malcolm Thain,
AUSTRALIA
[left]

Pascal Blanché
At first, it was the original Degas sculpture. Malcom shows a real talent for character modeing. I don't know what technique he used on the dress, but you can almost feel the fabric. The material is so impressive and gives a totally photo-realistic touch.

Fairy World
3ds Max
Olivier Ponsonnet,
FRANCE
[right]

Pascal Blanché
We all know Olivier's beautiful women portraits, but this illustration shows that he can handle more than one subject. There are lots of nice details going on here, from the dress to the fairy wings. Everything has been designed perfectly. I really dig the design of the little fairy on the left, very Yoshitaka Amano-like.

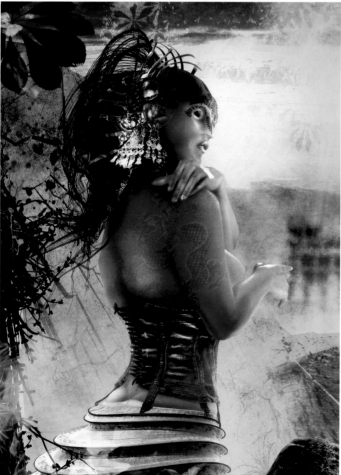

Kueotsa: times of war
Maya, Photoshop
Loïc Zimmermann,
FRANCE
[left]

Pascal Blanché
Kueotsa is the queen of the assassin. A vision in the dark, a Walkyrie. The work on the clothes and headdresses for these characters is astonishing. Always surprising, always original.

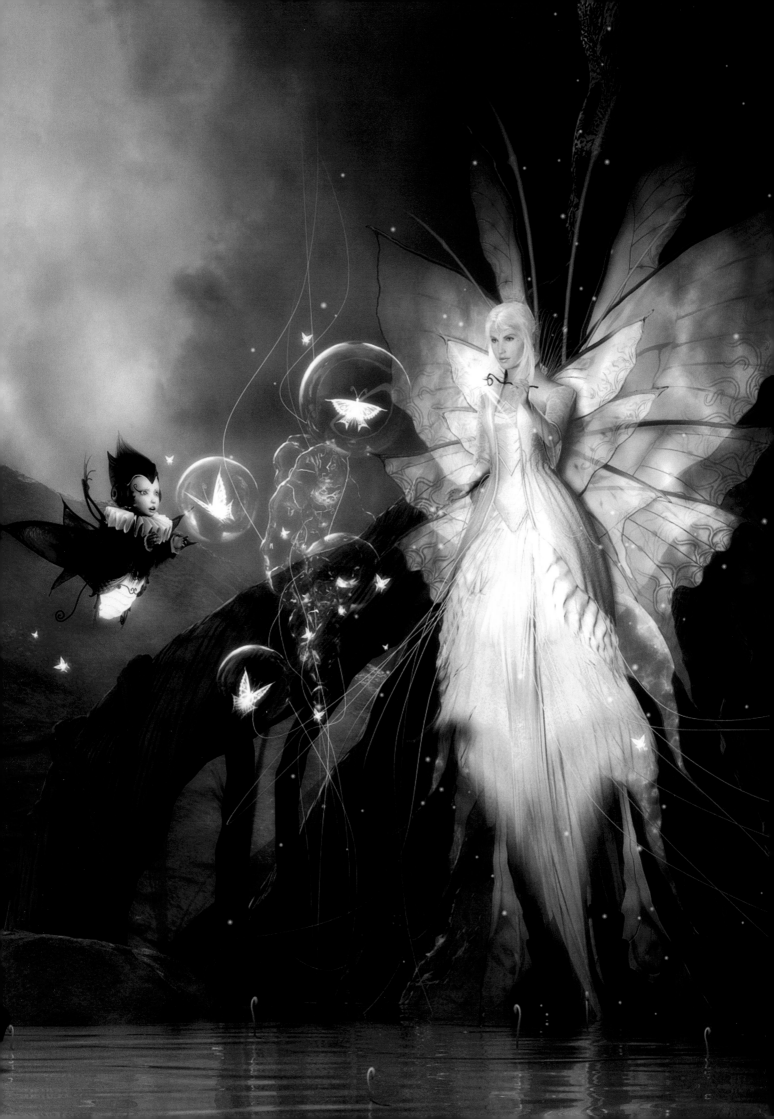

Undead Mutation
3ds Max, VRay, Photoshop
Yi-Piao Yeoh,
MALAYSIA
[far left]

Pascal Blanché
A ghoul with rotten skin and glowing eyes is a very scary subject. I like the skull details and the little broken jaw. A character that could easily fit in a classy horror movie.

The Huntress
Photoshop, 3ds Max, Brazil r/s
Dominic Qwek,
SINGAPORE
[left]

Pascal Blanché
I really like the amazing work on the dirt maps, and the perfectly functional clothes that come with the model. They make me believe in the character. Nothing too fancy. Great design!

Drake
3ds Max, Photoshop
Client: Blue Byte
Michael Filipowski,
GERMANY
[left]

Pascal Blanché
I love models that are like sculptures; the ones you could take and put on the top of your monitor. Drake has a good balance between modeled and drawn details. It gives the whole character a really painterly aspect, like its coming out of a comic book.

Nosferatu
ZBrush, Maya, Photoshop
Alexandre Camargo,
Casablanca Effects
BRAZIL
[right]

Pascal Blanché
Another classic theme created with great results. The idea of using a subscattered surface on the skin gives the character an even more ethereal, ghost-like aspect. The hands and face also have good details.

Index

SOFTWARE INDEX

Products credited by popular name in this book are listed alphabetically here by company.

Adobe	AfterEffects	www.adobe.com
Adobe	Flash	www.adobe.com
Adobe	Photoshop	www.adobe.com
Autodesk	3ds Max	www.autodesk.com
Autodesk	Combustion	www.autodesk.com
Autodesk	Flame	www.autodesk.com
Autodesk	Inferno	www.autodesk.com
Autodesk	Maya	www.autodesk.com
Autodesk	VIZ	www.autodesk.com
Avid	SoftimageIXSI	www.softimage.com
Blender3D	Blender 3D	www.blender3d.com
Cebas Computer	finalRender	www.finalrender.com
Chaos Group	V-Ray	www.chaosgroup.com
Corel	Painter	www.corel.com
Corel	Paint Shop Pro	www.corel.com
DAZ Productions	Bryce	www.daz3d.com
e frontier	Shade	www.e-frontier.com
e-on Software	Vue Esprit	www.e-onsoftware.com
Messiah	messiah:Studio	www.projectmessiah.com
Hash Inc.	Animation:Master	www.hash.com
MAXON	BodyPaint 3D	www.maxoncomputer.com
MAXON	CINEMA 4D	www.maxoncomputer.com
Mental Images	mental ray	www.mentalimages.com
NewTek	LightWave 3D	www.newtek.com
Paul Debevec	HDR Shop	www.debevec.org
Pixar	RenderMan	www.pixar.com
Pixologic	ZBrush	www.pixologic.com
Right Hemisphere	Deep Paint	www.righthemisphere.com
Robert McNeel & Assoc.	Rhino	www.rhino3d.com
Smith Micro	Poser	www.smithmicro.com
Splutterfish	Brazil r/s	www.splutterfish.com
Xara	Xara3D	www.xara.com

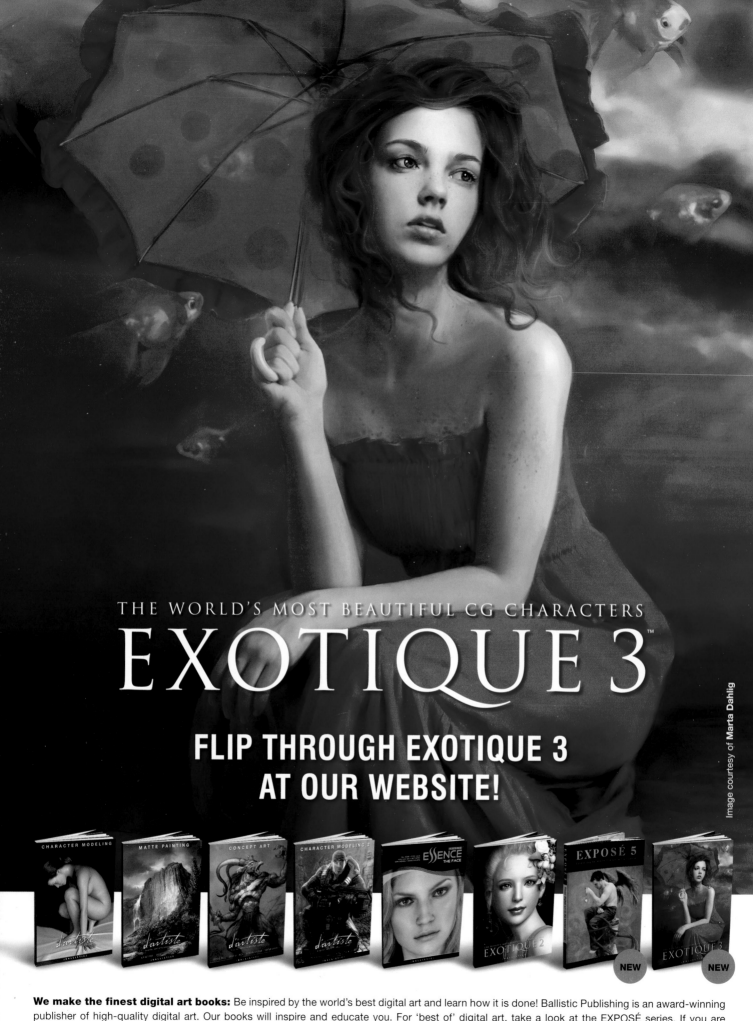